BEAUTY

MANCHESTER
UNIVERSITY PRESS

BEAUTY

James Kirwan

MANCHESTER UNIVERSITY PRESS
Manchester and New York

distributed exclusively in the USA by St. Martin's Press

The right of James Kirwan to be identified as the author of this work has been asserted by him in accordance with the Copyright, Designs and Patents Act 1988.

Published by Manchester University Press
Oxford Road, Manchester M13 9NR, UK
and Room 400, 175 Fifth Avenue, New York, NY 10010, USA
http://www.man.ac.uk/mup

Distributed exclusively in the USA by
St. Martin's Press, Inc., 175 Fifth Avenue, New York,
NY 10010, USA

Distributed exclusively in Canada by
UBC Press, University of British Columbia, 6344 Memorial Road,
Vancouver, BC, Canada V6T 1Z2

British Library Cataloguing-in-Publication Data
A catalogue record for this book is available from the British Library

Library of Congress Cataloging-in-Publication Data applied for

ISBN 0 7190 5571 7 hardback
 0 7190 5572 5 paperback

First published 1999

06 05 04 03 02 01 00 99 10 9 8 7 6 5 4 3 2 1

Typeset
by Northern Phototypesetting Co. Ltd, Bolton
Printed in Great Britain
by Bell & Bain Ltd, Glasgow

Farai chansoneta nueva
Ans que vent ni gel ni plueva ...
Farai un vers de dreyt nïen ...

Several moralists have recommended it as an excellent method of becoming acquainted with our own hearts, and knowing our progress in virtue, to recollect our dreams in a morning, and examine then with the same rigour, that we wou'd our most serious and most deliberate actions. Our character is the same throughout, say they, and appears best where artifice, fear, and policy have no place, and men can neither be hypocrites with themselves nor others. The generosity, or baseness of our temper, our meekness or cruelty, our courage or pusilanimity, influence the fictions of the imagination with the most unbounded liberty, and discover themselves in the most glaring colours. In like manner, I am persuaded, there might be several useful discoveries made from a criticism of the fictions of the antient philosophy, concerning *substances, and substantial forms, and accidents, and occult qualities;* which, however unreasonable and capricious, have a very intimate connexion with the principles of human nature.

David Hume, *A Treatise of Human Nature*, p. 219

v

Contents

Preface

This is not a book about the philosophy of art. It is unfortunate to have to begin on a negative point, and, indeed, it is a point which may at first appear redundant (after all, the title is *Beauty*), but it will, nevertheless, be useful for those readers whose speciality is aesthetics. Now, most readers who do not fall into this last class will probably believe, in the innocence of their hearts, that those readers who do fall into it would be the last people to require a reminder that the subject of beauty and the subject of art are not the same thing. Are there not a thousand different ways of enjoying, admiring, or even defining art that have nothing to do with beauty? Of course. Are there not infinite instances of beauty that have nothing to do with art? Obviously. And would not those who study both, that is, aestheticians, be best placed to realise these facts? Well, no.

The time has long since passed when 'aesthetics' could truthfully be defined as 'the study of beauty and art' (though it still often is so defined). When the word 'beauty' is used in aesthetics – as it sometimes is, in the forewords, conclusions, and even titles and subtitles of books on the philosophy of art – it is used as a mere rhetorical flourish: a word either without any meaning whatsoever, or given a meaning (for example, as a blanket term for the merits that art may possess) that is quite at odds with that normal usage which constitutes its meaning in the world beyond. To give the authors of these works their due, however, they almost never outrage this normal usage so far as to use the word consistently with this alien meaning outside of their forewords, conclusions, or titles. 'Beauty' quietly slips away from the serious business of philosophising about art – as, indeed, it should.

Yet the only place on the shelf you are likely to encounter a book purporting to be about beauty, aside that is from the 'how to' section, is

among works on aesthetics. Given this situation − that beauty belongs, nominally, to aesthetics, yet aesthetics has disowned it − it will not be necessary in this preface for me to follow the normal practice of prefaces by placing my work in relation to the contemporary debate on its subject. There is no contemporary debate on its subject. Hence the plainness of my title, which lack of adornment − no adjective, no 'and', 'of', 'in', 'as' − would be, at the end of the twentieth century, a mark either of great boldness or great naivety were the work about any other subject with so long a philosophical history.

This book, then, is about beauty. Everyone knows what beauty is. No one, however, seems to know how or why there should be such a thing as beauty. What gave me confidence in undertaking to solve this ancient problem was the conviction that the fundamental question had never been asked in the right way before. This question has traditionally been formulated as follows: 'How can we account for a disinterested pleasure of the kind beauty is?'. This is, I believe, a palpable begging of the question, though one that is, as we shall see, in itself one of the pieces of evidence that might help to answer the more accurately formulated question which I have chosen to address: 'How can we account for what is experienced by the subject as a disinterested pleasure of the kind beauty appears to be?'.

Chapter 1 sets out the nature of the problem, in particular those aspects of the experience of beauty which are usually held to be responsible for the intractability of its analysis. Chapter 2 is broadly historical, accounting for the rise of the consciousness of this intractability in the eighteenth-century − a consciousness almost universally tempered, or, it could be said, glossed over, in that century by a faith in some form of objectively 'valid' perception. I then turn to the more firm belief in the objectivity of beauty displayed by ancient and medieval writers, and argue that the contrast which can be made with eighteenth century thinkers on this point lies less in the ancients' apparent attribution of beauty directly to form than to their notion of how this form is invested with beauty. This last notion, that of the divine origin of beauty, is, I believe, one of the most significant pieces of psychological data for the examination of the nature of beauty, and points to an aspect of the subject which will turn out to be, in one form or another, ubiquitous in the history of the concept. For this reason I pursue this notion of divine origin, and, more particularly, the implications of the belief in such an origin, at length in Chapter 3.

Towards the end of Chapter 3 I draw together the characteristics of beauty so far discussed to propose the necessary elements for a theory of beauty which, while in no way requiring an appeal to speculative meta-

physics, nevertheless draws on what is revealed about the psychology of beauty by those theories which do make such an appeal, and, incidentally, shows why these two areas of discourse – the theory of beauty, and speculative metaphysics – so often gravitate towards one another. This new theory is more fully expounded in Chapter 4.

Chapters 5, 6, and 7 interpret certain traditional themes (knowledge, action, and morality, respectively) in the theory of beauty, in order both to reassess them in the light of the theory set out in Chapter 4, and to expand on some of the implications of that theory. Chapter 8 is, as it were, an aside on the fate of the concept of beauty within contemporary aesthetics. (This aside is, necessarily, quite long: I found I had to write at length about art in order to make clear why this is not a book about art.) In this chapter I use 'aesthetics' to mean 'the philosophy of art'; a narrow definition but one which is justified by the context, in so far as, while 'beauty' has often been co-opted to stand for merit in art, it has far more rarely been used to stand for merits, or charms, other than beauty, outside that realm. For this reason it seemed that the identity of beauty was most in danger of erosion from the misuse of 'beauty' within the philosophy of art, and, consequently I have particularly directed my attention to this area.

I would like to thank Joan Dowling for providing me with a very useful research lead with regard to theories of beauty within contemporary biology.

1

Impenetrable beauty

That paralysing apparition Beauty, the ineffable, ultimate, unanalysable, simple Idea, has at least been dismissed and with her have departed or will soon depart a whole flock of equally bogus entities. ... Even among those who have escaped from this delusion and are well aware that we continually talk as though things possess qualities, when what we ought to say is that they cause effects in us of one kind or another, the fallacy of 'projecting' the effect and making it a quality of its cause tends to recur. When it does so it gives a peculiar obliquity to thought and although few competent persons are nowadays so deluded as to actually hold the mystical view that there is a quality Beauty which inheres or attaches to external objects, yet throughout all the discussions of works of art the drag exercised by language towards this view can be felt.

Richards, *Principles of Literacy Criticism*, pp. 19–21

By the little which now satisfies Spirit, we can measure the extent of its loss.

Hegel, *Phenomenonology of Sprit*, Preface, §8

Beauty is in the eye of the beholder. This is, according to the wisdom of the world, the first and last word on beauty. In the section on 'beauty' in Voltaire's *Philosophical Dictionary* (a compendium of just such wisdom) he tells the story of a philosopher who, on finding that what was considered beautiful in France was not considered beautiful in England (and what is decent in Japan is indecent in Rome, and what is fashionable in Paris is not so in Beijing), by this discovery saved himself the trouble of composing a treatise on beauty.[1] Beauty is in the eye of the beholder. Yet in such contexts as the word 'beautiful' occurs there is usually little obvious indication that what the speaker is seeking to describe is an internal state. 'It looks beautiful *to me*' is a phrase that only occurs when the speaker is in retreat before some dis-

1

sension. That this should be so is indeed strange, and shows a paradox within the common-sense attitude towards the concept, for, while beholders will talk as if beauty were an objective category they will also insist, in argument, that it is a purely subjective one. This is perhaps the result, as with many such paradoxes, of intuitive feeling seeking to come to terms with an irrefutable but inimical piece of popular philosophy. But common sense in this matter is of a fairly recent date, and, as with much common sense, may not signify the solution to a problem so much as its evasion.

If we examine the course of Voltaire's reasoning we find that it assumes two things which are far from self-evident: first, that, since tastes differ, beauty must be subjective, and, secondly, that whatever is subjective cannot be a legitimate object of enquiry. Though the second of these two assumptions, when it is so baldly stated, is obviously unjustifiable, the first is one that, now at least, claims our intuitive assent. However, that the same thing is not beautiful to everyone or not always and everywhere beautiful to me does not, in itself, disprove the objectivity of beauty. Differences in taste might also be attributable to differences in the ability to discern beauty (as the Pythagoreans held we do not hear the music of the spheres because it is continual, and Augustine that we are not always and everywhere aware of the beauty of creation only because we cannot grasp it as a whole). Such differences would then be explicable on the quite plausible grounds that no two occasions of seeing the same object or thinking the 'same' thought are identical. So that the occasional nature of beauty (the uniqueness of each of its manifestations) could be attributable to changes in the context in which the object is seen, the thought thought – or rather to the fact that what I believe is the 'beautiful object' is really only one element, necessary but not sufficient, to what is the real, objectively beautiful object[2] (a distinction which, in another form, I will return to). All one would have to do to prove such an hypothesis would be to show which properties are both necessary and sufficient for any given object to be beautiful, and demonstrate what qualities in the perceivers qualify or disqualify them, at one time or another, from discerning these beautiful properties. The long record of failed attempts at just this project is discouraging but does not, in itself, rule out the possibility that it could be completed. Indeed, that beauty is a property which can be discerned in objects is an idea that remains, despite the popular avowals of subjectivity spoken of above, tenaciously part of the language game of the word 'beauty'. It may be that there is an historical dimension to our feeling of certainty about the subjectivity of beauty: that the present feeling about beauty is indirectly conditioned by its changed role in the discourse of

theory in precisely the same way as, in an earlier age, the opposite certainty – that beauty is objective – continued to exert a now discernible influence on even such subjectivist aestheticians as Kant. It may indeed be that we have no better grounds for our faith in the idea of the subjectivity of beauty than that we are used to it.

However, any reader who has ever read one of those many works that seek to demonstrate how what is small, round, smooth, and blue, or complex and harmonious, or symmetrical, or devoid of superfluous parts, or whatever, is inevitably beautiful, that is, who has read a book on beauty presumptuous enough to contain illustrations (or which could not possibly contain illustrations), will be reassured to know that I intend, despite what I have said above, to take the essentially subjective, and individually subjective, ground of our perception of what is beautiful as given. For the sake of convenience I will occasionally slip into such abbreviations as 'beautiful object', 'beauty of the object', or 'is beautiful' – each of which is to be understood to mean 'inspires, according to a particular subject at a particular moment, the sensation of beauty'. The disadvantage of allowing my description to drift towards the common, if theoretically disowned, tendency to reify the beautiful object qua object is outweighed by the advantage of avoiding the unwieldiness of prose which would certainly result from constantly reminding the reader of that – the subjectivity of beauty – which the reader is, in any case, probably more than ready to grant me. But this reassurance, that I will assume the subjectivity of beauty, is perhaps not likely to be found very reassuring. It is, as we have seen, the conclusion that beauty must be subjective which leads Voltaire's philosopher to abandon his project. For the obvious futility of arguing about what is beautiful has, commonly, led to a belief in the futility of asking what is beauty. What is surprising is that this conclusion would seem to imply what one of its premises denies, that is, that beauty is a real property of objects or it is nothing.[3] Few aestheticians, it is true, are guilty of this. yet almost everyone else to whom I have mentioned that I am writing a book on beauty has immediately responded with a sentence containing the words 'only' or 'just' in combination with 'subjective' or 'matter of opinion', uttered in the tone of voice I imagine Humpty Dumpty used with Alice.

Beauty, it is said, is subjective ... and that is the end of the matter. For this is what the word 'subjective' signifies – 'Here ends science', 'Here be monsters.' (It sounds so scientific and final, this 'subjective', like 'spontaneous generation' or lusus naturae.) The argument seems to be that if we cannot hold up even one object and say 'This is indisputably beautiful', then it is begging the question to ask what the feeling it inspires may be.

However, if I can even imagine one person saying on one occasion 'This is beautiful' and, even if I am not of that person's opinion, I nevertheless know what the person means, then I already have the object of my study: the feeling itself. For what is extraordinary is not that sometimes even apparently antithetical qualities are considered beautiful – that what is ugly here and now was beautiful there and then, and vice versa – but that the connotation of the word 'beautiful' remains stable, that the idea of beauty, this mute concept, has existed both here and there, then and now.[4]

The argument against even enquiring after the nature of beauty on the grounds of differences in taste is, then, like arguing against the existence of linguistics on the grounds that there is a variety of languages. It is always possible, of course, that different people may in fact be referring to different states or sensations when they use the word 'beautiful'. I admit that at times in writing this book I have been so flabbergasted by some of the things I have read about beauty *per se* (rather than what is beautiful) that I have thought that this might be the case. However, I still do not subscribe to this counsel of despair; I still feel that what has been written about beauty, even when I disagree with it, is in some way related to my experience of beauty, is trying to describe or account for something I am familiar with. Ultimately I can only present my own account and leave it to you to decide if it is solipsistic.

The theory of the beautiful does not fall within the scope of this work. For the discovery of what common denominator belongs to every object which inspires us with a sense of beauty would not itself constitute a theory of beauty, would not in itself account for the nature of that sense. Many of the more obvious omissions in the present work, then, are explicable in terms of its intention to present a theory of beauty, rather than a theory of the beautiful. For what I am concerned with is not the objective qualities of the beautiful, but rather the dynamics of the event of beauty, the perception of beauty, that is, the mental state which issues in the feeling that a thing is beautiful. Even those cases where certain conditions seem, in practice, to act as *a priori* functions of the beautiful – as is obvious with things which are nearly always beautiful in one context (for example, in relation to a specific nationality or age) and yet nearly always not in another – such connections are only causal after the fact. Even if it were possible to establish a complete taxonomy of beauties, to define the object in all its physical and temporal dimensions (and in relation to any particular hypothetical subject), to delineate precisely what objective properties would be beautiful for a specified subject under specified con-

ditions, and even if we were to take the establishment of such a taxonomy as proof of the objectivity of beauty (for this specified subject), the problem would still remain: why this particular sensation (or emotion, or idea) in connection with these particular qualities of this particular object? Such a taxonomy, then, while perhaps providing decisive data for a theory of beauty, would not, in itself, be an answer to the question 'What is beauty?'.

Why, then, is Voltaire's argument, from the subjectivity of beauty to its necessary inscrutability, so common? Perhaps it is because we almost resent beauty for not being objective. Indeed the 'subjective', which has become the orthodox response in the ordinary of the question of beauty, only seems worth insisting on, only seems like a significant and decisive assertion, because the subjectivity of beauty is not felt to be self-evident in the experience of beauty.[5]

Beauty is the one thing we do 'know' absolutely, its being is to be perceived, and thus it guarantees its own reality. The inscrutability of beauty, its traditional grounding in the 'I-know-not-what', simply signifies that the perception of beauty is so immediate as to leave no room for enquiry. I may doubt the existence of the external world, for a certain time, with at least some philosophical impunity, but I cannot doubt that what I perceive as beautiful is such; for even if the second glance reveals the object to be ugly, with the first glance I saw beauty. In the realm of beauty *esse* is *percipi*. Even Hume, with his faith in the verdict of experienced and impartial critics, can assert that, since the perception of beauty is 'determined by sentiment', and, since this sentiment cannot be unknown to a person who feels it, it follows that my 'judgement' of beauty is infallible.[6] For if there is no space between perception and judgement in which understanding may operate, there is no conceivable sense in which I can be wrong about whether I do or do not perceive beauty.

Yet the question 'Is anything really beautiful?' still, unreasonably, seems to be a quite different question from, for example, 'Is anything really frightening (as opposed to dangerous), or funny, or sad?'. (Is it not precisely this difference that haunts the tone in which I am told that the whole business is *only* a matter of opinion?) There is something in beauty that at once renders a universal guarantee of its 'reality' unnecessary, and yet which has prompted many to feel that if it cannot furnish such a guarantee, it is beyond the pale of enquiry, or even, in some vague sense, non-existent.

To what extent, then, does the concept of beauty now exist? The modern definition of 'beauty', the subject of this work, confines itself to

a characterisation of the purely phenomenal aspect of beauty, without (apparently) asserting anything about its ground; though, as we shall later discover, there is much even in what might be called the 'classical', agreed characterisation which I will now give, that, while appearing merely descriptive, in fact begs several questions with regard to the grounds of the sensation.[7] Beauty, according to this characterisation, is that quality we attribute to whatever pleases immediately, that is, pleases in itself, irrespective of any concept of, or interest in, the object (material or ideal) to which it is attributed. What is beautiful is that which appears to us as an object of necessary delight, though we remain aware that the grounds of this delight are subjective. This last is important, for the idea of laws of taste, in the sense of concepts by which beauty might be *a priori* defined and our taste compelled, is manifestly a self-contradiction. Beauty is immediately and (despite its felt subjectivity) irreducibly a sensation – it strikes me. This definition obviously shows few pretensions to explaining its object. As a characterisation of the way in which we 'perceive' beauty it is, if we ignore for the moment the adequacy of 'pleases' and 'delight', almost complete, yet so much of it is either antinomical or purely negative in character that, in order even to begin an analysis, I must first qualify each of its propositions with 'apparently'. This is the blind aspect of what Hume called the 'blind but sure' perception of the beautiful.

It is because of this very immediacy in the perception of beauty, that is, beauty's appearance as simple perception, that differences of taste, among other considerations, appear to render an enquiry into beauty *per se* futile: the object of our enquiry is, on reflection, not what it appears to be. As we shall see, however, it is precisely those differences in taste, and other instances which serve to impress the subjectivity of beauty upon us, which offer the readiest point of access to the universal conditions of beauty. Where, I believe, the study of beauty has most often gone wrong is in taking the definition of beauty as a sensation for the sensation itself, that is, in forgetting to qualify its terms in the way in which, as I said above, the antinomical character of its central axioms should naturally prompt it to do. Too often the subject matter of the theory of beauty appears to be this, essentially Kantian, definition rather than the phenomenon. So that theory develops not from a grasp of the phenomenon as a whole but rather from what is only a rationalisation of the most immediate characteristics of a sensation. (Again the root of this error might be found to lie in a certain unconscious reluctance to abandon completely the idea of beauty's objectivity.) For perhaps the easiest mistake to make in approaching beauty is to take it too readily at face value, that is, to assert

that everything which does not, on reflection, fulfil the criteria for the sensation of beauty cannot be beauty, despite the evidence of the senses.

The question of beauty is begged, then, primarily through theory disallowing the subject's perception of beauty on the grounds that, for someone other than the subject, this perception appears to rest on grounds that are incompatible with the agreed description of the perception of beauty; as when, for example, it is asserted that subjects were mistaken in claiming an object is beautiful for them if it can be discovered that this object has some private association for them, so that the 'delight' they feel cannot be said to arise from the object-in-itself in the way that the agreed description of the perception of beauty demands that it should. Such a demand does not necessarily imply that beauty is an objective quality; it might also arise from the presupposition that, though subjective, beauty must nevertheless be a form of subjectivity that could potentially be felt by anyone, by any (albeit negatively) 'qualified' perceiver. Of course the argument would be simply circular if one of the qualifications for being such a perceiver was an ability to prove that the object had no personal associations for one. There is less obvious circularity, however, in the real origin of the belief in the incompatibility of beauty with personal association, that is, the experience of beauty as disinterested and static. For this feeling that any taint of personal association disqualifies a feeling from being beauty rests, when it does not involve a belief in the objectivity of beauty, principally on the idea that a personal association must inevitably imply a desire or interest and therefore, since beauty is experienced (if only retrospectively) as disinterested and static, what is felt in such an instance, even if it is felt by the subject as beauty, is not really beauty. There are two problems with this. First, and most important for my general point here, it is begging the question to judge the authenticity of a reaction which believes itself to be a perception of beauty purely on the grounds of a characterisation of beauty which is, avowedly, only a deduction from such reactions themselves. Secondly, even if we grant that beauty is not only apparently but also essentially disinterested and static, to disqualify a feeling of beauty which is demonstrably but unconsciously 'adulterated' by association, we must first prove that the subject feels a desire or interest in connection with the association that is itself amenable to satisfaction by the object designated 'beautiful' by that subject, for otherwise the emotion inspired by this association could itself be pragmatically disinterested and, necessarily, static, in a way that would make it not incompatible with what is felt in the experience of beauty.

Let us for a moment consider, however, those responses which are obviously partisan. By an 'obviously partisan response' I mean those per-

ceptions of beauty which manifestly rely on an association that would seem necessarily to imply an interest; for example, the invulnerable beauty of the scene of one's childhood or of one's lover, the patriot's tendency to overrate a national poet, the scholar's enthusiasm for the speciality. Because such reactions are obviously partisan (particularly so if the scene of one's childhood happened to be a slum, if the lover's crystallisation of the beloved is obviously at variance with the facts, if the patriot's taste is otherwise conventional, or if the scholar is an otherwise rational person), they are often held up as examples of 'aesthetic mistakes', misuses of the word 'beautiful'. However, excepting those instances in which the subjects are actually conscious that their 'judgement' is influenced by some stubborn loyalty to the object, there is no reason for saying that they are mistaken when they say they perceive beauty. Rather what this partiality reveals is no more than what the subjectivity of beauty implies: that, in some sense, the object they perceive when they perceive their home, their lover, their poet, their subject of study, is not the same object as I perceive. ('I don't know what he sees in it.') The object about which they ostensibly speak is public property but the object which they call beautiful is something discernible only by themselves. (It is not even unusual for someone who apparently shares a beautiful object with another to discover, from some chance remark by that other, that, apropos its beauty, their objects are quite different.) This same disjunction is also the reason why, of all objects, it is a person which, for any particular subject, can show the most consistency in being beautiful, for, as the strangeness of using the word 'object' here indicates, a person is a being of such amplitude, entailing so many associations and implications, that the object (the material form) in this instance is always only the tip of a far more complex, and hence more stable, object, which latter object inspires the sense of beauty. This, I believe, holds true even in the case of a stranger.

However, in the case of an obviously partisan response, is there not a sense in which, in so far as I am non-partisan, my sense of whether the object is beautiful or not is 'right', and the partisan's therefore 'wrong'? But right can mean nothing here except objective, so that the partisan's response could only be called 'wrong' from the viewpoint of a theory of beauty which held it to be an actual property of objects. Once we have said that beauty is subjective we have foregone the right to say there can be such a thing as a 'mistake' with respect to the sensation itself, not only in the sense of someone being wrong about perceiving beauty but also in the sense of somebody attributing the beauty to what is only one aspect, necessary but not sufficient, of the person's real beautiful object. Whatever

kind of mistake this is, if it makes sense to speak of it as a mistake at all, it is not a misuse of 'beauty'. True, the person's description of the 'beautiful object' may be in some way mistaken, and there may be degrees to which one can be accurate in saying 'This is beautiful to me', but in so far as beauty is subjective, is not a quality, we cannot say that any perception of it is a mistake, though subjects' awareness of their grounds of attribution may be more or less adequate.

However, in so far as we cannot say what beauty is, that is, in so far as even if we can point to all the qualities of a thing which we believe make it beautiful for us, and even get another to discern them, we can still neither construct a syllogism from these qualities that would always and everywhere conclude in beauty, nor convince that other to perceive the beauty, the suspicion must arise that this divergence between the real cause of our perception of beauty and our perception of this cause is a universal condition of the sensation. (That is, that awareness of the grounding object can be more or less but never wholly adequate.) For once we have allowed that beauty both appears as the quality of an object (as the result of mere perception) and yet is necessarily subjective, that beauty is, in Schiller's words, both state and act, we must also be prepared to consider that the beautiful object itself may be a phenomenon of greater complexity than the simple designation 'object' would immediately imply.[8]

The seaweed appears beautiful − luminous, ethereal, animated, caressing. You need only lift it out of the water to discover that the essential, intrinsic beauty of seaweed is also a matter of the sea. Many assertions containing the word 'beautiful' are, on reflection, shorthand. So much is obvious. Yet, on further reflection, are there any assertions or even perceptions which are not abbreviated in just this way? For reasons that will become clear later, rather than either inventing an instance of beauty, or presenting one from my own experience, I will use a specific case history, as it were, to illustrate the point. In his Critique of Aesthetic Judgement Kant writes that while a bird's song is beautiful, if it could be exactly imitated by artificial means 'it would strike our ears as wholly destitute of taste'.[9] This would suggest, as Kant himself comments, that he has perhaps confused what he thought was a perception of the beauty of the song with what is in fact a feeling of sympathy with a 'dear little creature'. If this was the case, if the perception was mistaken and the bird's song was not in itself the beautiful object, then some concept must have been involved in that 'perception'. The difficulty cannot be resolved simply by saying that it is the bird's song coupled with the bird's singing that is the beautiful object, for, as Kant says, for him the song is 'mirth', and the bird a 'dear

little creature'. On reflection the 'beautiful' song begins to look less like an object of immediate, necessary delight, and more like the accidental occasion of some other feeling, the beginning of a chain of association. For at least some concept is involved (that of the bird), and quite possibly an interest (sympathy, and the concept of nature as a suitable object of sympathy). Still we might say that the concept, or even the concept of the interest, are beautiful objects, that is objects of an aconceptual, disinterested, necessary delight. And if we were to discover that these apparently beautiful concepts did, in fact, rest on others, or on some interest, then we could simply again postpone what we designated as the beauty of the 'bird's song'. Such a potentially infinite regress would render our initial definition of beauty, as 'disinterested delight', irrefutable – though it would also rule out the possibility of using the word 'beautiful' to describe what we merely perceived as beautiful![10]

Such a deliberate introspective analysis of an instance of beauty as Kant makes is unusual, though other instances, in which we find ourselves obliged to defer the attribution of beauty, are common experience – the photograph that fails to register the long waking night before this 'beautiful dawn', the music which, under different circumstances, has lost its power to move, the discovery that the beautiful 'place' you wished to return to is also a point in time.[11] (How even the most apparently enduring and tenacious of beauties, the beauty of a person, can suddenly evaporate with a gesture, a word, a change of expression or hairstyle, that is, a change in those very things which seemed most accidental to the beauty, and the decisiveness of which was completely unforeseeable.) The necessity, in such instances, of deferring the definition of what constitutes, or constituted, the beautiful object does not, of course, place beauty per se immediately under suspicion of being grounded in either a concept or an interest. What this premature attribution of beauty does, nevertheless, show is that, in the realm of beauty, sometimes our perception of what is 'immediate' or 'inherent', that is, our perception of what appears mere perception itself, is mistaken. (I am, of course, concerned here only with our perception of what constitutes the beautiful object, not with beauty itself; the word 'beauty' loses all meaning as soon as we try to assert that it is possible to be mistaken concerning whether we really perceive/feel it or not.) This possibility of being 'mistaken' – and I have dealt here only with those instances of beauty in which reflection becomes inevitable – suggests, even more strongly than the necessarily antinomical and negative character of the classical definition of beauty, that there is some inherent confusion, or perhaps even process of resistance, in the very perception of the beautiful.

This observation in no way affects the question of the subjectivity of beauty (even if I could perceive what the other perceives it does not follow that I would find it beautiful), but only the role of the phenomenal component of the instance of beauty – the object to which beauty is attributed. Neither, as I said above, is the immediacy of beauty compromised, for if 'beauty' is to have any meaning it must be allowed that what I perceive as beautiful is beautiful. It is rather my perception of the perception of beauty which is placed under suspicion by this need, on reflection, always to postpone what I would designate as the beautiful object. To prevent confusion, then, I must at this stage define more precisely what can be meant by 'beautiful object'. There is, obviously, no such thing as a beautiful object per se, only a beautiful instance, that is, a situation, or event, involving a phenomenon (material or ideal) and a state. 'Beautiful object', however, might be justifiably used to designate the phenomenal aspect of this situation, so long as what is understood by the term is the object in so far as it is involved in such an instance.

But a further distinction is necessary: between the 'beautiful object', as what appears to the subject necessary and sufficient for the perception of beauty, and the 'beautiful object' as reflection might discover it, that is the phenomenal aspect of the instance of beauty for the subject. The 'beautiful object'; in this second sense, is rarely perhaps what is perceived as the 'beautiful object', that is, that which is perceived as the object which inspires the sense of beauty, though necessary, may be by no means sufficient to what actually is the beautiful object. This actual beautiful object, then, being that hypothetical object – the existence of which we must infer both from the existence of 'mistakes' and from the obsolescence of every instance of beauty – which is comprised of all those phenomenal elements necessary to the instance of beauty, a set of variables a change in any one of which would cause the object, as beautiful object, to cease to exist. Moreover it would seem that this class is necessarily not open to conscious formulation; we are often surprised when reflection (time) reveals that what we would have sworn was accidental was, in fact, essential, and, far more often, we are aware only that, for reasons we cannot explain, the 'thing itself' is no longer beautiful.

What is perceived by the subject as the 'beautiful object', then, appears to be as much occasioned by beauty as it is its occasion. We may, therefore, provisionally distinguish between the beautiful object, meaning the phenomenal aspect of the instance of beauty, and the perceived beautiful object, meaning what is perceived by the subject as the phenomenal aspect of the instance of beauty. Yet this distinction, while mak-

ing it necessary to qualify the assertion that beauty, even considered sub-
jectively, 'simply appears', does not, in itself, indicate that either a con-
cept or an interest is at work in beauty. The problem of the causelessness
of beauty is not solved, though the finality of the 'disinterest' involved,
given that the perceived beautiful object is apparently a construction or
abstraction (whether deliberate or otherwise) made by the beholder, must
be located somewhere other than in the consciousness of that beholder at
the moment of beholding. So that while the sensation must fulfil the con-
ditions of appearing aconceptual, disinterested, and so on, to the subject
in order for that subject to use the word 'beauty' correctly, there is no rea-
son to infer from this, as the theory of beauty traditionally has, that beauty
itself must fulfil these conditions in order to be beauty.

One question which I do not intend to address at this stage, but which
must arise from the distinction I have made above, is whether subjects
would actually find the phenomenal ground of their perceived beautiful
object beautiful if they were able to perceive it consciously. That is, it may
be that beauty comes about only through a deliberately selective percep-
tion, a perception that is in some way aware of what it excludes, in so far
as, for the sake of the beauty of an object, it can deliberately exclude the
more complex object which is its ground. (It may even be that beauty
exists only in this act of exclusion itself.) Even if this is not the case, to use
the phrase 'beautiful object' to describe the true phenomenal ground of
the instance of beauty may be misleading, for, though it is this ground
which inspires the sensation of beauty in the subject, it is not, as an object,
part of the subject's conscious experience of the sensation of beauty.
Whatever the true nature of the ground of the perceived beautiful object,
it would appear to exist for the sake of the beauty the subject is conscious
of, for it only exists as a set of elements comprising a single object, in rela-
tion to this sensation. So that while to call the object which is the true
ground of the perceived beautiful object itself a 'beautiful object' may
appear a misnaming, in so far as, since it is not perceived by the subject,
it cannot be itself credited with beauty (which only exists in attribution),
nevertheless it can justifiably be termed the 'beautiful object' in so far as
it is the object which, by means yet to be discovered, ultimately inspires
the sensation, or emotion, of beauty in the subject.

This distinction between the actual and the perceived objects of the
sensation might begin to account for the antinomical definition of beauty
which is derived solely from the subjective experience of beauty itself.
For, since the perceived beautiful object is not the true ground or adequate
object of the 'delight' which is felt, there is no reason why this 'delight'

should appear other than disinterested and aconceptual. Indeed the very form which the sensation takes, its resistance to logical description, would alone imply as much, since if the 'delight' really were as immediate as it seems we should have to allow that beauty was, in some sense, a subjective objectivity – not simply an oxymoron but a contradiction in terms.

It is, then, those very instances (partisanship, changes in taste) where the subjectivity of beauty comes most problematically to the fore which, rather than supplying conclusive evidence of the inscrutability of beauty, in fact provide us with a point of access, an indication of something perhaps essential to every instance of beauty yet not evident in the direct experience of beauty itself. One way of proceeding from here would be to try to isolate the actual beautiful object in some particular instance, discover what features would make it a source of that species of pleasure which beauty is, including, of course, the cause of its necessarily remaining unperceived by the subject, and then see if we could generalise from this instance to others. But, as I have said, I am only indirectly concerned with the beautiful and, though I must have myself undertaken something like this process in order to arrive at the theory of beauty I will present, I nevertheless wish to keep my exposition on a more abstract level, to concentrate neither on the phenomenal aspect of the perceived beautiful object nor on its phenomenal ground, but rather on the division between them. At this stage I have hardly advanced beyond the traditional attribution of beauty to some 'I-know-not-what' in the perceived beautiful object. Indeed, in emphasising the elusiveness of the beautiful object itself, I have even, with respect at least to individual instances, suggested that this should be redefined as the 'I-cannot-know-what'. The usefulness of the distinction so far made, however, is twofold. First, it points to a way beyond that capitulation before the inscrutability of beauty expressed by the phrase 'eye of the beholder' (and more militantly asserted in 'just subjective'). Secondly, it points to some form of action on the part of this beholder, albeit at this stage posited merely as a resistance, apparently for the sake of the perceived beautiful object, to realising the ground of that object.[12]

'Beauty is in the eye of the beholder' is the attitude which leaves beauty as an in-itself, even while appearing to assert just the opposite. But once we have homonymically, so to speak, shifted this phrase to what it can meaningfully say, that is, that the source of beauty lies within myself, it emerges that the only alternatives are actually between examining beauty or leaving it unexamined. This is not to say that I can analyse what

to me is beautiful – for once a thing is beautiful to me there is every reason to assume it is beyond analysis. My study must therefore be, as it has been so far, a study of beauty's associations. I can also draw upon what is associated with beauty in my own experience, that is, its causes (its occasions: objects, ideas, situations) and its effects (feelings, attitudes), though, from the standpoint of considering it as a fusion of state and act, its causes may turn out to be effects (as in the 'construction' of the perceived beautiful object), its effects potential causes. I may also look at what the subject itself has inspired, for, as we shall see, the tendency for the description of the sensation of beauty to usurp the place of a definition of 'beauty' has also led to an impoverishment of this description – since anything beyond 'immediate and disinterested pleasure' appears too impressionistic, too much perhaps like an assertion about the very ground which the given part of the description implicitly renders inscrutable.

There are, in effect, only three theories of beauty. The first (that beauty is in the eye of the beholder) is not a theory at all, the second (the synaesthetic in its various forms) has never been found convincing even by its proponents, and the third (the Neoplatonic) is based on premises, and proceeds by a method, that place it quite beyond the bounds of sense. It is, then, this last theory, being furthest removed from that rigorous logic which abandoned beauty, which is, as might be expected, the most fruitful. However, given that this Neoplatonic discourse is, ostensibly, far removed from common sense, it will first be necessary to show the extent to which our common sense in this matter is, as earlier suggested, a peculiarly modern, conditional common sense. In the next chapter, then, I will consider the historical roots of the first (non-)theory, and, in Chapter 3, the Neoplatonic concept which it can be said to have supplanted. The synaesthetic theory of beauty will be dealt with in Chapter 5.

2
The eye of the beholder

La beauté est la seule chose au monde qui n'existe pas à demi. [Beauty
is the only thing that does not exist by halves.]
> Quoted by Swinburne from an unspecified 'greatest master now
> living among us', in *Essays and Studies* (1875), in *Complete Works*, XV,
> pp. 1–216 (p. 216)

In many productions of Nature and even of Art men find, beyond those per-
fections subject to their comprehension, another kind of mysterious beauty
which torments their intelligence in proportion as it pleases their taste, which
their senses can touch and reason cannot decipher; so it is that when they wish
to explain it, not finding words that satisfy their idea of it, they let themselves
fall, discouraged, into the formless assertion that a certain thing has an 'I know
not what' which pleases, which enchants, which bewitches; and there is no
profit in asking them for a clearer revelation of this natural mystery.
> Feijoo, *The 'I Know Not What'*, pp. 336–7

We no longer dare to believe in beauty and we make of it a mere appearance
in order the more easily to dispose of it.
> Balthasar, *Seeing the Form*, p. 18

It is only as we move into the eighteenth century that differences in taste
begin to become a problem for the notion of beauty, a warning against
over-subtle philosophers that the subject is best left alone.[1] What, for Kant,
becomes the 'antinomy of taste', is, for more self-assured souls like Pope,
a matter almost of ridicule:

> Tis with our judgements as our watches, none
> Go just alike, yet each believes his own.[2]

15

Voltaire's near contemporary, Testelin, holds that it is impossible to make judgements about beauty on the basis of individual inclinations since these depend upon the temperament and disposition of the individual's organs, which vary from country to country.[4] Crousaz comes closest to the modern philosophical position when he writes that, since 'That is beautiful' really refers to a certain bond (*rapport*) between the object and our feeling of pleasure or approval, so that it means no more than 'I approve of that' or 'It causes me pleasure', the word 'beauty' must be chronically ambiguous.[4] Now this sort of ambiguity is what we may expect of something which depends upon nothing more intelligent than the eye – the eye may see but it does not understand. This is why, indeed, if the eye is the judge, if beauty is contained in it and in it alone, then beauty is quite beyond the reach of concepts. This is a truly fallen state, in which the eye is no longer the window of the soul, but a self-moved mover. Moreover this eye is a prison from which no concept of beauty may escape. But is this, or can this be, what is meant by 'the eye' in the history of beauty?

Spinoza does actually refer to the eyesight as a factor affecting our perception of beauty, but also cites temperament in the same breath.[5] His belief that 'beauty is not so much a quality of the object which is perceived as an effect on him who perceives it' is often echoed in the eighteenth century. Hume, for example, holds that there is nothing 'in itself' beautiful, the attribution arising rather from the particular condition of human sentiments and affections, and Montesquieu writes that beauty does not have a '*positive* nature' but is 'merely *relative* to the nature and operations of the soul'.[6] But this is not quite to relegate beauty to the autonomy of the eye, or, since this was the age of Taste, the tongue.[7]

Beauty, according to Hume, is 'felt' rather than 'perceived', but, since the sentiment depends upon 'the particular fabric or structure of the mind', there must be 'something approaching to principles in mental tastes' that distinguishes them from the taste of the palate or the nose.[8] Montesquieu too, though he recognised that the source of beauty is within us, was led on from here to the assertion that to enquire into its cause is thus to 'investigate the springs of our mental pleasures'.[9] According to Burke the realm of pleasure and pain, of fear and hope, is the imagination, which, as the mere 'representative of the senses', we must presume to be more or less uniform, and therefore to respond more or less uniformly, in 'all men'.[10] Differences in reasoning and taste, then, he concludes, are more apparent than real, and the 'standard' of both is the same in all human creatures: 'For if there were not some principles of judge-

ment as well as of sentiment common to all mankind, no hold could possibly be taken either on their reason or their passions sufficient to maintain the ordinary correspondence of life.'[11] Even Voltaire writes that, though literary taste and the 'sensation of the palate' are alike in both being a 'quick discernment, a sudden perception', the use of 'taste' in connection with beauty is nevertheless to be understood as metaphorical.[12] Addison, who also believes that, despite the 'conformity' between 'Mental Taste' and 'Sensitive Taste', the use of 'taste' in the former is metaphorical, sums up (prospectively) this eighteenth-century line of thought when he says that the sense of beauty, or the 'Pleasures of the Imagination', are 'not so gross as those of Sense, nor so refined as those of Understanding'.[13] The figure with which I began expresses a similar idea though perhaps in a clearer way, for the eye can seem more metonymic than metaphorical.

This sensuous/cognitive notion of beauty also allowed the eighteenth century to have a concept which, though not entirely lost, is at least stated more circumspectly today, that is the concept of 'good taste', 'bad taste', and, therefore, the 'improvement' of taste. (Even Voltaire believed in this last).[14] Thus while Hume in one place asserts that taste cannot be a matter of dispute since its standard is a sentiment, elsewhere he writes that such judgements depend upon 'some internal sense which nature has made universal in the whole species', and thus, though some kinds of beauty are beyond any influence, with regard to many 'it is requisite to employ much reasoning to feel the proper sentiment; and a false relish may frequently be corrected by argument and reflection'.[15] Human nature, even allowing for cultural differences, and the 'gradual refinement of manners', is, according to Kames, universal and invariable; from which it follows that there must be a standard of taste, a right and wrong taste.[16] (Nothing of the sort does, of course, follow from this premise unless we make the further assumption that, even allowing for differences in culture, age, character, personal history, and so on, taste can be defined as a direct, unmediated, response of this human nature to the objective properties of an object.) This talk of sentiment may, however, be misleading. The notion of the disinterested nature of taste was also advanced as a reason for assuming its uniformity. Thus Smith writes that since objects of taste have no more 'peculiar relation' to the subject than do objects of science, we must assume that the standards of beauty and truth are similarly objective.[17] At the end of the century Kant came, by the same argument, to the same conclusion.[18]

However, the age had a 'stronger' argument than either of these; one that is still occasionally used today. The idea that tastes are not to be disputed, writes Gerard, 'would imply that our natural principles of taste,

unlike all the rest of our mental faculties, and our bodily powers, are incapable of being either improved or perverted; it would infer that it is absurd to censure any relish, however singularly gross'.[19] And let anyone who has never arrived at some unsympathetic opinion of a group of people from a consideration of their taste, or does not understands the meaning of the word 'kitsch', cast the first stone at this opinion.

Indeed it is often argued in favour of the idea of good and bad taste that since tastes change, and usually in certain predictable ways, this must constitute an 'improvement' in taste. Though this argument presupposes what it is intended to prove – the existence of some absolute yardstick, some Greenwich Mean against which to measure such changes ('improvements' or 'perversions'), that is the existence of good and bad taste, the 'really' and the only 'apparently' beautiful – its conclusion was sufficiently in harmony with the Enlightenment concept of human nature to pass for sound. For the eighteenth century, then, with its belief in 'good taste', and therefore the objectivity of beauty in all but name, beauty was, despite the boldness of their pronouncements on its relative or negative character, no less a property of objects than for any preceding age.[20]

Jeffrey, following Alison, could write that all tastes 'are equally just and true', but this view, and the theory of beauty on which it is based, are sufficiently exceptional to appear anachronistic.[21] Alison began from the familiar proposition that material qualities cannot be beautiful in themselves, but then, unusually for his time, went on to offer a theory of why such qualities do appear beautiful: by becoming, through association, 'the Signs and Expressions of such qualities, as, by the constitution of our nature, are fitted to produce pleasing or interesting emotions'.[22] At the beginning of the following century Alison's admirer, Jeffrey, wrote an essay that deserves to have been, but is not, seminal in the history of the theory of beauty. Beauty, Jeffrey asserts,

> is not an inherent property or quality of objects at all, but the result of accidental relations in which they may stand to our experience of pleasures or emotions, and does not depend upon any particular configuration of parts, proportions, or colours, in external things, nor upon the unity, coherence, or simplicity of intellectual creations; but merely upon the associations which, in the case of every individual, may enable these inherent, and otherwise indifferent qualities to suggest or recall to the mind emotions of a pleasurable or interesting description.[23]

Beauty, to Jeffrey, is 'nothing more than the reflection of our own inward emotions, and is made up entirely of certain proportions of love, pity, and

affection', or indeed any emotion that is either agreeable to experience or attractive to contemplate.[24] Objects appear beautiful when they 'possess the power of recalling or reflecting those sensations of which they have been the accompaniments, or with which they have been associated in our imagination', that is, when they are either 'the natural signs and perpetual concomitants' of pleasurable sensations or emotions, 'the arbitrary or accidental concomitants' of such feelings, or 'when they bear some analogy or fanciful resemblance to things with which these emotions are necessarily connected'.[25] Yet Jeffrey's theory does not explain why it is that, even if beauty does rest in some way on this kind of association (as I believe it does), the gaze yet remains attached to the object rather than simply recognising and reverting to what is signified.[26]

It is, then, the antinomical nature of taste that dominates eighteenth-century enquiry into the subject. Taste is lodged in the tissue of the Enlightenment principally as an irritant. Leibniz described it as something like an 'instinct', distinguished from understanding by the fact that it 'consists of confused perceptions for which we cannot give an adequate reason'.[27] Montesquieu asserted that taste 'does not consist in a theoretick knowledge, but in the quick and exquisite application of rules which, in speculation, may be really unknown to the mind'.[28] It was in connection with discovering the grounds of taste that Burke wrote that the 'great chain of causes ... linking one to another even to the throne of God himself, can never be unravelled by any industry of ours', since whenever we go 'but one step beyond the immediately sensible qualities of things, we go out of our depth'.[29] Likewise Schiller writes that the whole magic of beauty resides in its mystery, so that, in dissolving the essential amalgam of its elements through investigation, we find that we have dissolved its very being.[30] Kant, having attempted such an investigation, concluded that, since the subjective principle upon which the faculty of taste must rest is 'concealed from us in its sources', the faculty itself can never be rendered completely intelligible.[31]

The 'blind, but sure testimony of taste and sentiment' in those matters where the affection is suddenly caught, the 'I-know-not-what' of beauty, must be considered, according to Hume, as 'a part of ethics, left by nature to baffle all the pride of philosophy, and make her sensible of her narrow boundaries and slender acquisitions'.[32] Yet the relegation of beauty to the eye that takes place in this period is not principally a result of a new awareness of the rift between subject and object, but rather a new separation between subject and God, or Logos. Hume, like the Stoics and Christians, speaks of the standard of taste, since it arises 'from the internal

frame and constitution of animals', as 'ultimately derived from that Supreme Will, which bestowed on each being its peculiar nature', but he does not feel that he has thereby explained anything; he also speaks of beauty as 'a new creation'.[33] Hume may or may not have been too sceptical to be an atheist, but he was certainly too sceptical to resort to God as an explanation for anything.

Hume's 'I-know-not-what' echoes an idea that was not peculiar to the eighteenth century. The phrase, borrowed from Petrarch, had been used to apply to beauty two hundred years earlier by Firenzuola, who, writing of feminine beauty, had described it as *un non so chè* that 'mysteriously' arises from certain inexplicable proportions, affording us an 'incomprehensible pleasure'.[34] (The 1603 edition of Ripa's *Iconologia* portrays beauty as a naked woman with her head in the clouds, signifying that beauty is a thing almost beyond human comprehension.) But if beauty acted *occultamente* it was, for the writers of the Renaissance, nevertheless a matter of proportion, a property of objects. 'We cannot explain', writes Firenzuola, 'why that white chin, those red lips, those black eyes, that wide hip, that little foot should produce, or arouse, or result in beauty'.[35] (This is the difference, mentioned earlier, between a schema of the beautiful and a theory of beauty.) Bruno, while believing that there was such a thing as essential beauty, believed its essence to be indefinable and indescribable, and Pascal, who is eloquent on the *je ne sais quoi* of Cleopatra's nose, writes that the reasons one finds to account for the attraction and repulsion are retrospective and inevitably mistaken.[36] The eye, or the tongue, is simply the eighteenth-century site of this *je ne sais quoi*; Hume's 'I-know-not-what' differs in placing the response, as it were, in a vacuum. What he wished to do was to separate matters of faith and morals from matters of the understanding, and beauty was for him a matter of sentiment just like these former. But, as with faith and morals, he was able to rescue the rationality, and even the objectivity, of the sentiment by an appeal to opinion. The 'true standard of taste and beauty', he argued, is to be found in the joint verdict of such critics as possess 'strong sense, united to delicate sentiment, improved by practice, perfected by comparison, and cleared of all prejudice'.[37] But this, as I said above, presupposes what it sets out to establish. Opinion takes the place of revelation, but opinion will neither supply the real properties of objects nor provide a rationale for subjectivity. 'Beauty is in the eye of the beholder' is a mere phrase, hardly even a concept. Once beyond the in-itself we are lost.

We cannot, then, begin in the eighteenth century, the great age of rationalism (in a popular sense) and stuffed mermaids, the moment at

which thought awakens from the dream of antient philosophy and recalls, with condescending amazement, half amusement and half indignation, its own irrationality. This age pretends to no more than is reasonable, and hence, for all its speculation on taste, the matter remains fundamentally alien to it. For so tenacious, so well-fed, a belief in the omniscience of common, 'waking' sense (a belief which makes the century eternally contemporary) will never yield so far as to admit of what must be the first question ...

What is the 'eye'? That which perceives the form of things. But has any writer on beauty ever held that beauty can be defined purely in terms of form? There is, apparently, a long tradition of just such explanations of beauty, going back to the Pythagorean idea, partly scientific and partly religious, of proportion and measure, which made harmony a property of the cosmos, and musical harmony, which could be directly related to mathematics, immanent in the very structure of things. For Plato, in the *Philebus*, it is this measure and symmetry which are eternally and absolutely beautiful.[38] Augustine too defines beauty as a measure, form, and order determined by number, but his concept is more dynamic than Plato's, for this proportion is conceived of as rhythm (*numerus*); there is a rhythm not only in sounds but also in perception, memory, action, and an innate rhythm of the mind which perceives them.[39] (So that, for example, God has created evil men and an evil angel, despite his omniscience, because the revolutions of good and evil times in the world add beauty to history in the same way as the figure of antithesis adds beauty to a poem.)[40] Moreover 'beauty itself', which is God, is beyond the reach of the senses.[41] Nevertheless it is the *musica mundana*, the music of the spheres, and the *musica humana*, the harmony within man, which, though both beyond our weak senses, are the model for the music (*musica instrumentalis*) that we do actually make and hear.[42] In another version there is not only a music of the spheres but also a 'metaphysical' or 'transcendental' harmony, a *musica speculativa*, in everything that exists, not a matter of sound yet still intelligible.[43] The absolute beauty of the Middle Ages was indeed, then, proportion, a music beyond music, towards which condition all beautiful things – objects, actions, music itself – aspired.[44]

Here, then, is a definition of beauty in terms of form: beauty is a certain harmonious proportion. But this is not, and would not have been even for the writers mentioned above, a definition of beauty. Rather it is a definition of the beautiful. *Musica instrumentalis*, audible music, is only beautiful because it dimly echoes the *musica mundana*, the melodies unheard. The theory of proportion is a description of how a thing is beautiful, not

21

why it is beautiful. Harmonious proportion is merely the preparation, itself incorporeal, which matter (and sound) must undergo before beauty will, as the Neoplatonist Ficino writes, 'descend' into it; 'Beauty and shape', he writes, 'are not the same thing', for beauty is something common to virtue, shape, and sounds, is rather an attraction to something incorporeal expressed in these things but beyond them.[45] The cause of beauty lay quite elsewhere – beyond the senses.

Whence, then, the 'eye'? The emphasis on the notion of sensuous beauty as the type of all beauty does not emerge until quite late in the ancient era. Cicero, whose writings on the subject are largely an eclectic collection of old ideas, still maintains the ancient thesis that 'beauty' can be defined as order, measure, a suitable arrangement of parts. However, in separating the decent, or what is morally beautiful, from that sort of beauty which 'stimulates the eye' (*movet occulos*) he makes the notion of beauty more narrowly sensuous than it had previously been.[46] His eye is not, however, a subjective eye. Beauty is still a matter of a certain proportion which we admire because we have an inherent sense of beauty, because we are, indeed, created in order to contemplate the perfection of the world.[47] This distinction between the sensuous and the intellectual, the eye and the mind (*occulis et animo*), was also a feature of the twelfth and thirteenth centuries, but nowhere was it implied that the eye was a free agent. Bonaventure writes that beauty delights not only the eye but also the inner sight (*visus spiritualis*) and exists by virtue of a harmony of perceived with perceiver.[48] Aquinas likewise describes this *apprehensio* as not only *per sensum* but also *per intellectum*, and his notion of beautiful proportion is not only quantitative but also qualitative, that is, it is a certain relation between a thing and the soul. For in all this the eye is the eye of the soul, a fixed purposeful quantity no less than the fixed material quantity which is the beautiful it apprehends.

But let us return to the idea of the decent, of *decorum*, for it is this notion which appears to mark the relegation of beauty to the eye. Socrates had distinguished between things which are 'beautiful' in themselves and things which are 'beautiful' because they are fitting for some purpose at hand. This last can be identified with the Stoic concept of *decorum*, that is, what is appropriate to each object or way of life, that which causes admiration by its propriety. *Symmetria* or proportion was, however, for the Stoics, as for the Greek tradition they inherited, absolutely beautiful, beautiful in itself. Still later Augustine distinguishes between the appropriate (*aptum, decorum*), an apt and mutual correspondence between design and use that is relative to each thing, and the beautiful (*pulchrum*), which,

as we have seen, is an order, rhythm, and harmony within objects them-selves.[49] But his distinction is only a distinction within beauty.

There is obviously some analogy being drawn here: just as Socrates is only distinguishing between two forms of eurhythmy, so these later writ-ers are distinguishing between two different causes of the same sensation. It is the contrast of likes rather than of opposites. But where does the anal-ogy originate, in *decorum* or *pulchritudo*? That which is beautiful-in-itself can-not be a species of that which is beautiful-for-this, simply by definition, for if it were then the two would simply degenerate into the useless and the useful, or perhaps the good-for-nothing and the good. There may be some justification in this in so far as the study of the concept must begin with the Greek *kalon* which, though often translated as 'beauty', actually refers to everything that pleases, attracts, or arouses admiration, and thus is nearly identifiable with 'good' or 'fine'. But even here the element of usefulness is not primary. We could argue that the beautiful-in-itself is named by analogy through its arousing those feelings which the useful arouses, though on occasion when the use cannot be discovered. But not everything useful is beautiful. The concept of *decorum*, then, rather than succeeding in relegating beauty to the 'eye', literally understood, extends the concept to the *visus spiritualis*, the inner sight, and in so doing only suc-ceeds in emphasising that the concept of beauty is not to be physiologi-cally explained. Even Voltaire, with whom I began, can hold that acts of heroism and self-sacrifice, along with certain moral maxims are beautiful in the eyes of all, in themselves.

Just as the distinction between the objective laws of 'beauty' (*symme-tria*) and the spectator's requirements (*eurhythmy*) is not a statement of the subjectivity of beauty, but rather, even while asserting the importance of the eye as a judge, relies on their being an objective beauty-in-itself, *sym-metria*, which, if faithfully reproduced for the eye, will be beautiful, so the idea of *decorum*, or beauty relative to the interests of the individual, does not in any way contradict the notion of beauty as an objective property of things. Thus Cicero could hold that we admire beauty simply because it is beautiful, and Augustine, putting the case a clearly as it could be put, wrote that we do not find a thing beautiful because it pleases us but rather that it pleases us because it is beautiful.[50] Cicero, as we have seen, believed that we have an innate sense of beauty which simply responds to the beauty, that is, the perfection, of the world. Augustine is more specific; beauty is a rhythm which permeates the whole of creation, including man, who perceives it by virtue of his own innate rhythm.[51] But if the notion of subjectivity as we presently understand it in connection with the

'eye' under discussion was unknown to antiquity, then the simple fact of differences in the perception of beauty was not. And the reasons they found to account for this were very much a matter of the eye's place in the universe. Hence Augustine's claim that we are not always and everywhere aware of the beauty of the world simply because we do not have an intellectual grasp of it as a whole, and Boethius's that we admire such beauty as we do rather than the wonders of heaven only because our human eyesight is too weak to reach that far and must remain instead upon the surface of things.[52] (According to St John of the Cross, all that Adam and Eve, in their sensory innocence, saw, spoke of, and ate in paradise was a source of contemplative delight to them.)[53] Thus for these theologians, as for Plato and his successors, there are two forms of beauty – one human, superficial, and relative, and one divine, real, and objective, which is its cause. The world is beautiful, writes Bonaventure, though not so beautiful as the Church, which in turn is not so beautiful as the 'heavenly Jerusalem', though by far the greatest beauty is the Trinity.[54]

The relative beauty, that is, relative to our being human, which we know is thus a result of the Fall. But how then can we envisage the beauty of the heavenly Jerusalem? That is, why is it called 'beautiful'? As with all such terms ('good', 'just', and so on), when they are postulated of things pertaining to God we are to understand them analogically, that is, their mundane use is to point to what are pale reflections of those things that exist in a pure or real state in God. But this doctrine, even in denigrating earthly beauty for its relativity, asserts that it is nevertheless a real property of objects. It is made objective again simply by being predicated of God. Because it is 'beauty', this beauty beyond individual judgements, beyond even human perception, the concept of beauty-in-itself is rescued from being merely a product of the eye. Moreover, as we are created beings, nothing in our nature can be simply reduced to (unaccountable) instinct, to an eye. So that the very inaccessibility of the grounds of beauty, rather than, as later became the case, placing beauty beyond conceptual enquiry or even putting its existence into doubt, appeared as a token of divine origin. This, then, was a theory which concentrated more on the aspect of certainty than on that of subjectivity in the 'subjective certainty' of beauty.

Indeed, throughout the greater part of the European history of beauty, the answer to the question of what we perceive when a thing is beautiful to us has been the same: what we 'know' in beauty, what beauty is the perception of, is the ultimate reality, Plotinus's 'remoter principle', God. That this assertion has such an exotic ring to it is an index of the extent to which common sense has abandoned beauty. In the eighteenth

century, as we have seen, such a concept may receive only the most emol-liated expression. It lingers in the empiricism of Hutcheson, for whom 'beauty' properly denotes 'the perception of some mind', a perception not of the tongue or the eye but of an 'internal sense' given us through 'the sagacious bounty which we suppose in the Deity', for our greater pleasure.[55] But this central question – the origin of beauty, the beauty of the beautiful – is relegated more and more to a footnote as the theory of beauty advances (towards its eventual demise) in the present era. The the-ological dimension remains, albeit in the guise of the rational, and hence sentimental, deism of the nineteenth century, in aestheticism (née roman-ticism), and our 'buried life'. Ruskin, for example, who holds that beauty is that 'which can give us pleasure in the simple contemplation of its out-ward qualities without any direct or definite exertion of the intellect', will assign its existence, as that of all instincts and principles of human nature, to 'the simple will of the Deity'.[56] (The 'man of taste' derives pleasure always from that which God originally intended should give him pleasure; beauty is 'invariably exalting and purifying' to the degree to which it is beautiful.)[57] Schlegel had described beauty as 'but the spiritual echo of the soul – a sorrowful remembrance of a lost paradise'.[58] Poe will write of beauty as 'an immortal instinct', 'a thirst unquenchable' that is at once a consequence and an indication of our immortality, an 'ecstatic prescience of the glories beyond the grave' – an opinion repeated verbatim by Baude-laire.[59] But this is neither philosophical speculation nor faith – it is nostal-gia. What we hear is the fading echo of that Neoplatonism that was once, through its infusion into Christianity, vivid in the mainstream of European thought. It is to this Neoplatonism, and more particularly the works of Plotinus, Dionysius, and Ficino, that I will turn in the next chapter.

Through the invocation of the absolute, then, beauty is given a cause, and a cause which, being inscrutable, does not contaminate the essential autonomy of beauty; beauty is saved from the vacuum of the eye by the ultimate purposefulness of the eye. But why do we leap straight from a vacuum to a transcendental cause? Because it is the very essence of beauty, as, apparently, an end in itself, to demand one or the other. Biology or rea-son will account, or appear to account, for everything else; beauty alone must remain either in the irrational cause without a cause of the eye, or the transcendental cause without a cause of God.[60]

The metaphysics of the ancient and Christian writers saved them from inferring anything from the relativity of the perception of beauty to beauty itself. Indeed the difference between the Ancients and the Moderns

in this is the former's stronger notion of the connection between ultimate cause and final effect. There being for them no question, therefore, of objectifying beauty itself, they were, paradoxically, more free to objectify the beautiful. It is a lack of this coherent metaphysic which brings about the demise of 'beauty itself'. It is perhaps surprising, then, seeing that the metaphysical, in one form or another, is still as present in the everyday mind as it ever was, that it does not rescue us from the vacuum of the eye. But this is not a question germane to immediate perception, and thus the everyday mind is not likely to require a metaphysic with regard to beauty – it is satisfied with common sense. We know a beautiful thing is beautiful; 'I see it as beautiful' or 'I think it is beautiful' are tautologies. We cannot think or believe a thing is beautiful without falling into contradiction, precisely because beauty is its own guarantee. Common sense, then, accounts for beauty by ignoring it. Hence it may be that there is a metaphysic still at work in beauty itself, that the very definition of beauty contained in its perception as an end in itself expresses a metaphysic. For, though to say that beauty is relative is quite easy, to feel that beauty is relative is impossible; it requires that one detach from the object a quality which cannot exist separated from that object. (We can, of course, know that this is considered beautiful, or like the beautiful; as is particularly obvious with cultural artefacts, such as men and women. But these instances are not the perception of beauty. Indeed the idea of 'recognising' what is beautiful to oneself is a contradiction. Beauty may emerge from the familiar, but it is then in the familiar for the first time.) That beauty cannot exist for us in a separated state, in the manner of a concept which we may choose to apply, is all that its attribution to the 'eye' can meaningfully signify.

In the next chapter I will turn to the description of beauty in 'antient philosophy'. For it is in consulting those writers, uninhibited by the threat of Hume's fork, who could soar into realms where the paradoxical and even contradictory are not merely tolerated but actually demanded, in redreaming their dream, that we shall come closer to discovering the identity of the eye.

3
Beauty/God

Por toda la hermosura
Nunca yo me pederé,
Sino por un no sé qué
Que se alcanza por ventura.
[Not for all beauty
Will I ever lose myself.
But for I-do-not-know-what,
Which is attained so gladly.]

St John of the Cross, epigraph to 'Glosa a la Divino',
in Collected Works, pp. 735–7 (p. 735)

Gli occhi mie' vaghi delle cose belle,
E l'alma insieme della sua salute
Non hanno altra virtute
Ch'ascienda al ciel che mirar tutte quelle.
Dalle più alte stelle
Discende uno splendore,
Che 'l desir tira a quelle;
E qui si chiama amore.
Nè altro ha il gentil core
Che l'innamori e arda e che 'l consigli,
Ch'un volto che negli occhi lor somigli.
[Neither my eyes in love with all that is beautiful,
Nor my soul thirsting for salvation,
Possess any power
That can raise them to Heaven but the contemplation of beautiful
 things.
From the highest Heaven
There streams down a splendour

Which draws desire up towards the stars,
And here on earth men call it love.
And there is nothing that can captivate,
Fire and give wisdom to a noble heart
As can a face lit with star-like eyes.]

Michelangelo, 'Gli occhi mie' vaghi'

Plotinus begins his account of beauty by rejecting its identification with *symmetria*, for, since the same bodies appear sometimes beautiful and sometimes not, beauty must be something which 'shows' itself in bodies, something which irradiates *symmetria*, rather than *symmetria* itself.[1] Moreover there is a beauty in gold, in the stars, in sounds, in combinations of words, in ways of life, in thoughts, in actions, in character, in the pursuits of the intellect, in lightning at night, in virtues, in things, that is, for which no standard of measurement can be discovered. The 'remoter cause' of beautiful things, that is, beauty itself, emanates from 'The Good, which lies beyond'.[2] This beauty is perceived at first glance by the soul, which, as a fragment of the divine fallen into matter, names as from an ancient knowledge that which reveals any trace of kinship with itself. The delight of beauty lies in the soul taking its own to itself, in its being stirred anew to the sense of its own nature. Matter becomes beautiful by communion in the Ideal-Form which the soul contains within itself.[3] Plotinus, then, speaks of a beauty 'here' and a beauty 'There' which is its cause.[4] Music is the earthly representation of the rhythm in the Ideal Realm – harmonies unheard in sound create the harmonies we hear, waking the soul to beauty by showing it the one essence in another kind.[5] The Good is also the Primal Beauty, and in our act of recognising beauty we express the desire to be reunited with this absolute which is 'the Apart, the Unmingled, the Pure, that from Which all things depend, for Which all look and live and act and know, the Source of Life and of Intellection and of Being'.[6]

Beauty is, then, for Plotinus, at once token and presentiment of the Authentic-Existence, it flows from the real which is 'There'. This comes out most clearly in his account of ugliness, which he describes as the 'Principle contrary to Existence'.[7] The ugly is what is not in accordance with the soul, is that which has not been entirely mastered by pattern, by Ideal-Form, and which the soul, as divine, resents and shrinks from.[8] (An ugly soul is one abandoned to bodily sensation, one which abandons its true nature: 'in self-ignorance we are ugly'.)[9] Fire is beautiful beyond all material bodies because, making ever upwards, it is the most nearly disembodied of all elements; but noble conduct, the face of Justice and Moral

Wisdom, is an even loftier beauty than this.[10] How are we to ascend to the Primal Beauty, the Good, which we desire through these things? By a paradox which, as we shall see, is common in overtly metaphysical accounts. Having perforce started from beauty in the world, Plotinus now asserts that if we are to achieve a vision of beauty itself we must forego the beauty of the world. We must not pursue this mundane beauty, which is merely a copy, a vestige of the true beauty, but rather, like Ulysses counselling his shipmates against the enchantments of Circe, remember our homeland beyond. Those who cannot discern that it is the inner, the Ideal-Form, which has stirred them run after the outer, the appearance, not realising that they are merely pursuing their own reflection.[11]

The 'wonderment and delicious trouble, longing and love, the trembling that is all delight' which is the state of beholding beauty is, then, according to Plotinus, a longing for the divine that reveals itself through the beautiful.[12] His more or less direct heir in the non-pagan world is Dionysius the Areopagite, otherwise the Pseudo-Dionysius. For Dionysius God is the great 'Attractive Power' which moves all things simply by being desired by them, as fire warms without itself feeling warm. This attractive power cannot be distinguished from God; even the 'act' of creation is not to be understood as an activity; rather the world is attracted into existence by God's very being, the object of its desire.[13] All things turn towards God and yearn for It; those that have reason (human) by knowledge, those that have perception (animal) by perception, those without perception (vegetable) by the natural movement of their vital instinct, those without vitality (material) by that aptitude for bare participation whence this mere existence of theirs is theirs, that is, simply by existing.[14] God, then, is both beautiful and Beauty; beautiful because, as Attraction, It shares in the quality of beauty, but Beauty because It is the common quality by which all beautiful things are beautiful, the cause of the harmony and splendour in all things, flashing forth upon them all, like light, the beautifying communication of Its ray.[15] This super-essential beauty (*hyperousion kallos*), this Beauty beyond beauty (*hyperkalon*), holds all things in existence by their yearning for their own beauty; It is their origin, their Idea (that is, the ultimate law of being from which they derive their definite limits), and their goal.[16] All the motions of the soul – self-consciousness, reason, perception – have their cause in the Beautiful which is beyond motion and rest, from Which, in Which, unto Which, and for the sake of Which they are.[17]

Though I have begun with Plotinus, the pre-eminent Neoplatonist, and moved straight to the Pseudo-Dionysius, in fact elements of the thesis here considered are to be found in the writings of the Church Fathers

even before Plotinus.[18] Clement of Alexandria, for example, who died when Plotinus was still a youth, describes God as 'the true beauty'.[19] Moreover, between Plotinus and the Pseudo-Dionysius we can find ample testimony to the persistence of this strain. Methodius describes God as the 'Only Beautiful'.[20] Basil of Caesarea describes God as 'the most desirable beauty', beauty itself, and recommends that we raise ourselves to Him through that beauty of visible things which allows us an inkling of what, in fact, surpasses all the efforts of our imagination.[21] Gregory of Nyssa, in a passage even more strongly reminiscent of the ascent towards beauty as it is described in the *Symposium*, writes that as a spark is to the sun so is the beauty we admire to the boundless and ineffable Beauty (God) which is its archetype, though the one may serve us as a ladder by which we climb to the other.[22] John Chrysostom, though he most commonly invokes beauty to emphasise its role as a snare, at least on one occasion speaks of God leading us by the beauty of nature to a knowledge of the divine.[23] (Though he adds, characteristically, that the beauties of nature were made corruptible so that we should not lapse into a worship of nature itself.) Augustine describes God as 'beauty itself', a beauty beyond sense and representation, which can only be contemplated in truth and virtue.[24] We will later return to the place of beauty in Augustine's vision of the creation, but for the moment it is worth noting that in his *Expositions on the Psalms* he goes so far as to say that in the very seeing of the world as beautiful we are praising God.[25]

All of the above writers predate the Pseudo-Dionysius though none makes the idea of beauty so important a theme in his theology. Indeed, Dionysius, though he wrote as a professed Christian, appears to owe more to the Neoplatonist Proclus than to Christianity. However, the status of his work, deriving from its supposed authorship (the real Dionysius the Areopagite was a personal disciple of Paul), was high, and the Neoplatonic theory of beauty consequently remained extremely influential in the Christian world up until the end of the medieval period. (The one marked exception to this – an exception that perhaps accounts for why the theory never became quite ubiquitous – is Aquinas. Although Aquinas wrote a commentary on Dionysius and often referred to him as an authority, his own treatment of beauty is quite different.) We can find the influence of Dionysius in Eriugena's description of beauty as a reflection and manifestation of God, a glimpse of divinity itself in creation.[26] Hugh of St Victor writes that though visible beauty is diverse and varied, in its contemplation we can form 'notions of invisible beauty'.[27] Guibert of Nogent likewise says we should value phenomenal beauty as a mirror of eternal

beauty.[28] The Franciscans held, after Augustine, that the beauty of creation is the trace (*vestigium*) by which one arrives at the cognition of non-created beauty.[29] Robert Grosseteste, in the thirteenth century, describes God as the most beautiful beauty (*species speciosissima*), beauty itself, and the beauty of all that is beautiful.[30] In the fifteenth century, Nicholas of Cusa writes that while every beautiful face has its own beauty it is nevertheless not beautiful in itself, but is beautiful only because it conforms more or less closely to the face of God, which alone is beautiful in itself.[31]

Thus when, in the fifteenth century, Ficino came to write his *Commentary on Plato's Symposium on Love*, his concept of beauty drew not only on the dialogue of the title but also on Plotinus and Dionysius (both of whom he had translated), and scholastic tradition. The short title of his work is *De Amore* and by *amore* he means 'the desire for beauty'.[32] He is, however, careful to distinguish this desire from others; the soul seeks those things necessary for nourishing, or comforting, or procreating the body not for its own sake but for the sake of that body; beauty it desires for, in both senses, its own sake.[33] Love is content with itself as its own reward.[34] Yet the sight of beauty does not extinguish this desire, for it is a desire for 'the splendour of the celestial majesty' that shines through phenomenal beauty. Thus, though we know the perfume of beauty and are attracted by it, we do not know the flavour that infuses it, we do not know what we are 'desiring and suffering', for our true object is the incomprehensible, God.[35] Beauty is the ray of God penetrating through all things, so that, in desiring beauty in Mind, Soul, Nature and Matter, what we are looking at and loving is the splendour of God in them, and, through that splendour, God.[36] Beauty is the attraction of the soul back to its origin in God, it is God as attraction.[37] (Thus, Ficino continues, what is beautiful (*pulchritudo*) is called, in Greek, *kallos* meaning 'provocation', from *kalea* meaning 'I provoke'.)[38] The perception of beauty is the natural instinct of the soul, its turning towards God.[39] But beauty itself, that is, the beauty of God, is beyond comprehension. Ficino defines it negatively by starting from phenomenal beauty and subtracting from it first matter and place, then time, then form itself![40] It is the matter of the world, at the furthest remove from God, which is most degenerate, least beautiful, and Man, partaking of this corporeality, is likewise subject to what Ficino calls 'Necessity', that principle of change, decay, and compulsion which is the essence of creation and which stands in contrast to love, which is the product of free will.[41] This equation of love and free will is important, for, while the soul, as a fragment of the divine, is partly in eternity, it is also partly in time, and so its operations are subject to time.[42] Thus, for Ficino, beauty in the

phenomenal world is at once a state and an act. He likens the beautiful to a lodestone, which puts into iron a certain quality of its own by which the iron is first made like the lodestone and then drawn to it. in so far as this attraction starts with the stone it belongs to the stone, but since it occurs in the iron it also belongs to the iron; it has 'some attributes of both lodestone and iron'.[43] The analogy is unfortunate in that magnetism would seem to be very much an aspect of Necessity, but since the beautiful, in contrast to beauty, only exists for us as a consequence of the Fall, which is also our falling under the rule of 'the tyrant Necessity', there is perhaps some aptness in it, some significance, indeed, in the need to use a mundane analogy.

This identification of God with beauty is, however, fundamentally a Hellenistic concept rather than a biblical one, and the idea that through the beauty of the world we can gain a notion of its Creator, a notion of the divine, real, objective Beauty beyond beauty, is largely the legacy of such Greek Church Fathers as Clement of Alexandria and Basil of Caesarea, who were well grounded in Classical Greek and Hellenistic philosophy.[44] From a Judaic-Christian point of view the very association of God and beauty, let alone the idea that they are coessential, is, as it seems now, to a layman at least, trivial.[45] Even the contemporary Catholic theologian, Balthasar, whose 'theological aesthetics' argues for the inseparability within theology of the three transcendentals (pulchrum, bonum, and verum), finds it necessary to recommend constant vigilance against allowing the 'transcendental beauty of revelation' to slip back into equality with an 'inner-worldly beauty'.[46]

It is true that Dionysius, the Church Fathers, and Ficino all declared that the beauty of morality was a higher type of beauty than phenomenal beauty, but they still spoke of it as a type of beauty. Indeed, in positing such a hierarchy, they were saying no more than had Plato and, as we have seen, Plotinus after him.[47] It was as an unregenerate Gnostic that Augustine had asked 'Do we love anything unless it is beautiful?', but, accepting Ficino's definition of love as a desire for beauty, and beauty as the attractive power of God, the Christian Augustine might have asked the same question.[48] Moreover the identification of love and beauty is not simply a Renaissance gloss; Bonaventure, in the thirteenth century, had written that beauty 'by its very nature' arouses the soul to love, and the equation was commonplace.[49]

It would serve no purpose, however, to redream this dream of antient philosophy, nor perhaps is it even possible, unless I can discover myself in that dream, transcribe its significant elements into a new significance,

transpose its meaning to my own key. Let us return, then, from Beauty to the beautiful, from the absolute to the phenomenon.

The truth is, however, that we have never actually left the phenomenon. Phemonenal beauty, asserts this tradition, is the sign, image, trace, or reflection of the highest Beauty, the invisible Beauty, but we know only this sign, this trace, and we contemplate Beauty only through the beautiful; we call the absolute 'beautiful' only by analogy with this beauty. (The Pseudo-Dionysius himself writes that it is not possible for the mind to represent anything to itself without matter, nor to contemplate the divine other than by material means.)[50] This movement from the phenomenal to the absolute to the phenomenal is well illustrated by Book X of Augustine's *Confessions*, in which it is the phenomenal beauty of the world which gives rise to the necessity of a transcendental cause and which, though having been bypassed in favour of that cause, nevertheless provides the language whereby its transcendental nature is expressed:

> But what is my God? I put my question to the earth. It answered, 'I am not God', and all things on earth declared the same. I asked the sea and the chasms of the deep and the living things that creep in them, but they answered, 'We are not your God. Seek what is above us.' I spoke to the winds that blow, and the whole air and all that lives in it replied, 'Anaximenes is wrong. I am not God.' I asked the sky, the sun, the moon, and the stars, but they told me, 'Neither are we the God whom you seek.' I spoke to all the things that are about me, all that can be admitted by the door of the senses, and I said, 'Since you are not my God, tell me about him. Tell me something of my God.' Clear and loud they answered, 'God is he who made us.' I asked these questions simply by gazing at these things, and their beauty was all the answer they gave. ...
>
> But in which part of my memory are you present, O Lord? ... When I remind myself of you I go beyond those functions of the memory which I share with the beasts, for I did not find you amongst the images of material things. I went on to search for you in the part of my memory where the emotions of my mind are stored, but here too I did not find you. I passed on to the seat of the mind itself – for this too is in the memory, since the mind can remember itself – but you were not there. For you are not the image of a material body, nor are you an emotion such as is felt by living men when they are glad or sorry, when they have sensations of desire or fear, when they remember or forget, or when they experience any other feeling. ... Where, then, did I find you so that I could learn of you? For you were not in my memory before I learned of you. ...
>
> I have learnt to love you late, Beauty at once so ancient and so new! I have learnt to love you late! You were within me, and I was in the world outside myself. I searched for you outside myself and, disfigured as I was, I fell

upon the lovely things of your creation. You were with me, but I was not with you. The beautiful things of this world kept me far from you and yet, if they had not been in you, they would have had no being at all. You called me; you cried aloud to me; you broke my barrier of deafness. You shone upon me; your radiance enveloped me; I drew breath and now I gasp for your sweet odour. I tasted you, and now I hunger and thirst for you. You touched me, and I am inflamed with love of your peace.[51]

In this use of phenomenal language to apply to God, this material thinking of the spiritual, such sensuous terms as 'sweet' or 'fragrant' or 'beautiful' are predicated of God neither univocally, which would lead to anthropomorphism, nor equivocally, which would render them meaningless to us, but rather in an analogical sense. The meaning, according to Aquinas, which such terms have for us, when we use them of God is not adequate to the objective reality denoted by them when predicated of God; it is only an approximation based on our use of them to describe the human and the material.[52] The degree of meaningfulness such terms have for us, then, depends on faith in the ultimately unknowable. Ficino too, for all that there is a distinctively Gnostic flavour in his notion of the divine spark, the Ideas, in the soul, writes that human cognition arises from the senses and that we are accustomed to judge divine things by the mundane things that are no more than their shadows and which do not sufficiently represent them; 'The Soul, as long as it judges divine things by mortal, speaks falsely of divine things, and does not pronounce divine things but mortal ones.'[53] But the soul must always judge divine things by mortal ones, for God does not exist, is not phenomenal.

I should not enquire further, then, into what cannot be enquired into and turn rather to what these writers have pronounced upon the mortal. What, then, is this Beauty beyond beauty, this, as Philo says, 'more beautiful than beauty', the *hyperkalon, hyperousion kallos*?[54] It is, to appear to move no further, beauty itself. For the very phenomenality/psychology of beauty is the perception of a beauty beyond beauty, a beauty that transcends the perception of a thing as beautiful. The Beauty beyond beauty is beauty as phenomenon, that is, a phenomenon (an object of perception) which is, in so far as it is also our act, more than phenomenal. This is the corollary of the fact, which is also a paradox, that beauty *appears* in the eye of the beholder. The Pseudo-Dionysius writes that Beauty is all-beautiful and more than beautiful, eternally, unvaryingly, immutably beautiful, in itself and by itself eternally beautiful – which is to say that it is an absolute.[55] But this is true of beauty also, in that it defies interpretation in terms of cause, that it appears as an end in itself. Moreover, as we have

seen, even in these metaphysical accounts, beauty precedes God; God is the Attractive Power but our knowledge of this comes from the attraction.

The identification of beauty with God, therefore, is a consequence of the nature of beauty; the mundane beyond-which-not can only find its cause in the spiritual beyond-which-not; an effect for which no cause can be found within the world must derive its cause from beyond the world. The 'divine' source of this aspect of phenomena is immediately evident by virtue of the fact that it appears to spring from no source; it is a teleological short-circuit. The phenomenal identity of being with value, that is, being-as-value, can find a corresponding concept only in the suprasensible identity of value-as-being. The 'Argument from Beauty' is not, so far as I know, one of the accepted theistic arguments within theology, though I have heard it put forward informally several times (and seen writers on beauty invoke the divine innumerable times more). Augustine had asked creation 'What is my God?', and it had answered 'He who made us.'[56] Similarly Longinus writes that in beauty we perceive around us the end for which we were created, for we have an unquenchable love for what is greater or more divine than we are.[57] But it is only in a later age, an age in which it is the very existence, rather than the nature, of the noumenal which is in doubt, that signs become proofs. Balfour, for example, writing on the uselessness of beauty, exclaims that 'If design may ever be evoked where selection fails and luck seems incredible, surely it may be invoked here.'[58] According to Ruskin beauty is given us by the Deity to sustain the soul, hence beauty is always associated with virtue and life, ugliness with death and sin.[59]

But beauty as an unaccountable sense of meaning is, as it were, the world epitomised, a lifetime in an instant. For perhaps the most popular argument for the existence of God, that is, the 'Argument from Design' – that one only has to look at the regularity of the world to conclude that it is the work of a creator – is indeed an appeal to semantics; all this, and, more specifically, my life, must mean something. When no intermediate meaning or cause can be found the First Cause, the *causa causans*, *causa sui*, becomes the meaning. This is a consequence of the absence of any intermediate cause, discoverable within the world, of the apparent autonomy of the 'eye'.

Just as we did not abandon the phenomenal, then, in pursuing the Neoplatonic conception of the absolute, so in returning to the phenomenal we do not abandon the absolute. For precisely in appearing as significant-in-itself, the beautiful appears to express a beyond-itself. In so far as this beyond-itself is the essence of the beautiful, that is, in that mere being

appears as value, then beauty can be spoken of as a 'beauty beyond beauty', the transcendence (by the object) of what is transcended (the frigid materiality of objects). Now, such language might seem very much a candidate for some qualifications along the lines of those made by Aquinas when he speaks of 'inadequate notions', or perhaps even along the lines of linguistic philosophy – on the grounds that such a use of the term 'beauty' is far beyond a meaningful one. But with regard to the parallel with theological language there is a fundamental difference, and it is this: beauty is there, materially, before us. Thus while the theistic argument from design can be read simply as an account of the human need to charge the world with meaning, beauty is, in contrast, the one thing we do know with absolute certainty; even the beauty of a beautiful illusion exists, is real. With regard to the objection on linguistic grounds I must appeal to the fact that beauty is not simply state and act but a genuine fusion of the two, the two simultaneously, and thus, understood as either, is always paradoxically in excess of what it is.

It is for this reason that I have devoted so much time to the notion of the *hyperkalon*, of beauty beyond beauty. For, however outlandish the descriptions of Plotinus, Dionysius, or Ficino may seem, they contain, when understood agnostically, truths about the phenomenality/psychology of beauty which are simply suppressed by the idea of beauty being a product of the eye. It is true that these descriptions resolve the paradox of beauty, the antinomy of taste, only through assertions that are grounded in faith, only by replacing the riddle with a Mystery. Yet, at the same time, in positing the object of beauty in the absolute, in that which, by definition, cannot be encompassed by a concept, they emphasise an aspect of the experience which our more emotionally prudish age tends to overlook – the element of yearning. For there is a sense in which beauty is, as Ficino says, both abundance and lack, plenitude and desire.[60] It is abundance in that it is that which transcends itself in being itself, but, for the same reason, it is also a poverty, that is, it is that which is transcended by itself. Value and being become identical, yet, unlike the object which assumes its value in the eyes of desire, the object here invites no action, implies no orientation of the subject – being remains simply being, here and now.

Part of the phenomenality/psychology of beauty, then, is that it is always incomplete. This incompleteness is something reflected in what might be called the 'Ideal' theory of Neoplatonism, is, indeed, perhaps its very origin. It is expressed by Plotinus in the idea that matter can never be wholly mastered by the pattern which is the Idea – for it would then be that Idea – and so can never be wholly beautiful, and in what Ficino calls

the rule of Necessity, that phenomenal beauty exists in matter, place, time, and form, and is thus less perfect than that beauty which is bound by none of these. Schelling calls this same limitation the 'natural principle', that is, the law of cause and effect, which keeps productive nature, in contrast to the eternal, subject to time, 'enslaved to futility'.[61] Since, according to Schelling, no perfection (in the sense that the archetypal forms, the Ideas, are 'perfect') can come into being, beauty, which is the most unconditional excellence a thing can have, cannot exist in time. In created things, then, the elements which contradict the archetypal beauty are the result of the natural principle while those which are in harmony with it are not. Thus while beautiful objects can come into being, their beauty is eternal 'even in the midst of time'.[62] It is the feeling that this is so, that beauty is as much a token as a presence, which expresses itself in the ascription of timelessness to moments of beauty.

But beauty is also time in the midst of timelessness. The notion of the *hyperkalon*, for the sake of which Plotinus even asserts we should forego beauty, begins with the phenomenon, begins in time, and springs from the very nature of the phenomenon/act itself. God can be beauty, but beauty cannot be God. The notion of a beauty beyond time or Necessity, of beauty as, paradoxically, in being phenomenal, in itself incomplete in itself, is part of the perception of beauty. That is, we experience beauty not as a consummation but as an intimation. Hence it is that to describe this perception as simply a form of pleasure or delight seems absurdly reductive, for it is experienced as both a transcendence and a falling short.[63] *Et in arcadia ego*. This is the peculiar nature of beauty which has led its theorists, whatever else they may disagree about, to assert that our pleasure in the beautiful is not simply one pleasure among others. One response to this is the notion of 'disinterested pleasure', the other is the (Neoplatonic) notion I have been dealing with here: that beauty is a yearning for the ultimate beatitude. What I wish to assert now, abandoning any commitment to the transcendental in a theological sense, is that beauty is a yearning without object. This description both seems more apt than 'disinterested pleasure' and, if it is no less antinomical, then at least has the advantage of being more obviously so.

To replace 'pleasure' with 'yearning' is not to deny that what we experience in beauty is pleasant; it is rather to qualify the nature of that pleasure. The condition of yearning or longing is, after all, principally marked by pleasure – to the extent of always going under the suspicion of being self-indulgence. For yearning implies both a strong sense of the desirability of its intended object and the dominance of consciousness by

this desirability. To the extent that an attractive object becomes the world for the subject, the reverse must also be the case. Yearning differs from simple desire in that it posits a degree of desirability in the object which it would seem no object could ever satisfy. It differs from simple dejection in so far as this impossibility of being satisfied does not lead it to relinquish its fundamental orientation towards the object – it is an ecstasy of despair. For these reasons yearning seems the best characterisation of the kind of pleasure we feel in beauty; a pleasure, pervasive and intense, that is a combination of delight, regret, desire, and resignation.

The yearning for an inconceivable object, both described and expressed in Neoplatonism, that yearning for an identity of being and value which is the idea of God – towards which beauty has naturally gravitated (and vice versa) – can be said to be 'implanted' in us by nature as the vanishing point of our desire for happiness, as the objectification of our ultimate beatitude. But what of an identity of being and value, an in-itself, or beyond-which-not, which simply appears, which is 'there, materially, before us', the existence of which is not a matter of debate, since its existing as such is its existence?

Certainly the perception of beauty itself denies that it is a yearning for the object deemed beautiful; there is, for the subject, no overt implication of a goal or the satisfaction of a desire. Hence the attribution of beauty to the autonomy of the eye. Yet there is yearning. Here perhaps I should recall the distinction made in the first chapter between the perceived beautiful object and its phenomenal ground, a distinction which every reflection on the instance of beauty seems to demand. It is hardly surprising, in the light of this, that the sensation should appear to be inspired by an object which is yet, in some way, not adequate to the feeling inspired, that the sensation should, as it were, end in mid air. To posit the necessary and sufficient ground of the perceived beautiful object as the true object of the sensation of beauty would not, however, solve the problem, for we would still have to account for this particular sensation in connection with an object. Moreover the sufficiency and necessity of this phenomenal ground are only discovered in retrospect, once beauty has departed, so that it would appear that, while our perceived beautiful object was not adequate to the sensation, there is every reason to suppose our perceiving this object as the beautiful object was a necessary condition of the instance of beauty. What I wish to suggest, perhaps quite arbitrarily at this stage, is that the element of yearning in beauty must be directed towards something expressed by the phenomenal ground of the perceived beautiful object. The peculiarity of this yearning, then, is that it apparently conceals or sup-

presses it very object, to the extent of arresting our awareness of the phenomenal cause of the sensation at what is, in one sense, an intermediate stage – the perceived beautiful object. Which last object, since it is, by definition, not the final ground of the beauty involved, can never in itself account for that beauty.

In keeping with my intention to restrict this study to the structure of feeling involved in beauty – with respect to which the division between the perceived object and its ground is more important than any formal properties of either – what I must now seek, since beauty itself is inaccessible, is some analogue for this yearning without object, or yearning which suppresses its object. This, I believe, is to be found in the very realm through which this chapter has passed, that is, the realm of metaphysics; not in any particular manifestation of metaphysics, not in this or that theory, but in the very existence of metaphysics itself.

4

Impossible desire

[The] scales of the understanding are not, after all, impartial. One of the arms, which bears the inscription: *Hope for the future*, has a mechanical advantage; and that advantage has the effect that even weak reasons, when placed on the opposite side of the scales, cause speculations, which are in themselves of greater weight, to rise on the other side. This is the only defect, and it is one which I cannot even wish to eliminate.

<div style="text-align: right">Kant, Dreams of a Spirit-Seer, p. 337</div>

We are drawn toward [the beautiful object] without knowing what to ask of it. It offers us its own existence. We do not desire anything else, we possess it, and yet we still desire something. We do not in the least know what it is. We want to get behind beauty, but it is only a surface. ... We should like to feed upon it but it is merely something to look at; it appears only from a certain distance. ... It seems to be a promise and not a good. But it only gives itself; it never gives anything else.

<div style="text-align: right">Weil, 'Forms of the Implicit Love of God', Waiting for God,
pp. 137–215 (pp. 166–7)</div>

If there is one thing that is given in the experience of beauty, or rather, one thing inseparable from the notion of beauty, it is pleasure. (It has, indeed, been defined as pleasure regarded as the quality of a thing, pleasure objectified.)[1] *To kalon*, translated alike as 'the beautiful' and 'the fine', is that which attracts, arouses admiration, pleases. Democritus, a contemporary of Plato and a circumspect hedonist, held that 'great joys are derived from beholding beauty'.[2] For Aristotle the *kalon* is neither goodness in itself nor pleasure in itself, but rather the good when it is pleasant, what is desirable for its own sake.[3] Likewise in the Epicureans, beauty is talked of, not surprisingly, in terms of its value as pleasure; some went so

far as to identify the two – beauty and pleasure – thereby making the distinction a purely linguistic one.[4] In the twelfth and thirteenth centuries the feelings inspired by beauty were described in terms of admiration and delight (*admiratio, stupefacta mens*), pleasure and satisfaction (*gaudium, jucunda, delectabilis*).[5] The beautiful, writes Aquinas, is that the very perception of which gives pleasure.[6] And this is the way in which the pleasure of beauty is distinguished from all other types of pleasure: it does not answer an appetite, it is, as Aquinas writes, in contrast to 'good', an object of contemplation rather than desire; it does not lead to something else.[7]

This, indeed, is what the pleasure of beauty has been since its inception; neither appetence nor inappetence, or at least neither of these in an accountable form. Plato describes it as that pleasure of which the want is painless and unconscious, and of which the fruition is unalloyed with pain.[8] Indeed he introduces the notion of beauty specifically to demonstrate that not all pleasures are born of the cessation of pain, even while conceding that the majority are. Likewise Aristotle contrasts those pleasures which are passive, as, for example, the scent of flowers, with those in which what we enjoy is the promise of some satisfaction – the smell of food.[9] A wise man, writes Eriugena, looks at the beautiful object and is not seized with avidity or lust but refers it solely to the glory of God.[10]

It is not, however, the case that beauty is the only pleasure that is not preceded by a discoverable frustration, that does not seem to answer an appetite. Other examples might be drawn from the pleasure we take in activities that we are experiencing for the first time – though often such instances seem liable to analysis into components of desire fulfilled by that experience, notwithstanding our ignorance that the experience would fulfil them, or even that we entertained the desires. However, there are various aesthetic pleasures – being excited, vicariously frightened, held in suspense, moved to tears – which do appear genuinely groundless, or at least explicable only by appeal to the satisfaction of general psychological tendencies. (It is perhaps the formal condition of being a 'disinterested pleasure' that beauty shares with these other experiences that has led so many to use the word 'beauty' as, confusingly, synonymous with all of them.) What particularly marks out beauty is not that, on reflection, it appears to be a disinterested pleasure, but rather the peculiar emotion that attends this pleasure, or, rather, the nature of the emotion of which this pleasure is a part.

The phrase 'disinterested pleasure' is, quite simply, inadequate as a description of what is felt in beauty. Even the phrase 'necessary delight',

which at least seeks to convey something of the suddenness of the pleasure, fails to convey the precise quality of the feeling;[11] partly because, though the feeling is posited as a quality of the object, we call that object 'beautiful' precisely because we are, paradoxically, aware that the object only *appears* as an object of necessary delight – we do not recollect the instance of beauty as a delusion. More important, however, is the fact that, though we are struck by the beauty of a particular object, there is yet a continuity between every instance of beauty itself which is more than simply the coincidence of one object of necessary delight with another. Within the instance we experience something like a resumption of beauty: we become aware of beauty again. So that, while the instance may be fortuitous, the feeling itself does not have those qualities of singularity and surprise which the word 'delight' conveys. Aside, then, from the antinomical character of the phrases 'disinterested pleasure' and 'necessary delight', there is also the problem that they do not adequately describe the feeling of beauty. For beauty, as I noted in the last chapter, is experienced as intimation rather than consummation, as both abundance and lack.[12] If we do not call this feeling 'yearning' it is only because it has no ostensible object, or rather, we attribute its inspiration to an object which could not be an object of yearning. Indeed this may be why we are more ready to accept the obviously inadequate term 'pleasure' over the more adequate but obviously contradictory 'yearning', itself a form of pleasure, in so far as it is a state in which a desirable object dominates consciousness (even to the extent of suppressing the impossibility of that object's attainment), yet one to which not only an end but also a consciousness of that end seem essential.

What, then, is yearning? It is the entertainment of a desire in the face of a consciousness of that desire's futility. It is that state of mind which Kant describes as 'vain wishing'; a state of mind which, according to Kant, demonstrates 'the presence of desires in man by which he is in contradiction with himself'.[13] Such vain desires, he asserts, manifest themselves in those instances where we seek the production of an object by means of the thought of it alone, without any hope of succeeding, and with the full knowledge that success would be impossible; as for example when we wish to undo the past, or to annihilate the interval that divides us from a wished-for moment. (Such tricks hath even the weakest imaginations.) Though we are conscious of the inability of the desire to cause its object to come into being, our desire is, nevertheless, not deterred by this consciousness from 'straining' towards its object, just as if it might thereby find fulfilment.

All such contrary emotions, such expressions of autistic (as opposed to realistic) thinking, might be collected under the term 'yearning', in so far as 'yearning' conveys just this arrested or static aspiration. This stasis or poise is also, as we have seen, the fundamental moment of the metaphysical. The works of Plotinus, Dionysius, and Ficino are themselves both descriptions and expressions of a yearning without object; that is, the very existence of these works and the tradition in which they stand is the expression of a desire that posits its object in such a way as to place this object beyond achievement (or even conceptualisation) here, in the world. Because metaphysics expresses this desire for the absolute, for the transcendent, the concept of God is always its vanishing point. (Indeed certain metaphysical thinkers, such as Descartes or Berkeley, seem to get themselves into difficulties precisely in order to be rescued by an Absolute.) But if this Absolute is the vanishing point of metaphysics then the desire for it is also the starting point of metaphysics, for metaphysics is fundamentally religious, in that it always builds towards a keystone that can only be the unconditional, that which is beyond the world yet will render the world significant – God, Ein Sof.

The metaphysical, then, can be said to be not simply a type of discourse, a subject among others, but rather an element that diffuses itself through everything that makes an appeal to the transcendental; explicitly in religion and morality, implicitly in innumerable everyday turns of mind – feelings of destiny, finality, poetic justice. Nevertheless it is its existence as a discourse that I wish, for the moment, to consider, and, in particular, the parallels that can be drawn between its 'significant meaninglessness' and those 'contradictory' emotions I spoke of above. For while it is only by denying the impossibility, or the figurativeness, of the metaphysical assertion that it can be made an assertion about the world, at the same time it only exists by virtue of this impossibility, that is, because we desire the unconditional. Thus it is when our interest stops with the expression, the thought, isolated from any considerations of validity, that metaphysics (and wonder), as opposed to mere nonsense, comes into being. The metaphysical always appears at a point of greatest contrast between desire and impossibility. Were it not for the concepts of creation and free will, for example, the concept of God might be made perfectly consistent – man is the problem in theology. I weep with solicitude for one who is beyond all solicitude, and thereby comfort myself. Metaphysics exists in that moment when we are most 'aware' of both sides of the equation, the desirability of a desire we cannot renounce and the impossibility of that desire's fulfilment; both sides are action and reaction.

The significance of the metaphysical, then, is that nostalgia left behind by its cancelling out what it appears to assert, the vacuum created by this *contradictio in adjecto*. It does not collapse on itself, does not disappear into meaninglessness, because the impossibility it momentarily asserts is a desirable impossibility. Metaphysics depends upon a moment in which we entertain such a desire, and on letting that moment pass as a moment of desire. It is the impossibility which generated the emotion, and the emotion which generates the belief, the giving of significance. The metaphysical is that which I wish to be significant it exists because I choose that it should. Thus though metaphysics should, by definition, make no difference to the economy of thought, it is also, in contrast to error, and in contrast to simple meaninglessness, that which, by definition, does make a difference to this economy. This decision, then, not to separate form and content, feeling and belief, that is, the decision that metaphysics should exist, must be the result of a desire, a lack.

The metaphysical presupposes the existence of a state in which reason and affection, though apparently mutually exclusive in this instance, can 'combine' to express themselves in a single impulse. (It is reason, after all, which discerns the fallacy in the thought, and thus renders necessary its presentation as metaphysics.) Such a state is indeed commonplace; the very notion of self-deception presupposes its possibility. Psychology has given many accounts of the mechanism involved in such instances of the division of the soul, in forgetfulness and parapraxes of all sorts.[14] But how such states exist is not of interest to me here; the reason for their existence is, for my present purposes, sufficiently well accounted for by the way in which they are made manifest. (The unconscious is *that* which does *this*.) What I do wish to highlight is the parallel between the paradoxical structure of metaphysics, as that which withholds the present (the entertainment of the desire) from the future (the realisation of the impossibility of fulfilment) in the name of that future, and the paradoxical structure of beauty as 'disinterested pleasure', yearning without object, being as value, timelessness in time. For the existence of metaphysics provides us with a concrete example, in a way that the more ephemeral everyday examples of yearning mentioned above do not, of that paradoxical form of mental stasis that must result from the desire for the unconditional. It is in this desire for the unconditional, I believe, that we find the human tendency which will account for the 'yearning without object' that constitutes the feeling of beauty.

In the following outline of the structure of beauty (as I believe it can be deduced from consideration of the circumstances surrounding it, the

history of its theoretical treatment, and its enduring definition as 'disinterested pleasure'), while I will abandon the 'unreasonable and capricious' language of antient philosophy, the notion of transcendence must remain. This is the nature of the subject: if the concept of beauty could be exhausted by the language of mathematics or conscious motives, that is, without taking into account the unreasonable and capricious in human nature, its definition would hardly have remained, for two and a half thousand years, cast in the form of a contradiction in terms. The following account, however, does not require any commitment to the metaphysical – only the concession that the urge towards that form of feeling which the existence of metaphysics signifies is part and parcel of being human.

The instance of beauty starts with our taking an object (situation/thought) as expressive of the possibility of the existence of a state of affairs that would fulfil our inherent and enduring desire to transcend those very conditions, the contingencies of our existence, that give rise to desire. (Any of the many ways in which an object may become symbolic, including through personal association, may be responsible for our initial interpretation of the object in this way.) At this stage, however, we must be aware that, since this desire is, necessarily, an impossible one, our interpreting of the object as expressive of its fulfilment is an interpretation, an act of wishful thinking. In order, then, to continue entertaining the idea of the fulfilment, for the pleasure it affords us, it becomes necessary for us to ignore, or suppress, our cognizance that what we are experiencing is the effect of an action we have ourselves performed – the projection of our own feelings onto the object. To achieve this we must entertain the idea that it is the world itself which is showing evidence that our desire for transcendence, or perfection, is not vain.[15] In order to do so we must suppress the consciousness of this wish, which by its very existence negates what is wished for, by denying that our 'response' depends upon the idea of the object being expressive of anything. The pleasure that is beauty, then, could not be felt at all were it not that the subject, by a certain subreption, entertains that pleasure as 'disinterested', and therefore ascribes the feeling to the merely sensible qualities of the external world. Hence beauty's appearance as something we have reacted to, as a state we are thrown into by the mere appearance of the object, rather than the result of an action (interpretation) on our own part.

It is important to emphasise that there is no question of the presence of beauty until we reach the last of the stages of the process outlined above. It is the idea, given to us through the symbolic qualities of an object, of the satisfaction of a desire for transcendence, cognized as impos-

sible to entertain rationally, yet, at the same time, too desirable to relinquish completely, that is entertained by the subject in finding the object beautiful. But it is only the entertainment of the idea in this particular way that constitutes the beauty of the object.

It is not, then, the idea itself which is beautiful, but rather the object to which beauty is ascribed − though this object may be itself as intangible as a concept. Not only is the idea itself necessarily one that I cannot rationally entertain, but, since it is essential that the idea of transcendence be embodied, that is, exist independently of my desire, the very fact of significance is also part of what is signified: it would be impossible for the object to function as a symbol if we were to allow that it was in any way expressive. For to be conscious of interpreting the object as expressive would be to introduce myself as a condition of that expressiveness, thus precluding the object from intimating a satisfaction of the desire that the world itself should show evidence that my desire might be fulfilled.

But if it is not the idea itself that is beautiful, then neither can beauty be ascribed to the object that expresses that idea for us. This object, as I suggested in Chapter 1, is necessarily more complex than the object which we actually perceive as beautiful. The beautiful object, constituted by the process outlined above, in order for us to continue entertaining the idea of the desirable impossibility, is one aspect, or component, of the object that expresses that idea, since our cognizance of that object − the real phenomenal ground of the instance of beauty − is, necessarily, suppressed by the process. In Chapter 1 these two objects were designated, respectively, the 'perceived beautiful object', meaning the object to which the subject attributes beauty, and the 'beautiful object', meaning the true phenomenal grounds that are involved in the subject's perception of beauty. It should now be clear why I was, nevertheless, reluctant to use the word 'beautiful' in connection with the latter object: beauty is the end result of the process, and thus can only properly be predicated of what the subject posits as beautiful. Moreover, though sometimes an awareness of the contingency of the perceived beautiful object is forced upon us, this never occurs except in circumstances where the beauty has departed. It is not possible for the subject to trace the beautiful object back to its phenomenal grounds for the plain reason that, while that object is constituted by a complex of suppressions, no less are the grounds themselves constituted by a process of interpretation. If one is in a position to discover that what was apparently accidental to the instance was, in fact, essential, then it can only be because the elements which comprised the ground of the object are no longer held together by that interpretation. (The fact that one can,

on reflection, discover that, for example, the beautiful place was actually a beautiful time might easily lead one to conclude that it is in fact possible to discover the true grounds; though merely discovering an essential though overlooked element in the perceived beautiful object is not, of course, discovering the source *per se* of that beauty.) It is for this reason that I have said that it is futile to try to verify this thesis solely by an analysis of one's own experience of a particular example of beauty.

The difficulties of verifying this thesis at all are, of course, considerable – the nature of the experience itself is such that, as Kant remarked, its grounding can only be deduced from its 'formal peculiarities'.[16] What I would suggest, however, is that the structure of the experience of beauty given above best fits the shape of that blank, the *je ne sais quoi*, that has traditionally existed at the heart of the subject. It enables us to see both in what way many theories of beauty arose, and also what is valid in them. Beauty can, for example, be a matter of the formal qualities of an object (*symmetria*), at least in so far as this form can become symbolic; likewise, literally instinctive responses may play a role in some instances of beauty in so far as those instincts render certain qualities significant; it is rooted in basic physiological or psychological drives, or at least in that fundamental drive the goal of which is also implicit in these other drives; it is, figuratively speaking, a ray emanating from God, shining through matter and reminding the soul of its own divinity; it can only be experienced as the quality of an object; it is in the eye of the beholder. What the thesis does not allow, however, are some of the more problematic and counterintuitive deductions that have been made from such theories in their absolute forms: for example, that what is beautiful about an object is quantifiable solely in terms of the properties of that object (to the exclusion of the particular subject's interpretation of those qualities), or even quantifiable at all by the subject who finds the object beautiful; that the pleasure of beauty is, somehow, identifiable with the pleasure attending the satisfaction of specific physiological goals; that experiences of beauty are qualitatively different from one another ('high' or 'low') depending on the nature of the object or the attitude of the subject. The grounds of the attraction of some of these ideas might, however, be sought in the very structure of beauty I have outlined above; as, indeed, might a motive for beauty's remaining so long ineffable.

More importantly, perhaps, than the way in which this thesis accounts for both traditional theories of beauty and their shortcomings is that it best accounts for the quality of the experience; what I referred to as the feeling of 'yearning without object', combined with a sense of ineffa-

ble meaningfulness. The Neoplatonic and early Christian versions of beauty did provide an adequate object for this feeling in a way that the desiccated definition of beauty as 'disinterested delight' could not. (It is, however, curious to note how the source of the very resistance to inter-pretation, inspired by a desire for transcendence, that characterises the genesis of beauty passed over into modern aesthetics; to the extent that this aesthetics continued to insist upon framing the question of beauty in the form 'How can we account for a disinterested pleasure?', in preference to the more accurate, and ultimately more answerable question, 'How can we account for what is cognized by the subject as a disinterested pleasure?') This is the advantage of approaching beauty through Neopla-tonic texts – their truthfulness. What distinguishes them from other forms of discourse is that, in them, the God that will complete us is not hidden within a love of humanity, or life, or justice, or integrity, or even truth; they are explicit on the impossibility of conceiving of the in-itself, and, in being so, can account for the positive pole of beauty.

Indeed everything associated with the experience of beauty, both the sensation itself and the resistance of that sensation to logical definition, points to beauty being a yearning not for any individual end or object but rather for that object which is the goal of being itself, that perfection of the self towards which every action aims and which every pleasure registers.

This self, towards which being aims, should not, however, be con-fused with what is called the 'true self'. What is called the true self is an illusion created by those particular, yet persistent instances in which you feel impelled to do what you do not want to do. The true self is a state of grace that the very necessity of action at once creates (as a conscious ideal) and renders impossible; an absolute freedom, existent yet immutable, that would yet preclude the possibility of doing anything! It is that hypotheti-cal person who would not do all these things and who is, despite the fact that I do them, really me. The idea of the true self, then, in so far as that self thrives on its own attenuation, is a sentimental one – the more people submit to conformity the more avidly they cling to what becomes a sub-stitute not merely for action, but even for desire itself.

The notion of the true self is, then, strictly a notion, a reflection on life, rather than a sensation. It is this which distinguishes it from what is felt in beauty, which also contains, as one of its moments, an intimation of the paradisical, the eudaemonic.[17] Such, however, is the nature of the beautiful instance that this intimation exists in it in such a way as to be qualified *a priori*. The experience of beauty is, necessarily, too comprehen-sive to resolve itself into the notion of a self, too vague to correspond to

any way of being: it remains a sensation. Thus though beauty, particularly in art, may inspire in us certain specific desires (perhaps through association), it never inspires what is the corollary of the negative desires of the true self, that is, a sense that the universe conspires against their expression. For, though part of the instance of beauty is a knowledge of the impossibility of eudaemonia, there is, nevertheless, no renunciation involved. Although we realise that the end of every desire cannot be, we do not therefore giving up desiring; indeed, it is in beauty that we are particularly aware of how much we are attracted by the world, albeit that this desirability appears as an abstract quality projected, paradoxically but necessarily, onto an object that we do not experience as itself an object of desire. In this sense the impulse created by beauty, in contrast to the reflection which issues in the loyal protest of the idea of a 'true self', is always a total revolt.

I have pursued this digression at some length because beauty is so often associated with that very form of sentimentality which is to be found embodied in the idea of the true self, the 'buried life', 'immortal part', 'finer feelings'. Such an association is accidental to the present subject, a particular conceptual response to beauty, rather than a necessary element in the response of beauty. What is expressed in beauty is not even a concept of that self, as state-of-being, which, as I said above, existence endeavours to arrive at, rather what is expressed is the endeavour itself. We know that such a perfection of the self cannot exist in time; we are cut off from its attainment by the very conditions that give rise to our desire for it – though it is a desire that can exist only here.

Beauty, then, involves the preservation of desire in the face of rationality, a holding fast to what exists only in its slipping away. The endeavour to persist, as Spinoza observes, involves an indefinite time, is unbounded by reality.[18] Yet the desire is bound by knowledge, and emerges not simply as desire but as wonder, longing, and regret, in short as beauty. This is because the knowledge involved is inseparable from, or appears as, emotion; the desire may be impossible but it passes as a moment of desire. This letting be of the desire, this timelessness in time, is a positive act, a letting be. Thus it is that even the phenomenal ground of the object perceived as beautiful remains concealed. It is this ground, we may surmise, which expresses, for the subject, that desirable impossibility which gives rise to the instance of beauty; which instance is preserved by the abstraction or construction of the perceived beautiful object, that is, of beauty. The source of the sensation must remain ineffable. Indeed, when I look again at something I once found beautiful but no

longer do I am amazed not because I can see no reason why it should have attracted me, but precisely because I can, or think I can, see such a reason. In my seeing this reason the thing has ceased to be beautiful, state is separated from act and beauty departs. Likewise with the bad taste of others; bad taste is always obvious taste, it reveals the source of its attraction, it 'caters to a need'. The true opposite of beauty is not ugliness – itself an identity of being and value – but rather the dissociation of being and value and their separate appearance as such, that is vulgarity. For beauty is not something that stands for something we can attain; if it were it could not be the in-itself which, by all accounts, both metaphysical and ocular, it is. The phenomenal ground of the object must express the end of a desire, but express it in such a way that this particular desire is made to exceed the particular, to stand for the fulfilment of all desire. We wish for that union of being and value which will be an end in itself; we experience such a union only in that which is also an expression of its impossibility, that is, only in beauty.

In the following chapters I will examine some of the themes traditionally part of the discussion of beauty – its relationship to knowledge, to interest, to morality, and to art – in order not only to expand on the definition given above, but also to show what, in the light of this definition, is valuable and what is moribund in past theories, and, incidentally, how the very motive which gives rise to beauty can be seen at work in the way those theories strive to preserve the ineffability of their subject.

5

Beauty as cognition

What cannot be spoken of with words, but that whereby words are
 spoken ...
What cannot be thought with the mind, but that whereby the mind can
 think ...
What cannot be seen with the eye, but that whereby the eye can see ...
What cannot be heard with the ear, but that whereby the ear can hear ...
His name is Tadvanam, which translated means 'the end of love-
 longing'.

<div align="right">Kena Upanishad in Upanishads, pp. 51–4</div>

That the world of the child is more beautiful than the world of the adult
is a commonplace. That this commonplace is an error caused by adult
nostalgia is another commonplace. Childhood, despite the intensity of its
sadness, is primarily a world of the most intense pleasure, that is, the
pleasure of anticipation. Childhood is a paradise not for those things
which it could equally well give the adult, but for those things that it
promises and one's ability to believe in its promises. Childhood is happy
not because it is free from care (certainly an error of nostalgia), but
because it is free from scepticism. The promise may be one of consum-
mation, or even release, but the present is entirely preoccupied with this
promise, lives on this promise. The foggy morning, the unknown road –
it was what these promised that set me running, but I *was running*; the pro-
mise enveloped them and was embodied in them. The world of the child,
to invoke yet another commonplace, is beautiful because it is still new.
Perhaps, in retrospect, now that the bush is bare, or almost bare, of
flame, this promise, this intimation, is all we ever have, is, indeed, the
best part of our lives.

A problem arises here. I have said that childhood is beautiful because it is free from scepticism. Yet scepticism, if not as conscious doubt then at least as the propensity of the mind to resist confusing the impossible with the possible, is necessary to beauty. For it is not the desire itself which is beautiful, but rather the desire combined with our consciousness of its impossibility. One solution which immediately offers itself is an idea implied in many nostalgic accounts of childhood: the idea that we actually begin to guard against beauty, as a gratuitous emotion, for the sake of 'adulthood'. So that it is only our behaviour in connection with beauty, rather than the frequency of our experience of beauty, that changes; we cease to allow it to eclipse all other sensations, cease to linger over it, to luxuriate in it, as we did when we were still 'careless'. (Certainly beauty often breaks upon adult life accompanied by a feeling of anamnesis, manifests itself as the renewal of a dimly recollected and yet profound intimacy.) On the other hand it might even be that the beauty we remember perceiving in childhood is no more than the present perception of the beauty of the memory; that is, that the beauty belongs to the retrospective concept of childhood, rather than childhood itself. Yet against both these solutions is the fact that childhood can be remembered as a time of beauty without being remembered as careless, and without the memory itself striking one as in any way attractive. The solution to the problem lies rather in the child's greater capacity for entertaining impossibilities as possibilities while remaining aware of their impossibility; a capacity grounded entirely in ignorance. For the very 'originality' of the world results in a plethora of forms and ideas into which the impossible desire may be projected.

We look back with that resigned envy called 'wisdom' on passions which we are simply no longer naive enough to entertain, passions which, even given the same external circumstances, we could not repeat. Our longing, our nostalgia is evidently not for the object of the passion, except in so far as it is still partly confused with what was the instance of beauty, but for the strength, the very exclusory nature of the passion itself. We find beauty where we can, and it is in this sense that the scepticism which must accompany increasing knowledge perforce reduces the range of possible instances of beauty. For, paradoxically, the more necessary associations which any object accumulates, the more its intrinsic plenitude, its capacity to suggest/accommodate the impossible desire, diminishes.[1] (It is well known that the most bel thing about le bel inconnu is that he is inconnu.) Hence both the traditional notion of 'veiled beauty' and the obsolescence of every instance of beauty.

In this chapter I will address that relationship between beauty and knowledge to which I have so far made only passing reference. It is a subject which returns us to the heart of our subject, that is, the confounding of phenomenality with emotion which beauty appears (and does not appear) to be. Moreover, the association of beauty with the epistemological is one 'aspect' of this phenomenality/psychology which has, at different times and in a variety of forms, dominated the definition of 'beauty'.

The equation of truth (there being no knowledge without truth) with beauty has rarely been so straightforward as its famous identification by Keats; Muratori, for example, described beauty as the resplendent aspect of truth, Maritain as not simply knowledge but a delight in knowledge, and the beautiful as that which exalts the soul by the bare fact of its being given to the intuition of that soul.[2] Hutcheson, whose theory had an indirect but decisive influence on the modern form of this approach, likewise casts his explanation of the 'final causes' of what he calls our 'internal sense' of beauty in terms of 'reasons worthy of the great Author of nature', though, in fact, they can be understood just as easily in terms of evolutionary advantage. Having defined beauty as a high degree of uniformity amidst variety, he speculates that objects demonstrating this property are a source of pleasure because they stand as exemplary of the ultimate intelligibility of the world. It is to our advantage, he writes, that our internal senses be so constituted as to receive pleasure from 'those objects which a finite mind can best imprint and retain the ideas of with the least distraction, to those actions which are most efficacious and fruitful in useful effect; and to those theorems which most enlarge our minds', that is, from whatever exhibits a unification of the various.[3] The pleasure arises from our interest in discerning as much uniformity amidst variety, that is, order, as we possibly can, and also from the evidence of our own capacity to do so: 'were there no general laws fixed in the course of nature there could be no prudence or design in men, no rational expectation of effects from causes, no schemes of action projected, nor any regular execution', and thus, since 'our greatest happiness must depend upon our actions', it follows that we have an interest in discovering evidence that the universe is governed 'by general laws upon which we can found our expectations and project our schemes of action'.[4] (By contrast Kant – whose own theory can be seen as an unsuccessful attempt to give a moral twist to Hutcheson's argument – holds that, for the necessities of practical action, the universe need only be viewed *as if* it were ultimately intelligible; though,

from the point of view of considering why pleasure should arise from the perception of uniformity amidst variety, this is a distinction which makes no difference.)[5]

This explanation became something of an unacknowledged ortho-doxy in the eighteenth century, even among those who wrote specifically against Hutcheson. Certainly the notion that reason was in some way involved in the process was a grateful one to that era. Diderot, for example, defines the beautiful simply as that which 'can reveal to my understanding the idea of relation', adding that it is only the indetermi-nacy of these relations, the ease with which we group them, and the pleasure which accompanies the sensation that lead us to believe beauty is an affair of feeling rather than reason.[6]

This thesis survived the relative dormancy of beauty during the course of the nineteenth century to re-emerge at its close. Santayana, for example, believes that the beauty of the sensible world is the result of the pleasure that accompanies the discrimination and clarification of the con-tents of consciousness by perception and understanding.[7] Many modern attempts at a theory of beauty emphasise such an equation. Spencer describes beauty as an arrangement of parts which exercises the largest number of structural elements in perception while overtaxing least.[8] Allen defines it as that pleasure which is the 'subjective concomitant of the nor-mal amount of activity, not directly concerned with life-serving functions, in the peripheral end-organs of the cerebro-spinal nervous system'.[9] Ogden, Richards, and Woods, in their Foundations of Aesthetics, similarly describe beauty as an equilibrium in which the free play of every impulse joins with the entire avoidance of frustration.[10] (Richards describes it else-where as an activity involving the widest and most comprehensive coor-dination of activities with the least curtailment, conflict, starvation, or restriction.)[11] It is true that these writers do account for the value, prefer-ability, of this state of equilibrium by describing it as a state in which, experiencing the full richness and complexity of our environment, we are most fully alive – though this explains nothing until we know what it is to be alive.

However, the main weakness of these synaesthetic theories is simply that they do not seem to adequately account for what is felt in beauty; they do not explain why beauty feels the way it does. (Allen and Richards are quite self-consciously iconoclastic in this respect.) This may not seem a serious objection, but, since the mechanism of beauty is something that can only be inferred from its effects (these theories offer no procedure for validation), the measure of the justice of any theory of beauty can only be

its appropriateness in explaining these effects; that is, the quantity of observable phenomena it will account for, the number of ends it does not leave loose. In this respect the theory of 'efficient functioning', while perhaps quite adequate to the sense of well-being sometimes experienced when dancing, solving crossword puzzles, or indulging in any of those pastimes which Addison includes under the heading of 'False Wit', seems, as an explanation of beauty, quite arbitrary. It also throws the responsibility for beauty back onto the demonstrable objective properties of the object (the possession of uniformity amidst variety, or harmonious complexity), where, as we have seen, theory invariably founders.

Newton, though still beginning from the vapid characterisation of beauty as 'pleasure', extends and sophisticates this theory of efficient functioning very much after the manner of Hutcheson by introducing the notion of beauty as the satisfaction of a general desire – the desire for order. Beauty, he writes, is a 'law-abiding behaviour' that can be expressed in mathematical terms, and our response to beauty is an instinctive recognition of that law.[12] The desire that beauty satisfies, according to Newton, is the desire to understand and to correlate, it is the pleasure we feel at intuiting the mathematical behaviour of the universe, a behaviour so complex that it can only be grasped intuitively; 'The remarkable feature of this process is the power of the mind to arrive at a verdict without being conscious that the evidence on which it is based comes from so many different sources.'[13] Beauty, for Newton, is 'the underlying mathematical behaviour of phenomena apprehended intuitively', a behaviour that 'varies objectively with the number of interactive laws and the resultant mathematical complexity, and subjectively with the intuition of the beholder'.[14] (The opposite of beauty, he asserts, is chaos.) He does soften this formalism by saying that every instance of beauty cannot be reduced to mathematical formulae, since association must perforce enter in to every object – both the symmetry and the desirability of the film star, for example, are operant factors in our finding her beautiful. Such associations, he continues, may enhance or detract from the beauty but 'they cannot fail to affect it'. This concession to the non-geometrically expressive is, however, retracted in the customary Platonic fashion: the less sensitive the spectator to formal beauty, he writes, the larger the role association will play.[15]

This notion, that beauty is delight in the intuition of order *per se*, appears less arbitrary than the 'efficient functioning' theory, if only because it begins from desire and is worked out, by Newton at least, with a refreshingly permissive attitude towards what kinds of factor may play a

role in this order. But this same permissiveness, which raises his argument above what Croce called the 'astrology' of formalism, undermines, or even renders empty, the basic premise of that argument. For, in extending the notion of order well beyond geometry – the possibility of mathematical formulation is evidently ruled out by many instances of beauty – he must end by explaining the 'geometry' of this order itself in terms of another property, some mysterious x by virtue of which we perceive the beautiful object as ordered, as 'geometrical'. This x being ... beauty?

The same objection can be made to those theories of beauty, originating in the fields of cognitive science and biology, that ground beauty per se in a humanly innate sensitivity to vertical symmetry (enabling us to detect whether another creature is looking at us), or in the relationship between symmetry and the health/fertility of a potential mate: that symmetry is, demonstrably, not a necessary condition of every instance of beauty. There is, however, another theory, originating from biology, that grounds beauty in a sense of the furtherance of life that yet does not have to rely on the presence of symmetry, that is, the theory that beauty is a subliminal response to sexual attractiveness.[16] (That beauty is obviously not identifiable with either attractiveness or sexiness is not a relevant objection to this hypothesis, since what concerns us here is an instinctive response, a legacy of the species' history.) Recent research appears to establish a direct relationship between perceptions of beauty in female faces and the degree to which the face possesses features and proportions indicative of high fertility.[17] It seems, however, highly unlikely that such findings could be extrapolated to cover instances of non-human beauty: what, for example, could we take to be even vaguely analogous to chin size (indicative of oestrogen levels) in the sound of rain starting to fall on a still spring night? This does not, of course, invalidate the theory that perceptions of human beauty may be to some degree determined by evolutionary factors. As I noted at the end of the last chapter, given that it is the meaning of the object which gives rise to beauty, it is quite possible that such literally instinctive responses may play a role in some instances of beauty, in so far as those instincts render certain qualities significant. However, given that other sources of significance, arising from associations that may be either cultural, idiosyncratically personal, or even perhaps the result of other instincts, may equally be at work in any particular instance of beauty, what we might expect to find is that, while there may be a general, biologically inspired, tendency within perceptions of human beauty, there will also be wide, not to say wild, degrees of variation. Which is, indeed, precisely what we do find.

Another way of interpreting the revelatory aspect of beauty, which yet avoids the emptiness of positing it as the local 'perfection' of disinterested sensuous apprehension, or the restrictiveness of attributing it to biological causes which will only cover, and even then not completely, some classes of objects, is to extend the range, or even change the quality, of what it is that is apprehended. The Neoplatonic theory of beauty is such an extension; one that can account for the static nature of beauty by positing what is apprehended as both good in itself and yet, by the very (worldly) conditions of its apprehension, unattainable. For Plotinus, as we have seen, the sensory world reveals, albeit imperfectly, the reason or logos that flows from the Divine. Beauty, for him, is not proportion itself but rather that which 'illuminates' proportion; a thing is beautiful by virtue of its communion in 'Ideal-Form'.[18] Beauty, in this system, is the aspiration of primal matter towards its perfect form, a form we recognise because its Idea is inherent in ourselves. Thus the soul is awakened from its stupor and drawn towards the Absolute, the source of this illumination, and towards, therefore, a beatific knowledge of what really is. For Christian writers also, such as Lactantius, Basil of Caesarea, Clement of Alexandria, and Athanasius, the beauty of the world, its order and harmony, reveal the intention and wisdom of its creator.[19] Beauty, for Eriugena, is the becoming visible of that which is invisible, the becoming comprehensible of that which was incomprehensible, a revelation attended by ineffable delight.[20] Beauty is thus the coming forth of the world, the first word of God, an illumination.[21] Cardano in the sixteenth century went so far as to say that what is known through hearing is called 'harmony' and what is known through sight 'beauty'; for he too believed that pleasure was inseparable from cognition.[22]

The association of light with beauty was a common one in the patristic and medieval periods – light itself being held to be the most beautiful of things.[23] Basil of Caesarea accounted for its beauty by the relation it bears to the organs of vision (it is the means by which we know), and when Aquinas defined beauty as a certain proportion and lustre (claritas), that claritas meant not only bright colours, as it had for earlier writers, but also the showing forth of the essence of a thing.[24] Thus for Aquinas sight and hearing were proper channels for the perception of beauty but taste and smell were not, these latter being without an intellectual element. For Ficino, too, since beauty pertains to the intellect, those senses which have most in common with the concerns of the body, that is, smell, taste, and touch, give little pleasure to the soul and belong more to lust than to that love which is the enjoyment of beauty.[25]

In the Christian scheme, of course, we are at once plunged in the world yet, as a consequence, cut off from the glory of the world as Creation. To see the world as Creation is at once, to have, an intuition of a promised yet inconceivable bliss, and to have this promise only in terms of what is not this bliss! But any promise of transcendence, either beyond the world or, as with Schelling and Schopenhauer, to a paradisical apprehension of the world, will do as well. Thus for Schelling the beautiful is knowledge, only more so, for philosophy simply travels along in its wake. Indeed for nineteenth-century German philosophy in general, and most famously for Kant, beauty was that which could, in one way or another, mend the rift between subject and object, the dichotomy which Gabriel Betteridge rightly discerned as the ruling genius of Continental thought during this period. Schelling, in his *System of Transcendental Idealism*, posits it as a fundamental problem that philosophy, while it must start from an 'absolutely simple and identical principle', that is neither objective nor subjective, cannot grasp or communicate such a principle, that is, cannot intuit what is internal to itself as objective for itself.[26] The sword which cuts this Gordian knot for him is beauty, which he describes as 'intellectual intuition become objective'. Thus he can describe beautiful art as 'at once the only true and eternal organ and document of philosophy, which ever and again continues to speak to us of what philosophy cannot depict'.[27] Beauty, then, allows the very foundation of our knowledge, that is, 'the coincidence of an objective with a subjective', to come into being; it is 'the infinite finitely displayed'.[28]

In Schelling's scheme the creation of Mind through beauty takes place 'within' existence. Consciousness, for him, is a degeneration of our preconscious unity with the world, a loss of harmony, emerging only through the splitting of object from concept. The Mind is thus an 'eternal island', touching and touched by nothing. Truth, he asserts, cannot be granted to the sort of cognition that is accompanied only by present certitude; a changeable certitude, since our cognition is either directly linked to, or facilitated by, those immediate affections of the body which are subject to time. Neither, he continues, can truth be granted to enduring certitude, for this is still only valid for human understanding and is not that certitude beyond time, that truth in the sight of God, the archetypal understanding, self-contained and eternal. We cannot be said, then, to have scaled the summit of truth, according to Schelling, until our thought has reached up to the non-temporal existence of things and their eternal concepts, for within productive nature these things are subject to time and the laws of mechanics – enslaved to futility. It is the perception of these

archetypes, which are like the immediate offspring of God, more splendid than their created images, and freed from the conditions of time, which we experience, according to Schelling, in beauty; beauty, which is 'only appearance', is, as the coincidence of the conscious and unconscious, as the non-conceptual, a 'unique and eternal revelation'.[29] Likewise for Schopenhauer the thing-in-itself, the purely objective perception of the idea, the essence independent of all relation, comes into being for us only in 'aesthetic contemplation', and this because such contemplation is disinterested: 'In the aesthetic method of consideration we [find] *two insepara-ble constituent parts*: namely, knowledge of the object not as individual thing, but as Platonic *Idea*, in other words, as persistent form of this whole species of things; and the self-consciousness of the knower, not as individual, but as *pure, will-less subject of knowledge*.'[30] Outside this form of contemplation we experience the ideas only by means of concepts, and thus as copies, or shadows; the world as the mind generates it is a dream, a phantasmagoria – everything would be beautiful if we could see it objectively.[31] For Hegel, too, beauty is 'the Idea as developed into concrete form'.[32]

If all these theories of the apprehension of a transcendental knowledge appear too transparently metaphysical today, there is, nevertheless, one notion that, because it corresponded so closely to the phenomenology of beauty, endured even into the second half of the twentieth century. This is the notion that beauty arises not from an apprehension of the supersensible that comes about through a 'disinterested' contemplation, but from 'disinterested contemplation' in itself. This is anticipated in Schopenhauer. For, as we have seen above, he solves what he considers to be the intrinsic problem of the metaphysics of beauty (how we can take pleasure in an object which has no connection with our desires) by positing that in the beautiful we perceive the intrinsic and primary form of things, which stipulates the existence of its essential correlative – the will-less subject of knowledge. The will, for Schopenhauer, like Time for Schelling, and, more explicitly, Necessity for Ficino, points to a state of fallenness; it is enough, according to Schopenhauer, for the will, the cause of suffering, to disappear from consciousness, for us to feel pleasure – happiness being a negative state, the cessation of suffering.[33] (This is half true, or rather, half the truth: it accounts for the sense of transport but not the sense of yearning that beauty inspires. What Schopenhauer describes – a consciousness of the world so intense as to exclude our awareness that we are part of it – is ecstasy; a state in which, in contrast to the perception of beauty, all sense of the relationship between subject and object is abolished, and with it the very possibility of beauty.[34]) Nietzsche feels that

Schopenhauer's attitude to beauty does imply an interest in so far as, being the suspension of the will and, therefore, of suffering, it represents the strongest of personal interests, that is, 'that of a tortured man who gains release from his torture'.[35] This is, of course, sophistry, since, even if Schopenhauer is right about the consequences of beauty, this does not prove that beauty is caused by a desire for these consequences. Indeed, though, in one sense, we make things beautiful all the time, it is yet beyond the conscious mind to will the perception of beauty.

This very inability to will beauty, combined with the reflective realization that beauty neither satisfies a discoverable desire nor demands an appropriate reaction, are the very aspects of beauty that give rise to the characterisation of our consciousness of it as 'disinterested'. It is a small step to reverse the equation, that is, to make 'disinterested contemplation' the cause of beauty. Croce, for example, makes beauty an intuition, a form of 'taking possession', in which we objectify our impressions independently of any intellectual function, concern for reality or unreality, sensation, or feeling, and indifferent to later empirical discrimination; a knowledge free from concepts![36] Likewise Prall:

> Discriminating perception focused upon an object as it appears directly to sense, without ulterior interest to direct that perception inward to an understanding of the actual forces or underlying structure giving rise to this appearance, or forward to the purposes to which the object may be turned or the events its presence and movement may presage, or outward to its relations in the general structure and the moving flux – such free attentive activity may fairly be said to mark the situation in which beauty is felt.[37]

It is difficult to see how such 'disinterested contemplation', not, after all, immediately distinguishable from the mental state of one staring at a blank wall with their mouth open, could be said to constitute a form of enhanced intuition. What such a theory requires is a general characterisation of 'interested contemplation' which would show that it was in some way inadequate, some proof that our normal consciousness of the world, in the sense of cognitive grasp, is in a constant state of partial failure.[38] (This, as we have seen, is Schopenhauer's basic premise: that both objective knowledge and happiness – or at least the absence of suffering – are inhibited by the will *per se*.)[39] A more prosaic, and hence persuasive, linking of disinterest and 'knowledge' (though one which, paradoxically, would have to hark back to 'efficient functioning' in order to explain the element of pleasure) is to be found in Stolnitz's concept of the 'aesthetic attitude'. According to Stolnitz our normal attitude towards things is prac-

tical; we see things in terms of their usefulness, and our perception of them is correspondingly 'limited and fragmentary'.[40] We can, however, according to Stolnitz, adopt an attitude of 'disinterested and sympathetic attention to and contemplation of any object of awareness whatever, for its own sake alone', and with no other purpose governing the experience than the purpose of just having the experience of the way that object looks, sounds, or feels. Such attention is 'sympathetic', he continues, in that we prepare ourselves to respond to the object by inhibiting any response which might alienate us from it, that would prevent us from following the lead of the object and responding in concert with it. Such attention, then, is accompanied by a form of activity, not 'goal-seeking', but nevertheless concerned with whatever is required for, or evoked by, the perception of the object.

Both Schopenhauer and Stolnitz, then, allow for beautiful objects, or some objects that are more appropriate to beauty than others; those objects which 'stand out' from the world and 'rivet our interest', as the latter says. Disinterested contemplation, in this theory, is thus a necessary but not a sufficient condition of the perception of beauty. That is, the hypothetical person staring at the wall with open mouth will not perceive beauty unless there is some appropriate object in front of them. (Stolnitz's nonsensical assertion that we must prepare for the experience is of a kind that is discussed more fully in Chapter 8 below.) That disinterest should be disinterest under the right circumstances certainly solves several problems – principally the problem of why this 'mood' should become associated with a disproportionate number of examples from some classes of objects rather than others. But it also weakens the idea that our disinterest is so pure as to exclude discrimination of the provenance of the object, and, as with the 'efficient functioning' theory, throws the responsibility for beauty back onto universally beautiful, or potentially beautiful, qualities possessed by certain objects.

This last is not, of course, an insuperable difficulty for the theory. What is an insuperable difficulty is the adequate definition of 'disinterested contemplation'. For 'disinterested' is a description that is meaningful only in a specified context; meaningful only in relation to the exclusion of a specific potential interest, and, thus, applicable only to specific particular judgements. The judge, for example, is disinterested if he does not take a bribe or allow his prejudices to infect his judgement (even if he hates his job and has only come to work because he needs the money). Can this definition be extended to characterise a general psychological state? An action or judgement can be disinterested only within certain

parameters set by what interests might conceivably be involved in a given context. In contrast the parameters by which we measure attention or perception are quite different; we attend/perceive or we do not, and if we half attend/perceive we are attending to or perceiving some aspects and simply not attending to or perceiving others. 'Interested' and 'disinterested', then, are not adjectives that can be used to characterise any fundamental orientation in this domain. Moreover, attending while being conscious of no ulterior purpose – 'just looking' – is an attitude that certainly does not belong exclusively to beauty. Disinterest *per se*, absolute disinterest, is inconceivable. This is the problem with Stolnitz's concept of following the lead of the object: objects give no lead unless they are already embedded in a matrix of interest. We construct the world according to its significance as a field of action, construct it out of our needs and the means by which they may be fulfilled. Indeed, the only real cause of absolutely disinterested response appears to occur in beauty itself – which renders the argument circular. Defining our apprehension of beauty as 'disinterested' is, of course, another matter, for here, despite its awkwardness, it does capture the fact that, on reflection, we can find no reason why we should be so pleased or moved by the object of our attention, or rather all our reasons return to a description of the object itself and the plain statement that 'it is beautiful'. Certainly we might say that we discern/create beauty because it gives us pleasure, but this does not explain why it gives us pleasure – the sensation itself remains apparently static, ateleological, 'disinterested'.

What, then, is there in beauty that gives rise to the claim that it is a form, even a higher form, of cognition?[41] Partly, no doubt, the idea arises from the fact that, since beauty is so obviously neither action nor desire, there appears to be nothing other than knowing left for it to be. Yet beauty certainly feels in some way revelatory. If, however, it were the perfection of sensuous knowledge, joy in the harmony of the faculties, it would be simply euphoria – which is only half the truth. If it were that state in which we comprehend the full richness and complexity of our environment, it should, presumably, issue in some demonstrable increase in understanding – which it does not.[42] Yet in beauty we feel more closely bound to the world, more aware of the world. So much is true. But this is not a more clear perception; rather it is a more general, more encompassing, more intimate perception of the world. In beauty we feel the world, and life, as a whole, as a generality. To this extent Kant is right: in feeling the world as part of ourselves and ourselves as part of the world, what is revealed to

us, or rather what we become aware of, is our relation to the world. Beauty is neither euphoria nor communicable knowledge (that is, knowledge); it is rather an unconscious sense of the prevailing course of our life, our relation to the world we are passing through – a sense of our ultimate goal and of its ideality, of the absolute in the finite and the finite in the absolute, desire and the impossibility of its fulfilment. At such a moment our being, as a generality, is intimately present, though this does not involve our seeing the details of the world with any greater clarity. As Plotinus says, in the beauty of appearance we are pursuing our own reflection. And there is only a beauty of appearance.

It is, indeed, perhaps those Neoplatonic and Christian accounts which describe beauty as at once a revelation of the soul's origin, and yet a distraction, which come closest to an intuition of the relationship between beauty and cognition. It is also in these accounts that we meet with another facet of this relationship that I wish to pursue here – that beauty, though not a source of knowledge, is, nevertheless, the source of knowing.

In the beginning, according to Ficino, there is chaos, the unformed world. The first world that God creates is that of the Angelic Mind, itself formless and dark in the first moment of its creation, but turning towards God by the innate appetite which Ficino calls 'love'. In turning towards God it is illuminated by His light and receives form, has imprinted upon it the Ideas of all that we perceive in the world. The desire for beauty, then, is the step that transforms Chaos into World, since the appetite of the mind precedes its receiving the Forms and it is only in the mind thus formed that the world itself is born, that the primordially formless World Soul receives from the mind the Forms, and 'becomes a world'.[43] Thus it is the response of the mind to the beauty of God which gives rise to Ideas, and the response of matter to the beauty of the soul which gives rise to a world modelled upon these Ideas; the visible world is composed of shadows and signs of souls and minds, but they are shadows and signs that correspond to the shape of those things whose shadows and signs they are.[44] Beauty for Ficino is a ray emanating from God, penetrating through all things, adorning the mind with Ideas, the soul with reasons, matter with forms; at once the grounds of knowledge and the source of its object, the basis of knowing and the known.

Before pursuing this idea of beauty as a 'unique and eternal revelation' of the a priori, as the means by which the world comes forth to the mind, I wish to contrast it with another view of knowing chosen along the lines of the traditional antithesis between beauty and use. For Ficino the hammer appears because of the beauty of its Idea in God; for Heidegger it

appears through our concernful dealings with the world, that is, it appears through its use – the hammering knows the hammer. Heidegger does not begin with things because to do so would be to miss the pre-phenomenal stage at which the world is first encountered, to prejudge its ontological character. Things are equipment (*das Zeug*), implements, that by which we implement our concernful dealings, and show themselves only in such dealings. But in this, it could be said, the world is already presupposed, for it does not explain in what way there is a world in which such dealings take place. One answer is that the 'towards-this' of equipment is disclosed only when the hammer is broken or cannot be found. But this disclosure only discloses what already was the case, what was presupposed in our dealings, known but not reflected on. Heidegger's answer is that the world is known as the 'wherein' of our 'towards-this'; it presupposes and is presupposed by our dealings.[45] Ficino too does not begin with things; like Heidegger his world is ultimately for the sake of possibilities of our being. But the human being is not for Ficino, as for Heidegger, a 'being-there' (*Dasein*), a worldly being, but rather a 'being-here'; 'there', our true homeland, is God, and 'here' only exists as a separation from this homeland. The possibility of being that, for Ficino, calls the world into being for us is the innate appetite of the mind for the beauty of God.[46]

Is there really a contrast here with the world revealed through use, as it is in Heidegger? There is no Absolute in Heidegger's scheme – we're here because we're here because we're here – but there is nevertheless some ultimate 'towards this' implied by all our dealings. For Heidegger the soul is native and is care; for Ficino it is adventive and expresses itself as yearning. A world separates Heidegger's *Unheimlich* from Ficino's fallenness. But the feeling of belonging as much to an ever-postponed future as to the present is what constitutes both Ficino's soul and Heidegger's being.

To be is to be disenparadised – this is what the notion of the soul signifies. But the soul, the divine spark, is not an 'aspect' of being; still less, though this is a common error, is it a state. The existence of the soul is perhaps the only demonstrable psychological fact; it is, indeed, the psychological fact *par excellence*. Moreover everything that has been said about it – its immortality, its fallenness into matter, its yearning – is quite true. But this soul is not simply the mind as desire; such a distinction could exist only in theory. Rather the soul is what the soul desires, this desire being always and everywhere made manifest – which is why it is the commonplace which is least bearable, and why the notion of surface and depth with respect to human nature is an illusion.

Beauty, as we have seen, is the promise of the fulfilment of every possibility, the absolute fulfilment of possibilities. Aristotle reports that the Platonists arrived at the theory of Forms or Ideas as a consequence of their belief in the Heracletian notion of the world as in a constant state of flux.[47] The Forms were to be our guarantee of knowledge outside this stream, eternally certain. This is a beautiful idea. The idea that the world comes forth for us through love is also a beautiful idea. They are beautiful ideas because they are ideas which infuse meaning into the world; they provide the 'towards this' with a homeland, a resting place. To identify the beautiful and the ultimate 'towards this' of the useful is therefore no contradiction. Ficino has, in contrast to Heidegger, provided a point to it all. Some absolute is the goal of every voyage of metaphysics, but this does not mean that this absolute is to be absolutely encountered on each step of the way; for Ficino, as for his mentor Plotinus, the rays of light that emanate from God become dimmer and dimmer as they descend through the created world.[48] For Plato the division is even greater; it is the difference between the firelight of the cave and the sunlight outside, the only constant being the eyes. The point of it all is beautiful, then, because it is the point of it all. The ultimate goal which I have, more or less, in mind at any time is beautiful because it is my goal, that is, that which pleases and attracts me for no end other than itself. I do not look beyond it because there is no beyond, it is my absolute contentment.

Nevertheless, while beauty may be my *raison d'être*, this does not explain the being of the world for me; that is, it appears to explain why I look for what I look for but not how I find it. I have still to justify the notion that it is the *hyperkalon* which attracts the world into being and holds all things in existence by their yearning for it. But, in fact, in discovering the nature of the end we also account for the nature of the means. For there must be an impulse towards the world in order for there to be a world; the eye that is perfectly still sees nothing. In being, that is, in the very positing of 'I' (prior even to my positing of an 'I'), I am presented with a lacuna in terms of being, a problem of interpretation. I *come into* being; it is always prior to me, before me, demanding explanation in terms of my separation from it, which I experience immediately only as desire. The hermeneutical task must always start from a perception of something surplus or deficient, a hiatus in the coherence of what is given. I am, primordially, what is given, yet this 'I' includes the world. At the same time everything that is not 'I' is surplus, so that, in being, I necessarily experience the paradox of a surplus in what is given. My understanding can neither appear nor grow, it can only evolve – by the removal

of the expletive in being (which eventually becomes, by the same process, the expletive in experience) – as a result of my desire for coherence. I must anticipate. I cannot simply observe, for, until I conjecture, there is no place from which I can observe, no criteria for choosing what to observe or what will count as an observation. The desire for coherence is primordial, is the condition of interpretation, and thus, necessarily, must always run ahead of what is given. Kant writes that enlightenment, as the perfection of thinking, is constituted (if only ideally) by 'that merely negative attitude' in which opinion or belief does not strain ahead of knowledge into vain desires or prejudices.[49] But the absolute attainment of such an ideal of thought would also be the cessation of thought, for thinking exists only to serve feeling, and every feeling is, in this sense, a form of prejudice, of thought running ahead of itself.

The world is not only born but also lives only in the mind that aspires after some end; this aspiration constitutes the mind. The world comes forth, ceases to be formless and dark, in response to our desire. We know by beauty because beauty is meaningfulness. The contentment which we seek through every act of knowing is, by definition, an end which is an end in itself, that is, it appears to us, and is, the beautiful.[50]

In the last chapter I suggested that beauty, as a sign of the prevailing course of being, lies at the heart of metaphysics. Indeed it lies at the heart of all desire for knowledge, and it is the very existence of metaphysics which demonstrates this. For it is in metaphysics that the desire for beauty causes belief to exceed those limits of consistency which define what is truly 'knowledge' – thus pointing to the origin of knowledge in desire. So long as knowing remains within that economy which rationality recognises, it remains transparent and thus groundless. But, just as the process of interpretation remains transparent until it becomes misinterpretation, so it is only through excess that the act of knowing becomes visible, only in excess that we recognise it as an act. The 'pursuit' of beauty, which is no more than the perception of beauty, marks that point where the essential endeavour-to-be rebels against the condition of being, thereby illuminating the essence of this condition. It is for this reason that the sense of beauty may be described as the primordial sense of the world.

What, then, of the beautiful object, the beautiful moment? For, if beauty is the result of a fundamental orientation, how can it become a particular event? We do not, of course, experience beauty as an orientation at all – it is a yearning without object – since its adequate object cannot be embodied. However, in so far as we live in time and in the particular, this absolute can only appear to us in time and in the particular. (One may see

beauty from the window of a palace or a prison, as Schopenhauer says, but what one finds beautiful will depend on which of these places one is in.)[51] It is our experience of necessity, of the particular and the relative, which gives rise to the absolute, and, hence, can give form to, or express for us, a desirable impossibility of which this absolute is the type. We feel the unconditional only in terms of the conditional. This dependence on the subject's facticity does not, however, immutably determine what will be beautiful for that subject, any more than it determines the subject's being itself, since this facticity exists as a realm of possibilities. Beauty is a particular moment because it is a moment of arrest, of poise; it is what we feel in the presence of that which expresses, for that moment, a transcendence of the particular while remaining particular.[52]

Such a loose (and convenient) notion of the concatenation of events giving rise to what is expressive of this fundamental orientation combined with a mood, or personality, that is receptive to this expression should not be taken as a *deus ex machina* in my account. We are not incessantly alive. Such a condensation of feeling as this notion supposes, where the import, the emotional implication, of what is abiding is suddenly brought to us in a way that transcends mere awareness of the facts, is a commonplace event. It is an event so commonplace, indeed, as to go unremarked.[53] Such moments, when joy or grief or despair engross the present, marking changes that are apparently inexplicable in terms of changes in circumstance or knowledge, are the inevitable high-water marks of that ebb and flow of feeling without which consciousness over time is inconceivable. Beauty is a realisation that, since it takes place in the emotional realm, adds nothing to knowledge; we simply feel what we know.

The idea that the poetical is about feeling is, of course, entirely erroneous, the product of a post-poetical experience of poetry. The way in which we first encounter the poetical, a way in which, especially if we become thinkers about the poetical, we are unlikely to encounter it ever again, is as a description of situations and places, an embodied beauty. The 'world of poetry' was a world I could journey to, it was the world I would grow up and find myself in. It lay beyond any journey yet seemed to lie at the end of every journey. I did not desire it as one desires other things, things one can envisage being satisfied with, assimilating, accommodating, being beyond; it was simply there, the as yet undiscovered world I had discovered. This place lived in my desire for it, so that what I fear, as each year carries me further from my fabulous homeland, as I begin to seem to have outlived myself, is not exile but rather naturalisation in another place

(the haft rotting in the blade). This is the nature of the paradisical, that it is always elsewhere. Goethe, reflecting on that period of his life which became *Die Leiden des Jungen Werther*, wrote that our greatest happiness rests in our longings and that true longing may have as its goal only what is unattainable. Werther, for all that he blows his brains out, is the happiest of mortals. For the true paradise, as Proust observed, is the paradise that is lost, that is truly and finally rendered unattainable by time: Goethe's Wahlheim, 'the place where all unique things happen', Nerval's Ermenonville, Proust's Bois de Boulogne (*circa* Mme Swann), and, pre-eminently, Alain-Fournier's Les Sablonnières. Paradise is never here and now, for one cannot be conscious of being entirely happy; the moment I become absolute, in ecstasy, the 'I' disappears; such a moment is timeless, but the 'I' that wanted ecstasy no longer exists. Thus time, as finitude, separates us from paradise now, yet time causes paradise to come into being – then.

6
Blood and light

Pace non trovo e non ò da far guerra
e temo e spero, et ardo e son un ghiaccio,
e volo sopra 'l cielo e giaccio in terra,
e nulla stringo e tutto 'l mondo abbraccio.
[I find no peace and have no strength to make war,
And fear and hope, I burn and I am ice, and I fly above the heavens
 and lie upon the ground,
I grasp at nothing and all the world I embrace.]

<div align="right">Petrarch, Il Canzoniere, 134, ll. 1–4</div>

tot mos desigs sobre vós los escamp;
tot és dins vós lo que em fa desijar.
[I scatter all my desires on you;
Everything that makes me desire is within you.]

<div align="right">March, Selected Poems, p. 37 (Poem IV)</div>

adyapi...
[Even now...]

<div align="right">Bilhana, Caurapañeàsikà</div>

When beauty no longer excites in us any need of approach, of contact, and
of embracing, the state of calm that you were once fool enough to long for
at a time when an excess of desires tormented you, that state no longer seems
to you anything but apathy and deserves to be praised only because, perhaps,
it makes the idea of death less atrocious, by taming you to it.

<div align="right">Gide, Journals 1889–1949, p. 366</div>

Du mußt dein Leben ändern.
[You must change your life.]

<div align="right">Rilke, 'Archaic Torso of Apollo'[1]</div>

Beauty and action. It has emerged that the contemplative genius that rules beauty is itself the product, the result, of two opposing movements, that the stillness of beauty is not repose but poise; a poise that results from our consciousness of the impossibility of the end at which we nevertheless must aim, from the frustration of this end by the very means (cognition) which exist only for its realisation. Yet this discovery has, if anything, emphasised the inviolability of beauty, for, while before there remained the possibility of penetrating deeper into beauty and discovering its mechanism, penetration now appears only as a going beyond beauty, a leaving of beauty. Whence, then, the subject of beauty and action? Simply that it is a problem that beauty itself presents us with.

I have already said that the desire to possess beauty, the seeking of something in or through beauty, extinguishes beauty by making it simply the attraction something has in the light of a further end, thus splitting the identity of being and value which beauty is. How, then, can one possess beauty? I do not mean simply ensuring the presence of beauty, not yet at least. What question is left? Only one that grammar itself will not tolerate. And yet I have said that the question is one that presents itself, though not as a question, within the very experience of beauty. Ficino recounts how Lucretius, having abused love by descending from the desire for contemplation to the desire for embrace, as a consequence went mad and killed himself.[2] But beauty is already an action, or contains an action – an impulse and its opposition. Though he can write that in loving bodies we are really loving the shadow of God, true love, according to Ficino, though aroused by corporeal beauty, nevertheless flies upwards to divine beauty; this is the plenty and the poverty of the presence of beauty, about which I have already written.[3]

In Plato's *Symposium* Diotima tells the story of the conception of Love, or the desire for beauty. At a banquet to celebrate the birth of Aphrodite, Resource, drunk with nectar, fell asleep in Zeus's park. There Need, who had been unable to enter the feast, found him, lay with him, and so Love was conceived.[4] Thus it is that the desire for beauty is neither mortal nor immortal, but a thing of the spirit, the function of which, according to Diotima, is to mediate between the gods and mankind, to bind them together into a whole.[5] Love, she continues, is a philosopher for it is neither wise nor ignorant, it knows its want of knowledge.[6]

While cognition, or life, may begin, as we saw in the last chapter, with transcendental desire, only rationality, only deference to Necessity, can carry on the project. Yet it is also rationality that reveals the impossibility of that which is the end of the project. Rationality and beauty, then,

far from being antithetical, depend upon one another; beauty as the motive, rationality as the cause, for there is no beauty where the end of the desire is conceived of as possible. It is something beyond rationality that is desired in beauty, it is the impossible union of metaphysics, the binding together of god and man, in which the absolute is assumed. What is it, asks Diotima, that the person who loves beautiful things loves? Those who followed Plato answered 'God', that is, the ultimate beatitude which is implanted in us as a general and necessarily confused notion. This is also, in effect, the answer that Plato gives. Diotima, on finding that Socrates cannot answer her question, changes it to 'What is it that the lover of the beautiful is longing for?'.[7] The answer it emerges is that what the lover desires and gets from good things is happiness, and to this end he desires to have the good for himself always.[8] She then returns to beauty to declare that the desire for the beautiful is likewise a desire for immortality, a pregnancy of the soul, which longs to give birth to what will last and will be itself beautiful.[9] But this does not explain the attraction of the beautiful, does not explain beauty. Beauty is beyond explanation:

> Whoever has been initiated so far in the mysteries of Love and has viewed all these aspects of the beautiful in due succession, is at last drawing near the final revelation. And now, Socrates, there bursts upon him that wondrous vision which is the very soul of the beauty he has toiled so long for. It is an everlasting loveliness which neither comes nor goes, which neither flowers nor fades, for such beauty is the same on every hand, the same then as now, here as there, this way as that way, the same to every worshiper as it is to every other. Nor will his vision of the beautiful take the form of a face, or of hands, or of anything that is of the flesh. It will be neither words, nor knowledge, nor a something that exists in something else, such as a living creature, or the earth, or the heavens, or anything that is – but subsisting of itself and by itself in an eternal oneness, while every lovely thing partakes of it in such sort that, however much the parts may wax and wane, it will be neither more nor less, but still the same inviolable whole.[10]

This is the ultimate beatitude, the aphasia that becomes the I-know-not-what of beauty.

The eye alone enjoys the beauty of the body. (Even the final revelation awaiting Diotima's initiate comes in the form of a vision.) But beauty is not simply enjoyment, there is a plenty and a poverty in the mere presence of beauty, the poverty arising from the fact that it is mere presence. Indeed, the less instantial and fortuitous, the more enduring and purely phenomenal, the beauty seems, the more this poverty of presence emerges. All our

71

conscious desire can at times crystallise, in some self-evidently irrational fashion, into an object that we define for ourselves in such a way that it could not conceivably offer a course of action for the fulfilment of this desire. This crystallisation is passion; that which we feel towards a beauty in relation to which we believe, against the very evidence of perception, that action is possible. Passion is our *acting as if* beauty could be realised in a particular instance; hence the belief that passion is somehow the quintessence of life, that in passion we are more fully alive.[11] ('I do not want to forget.') For the first time there is no surplus, nothing matters except my 'relation' to the object. It makes everything ineffably meaningful. And everything that cannot take part in it becomes meaningless.[12]

I am not here talking exclusively of sexual passion, though it will be difficult for both of us not to forget this fact. Rather I mean any ardent love or absorbing interest, anything which, to another, would appear as fascination; we are passionate about a plan, a cause, a person, anything, in short, in which self-interest does not appear! (Or where, to an observer, our degree of commitment appears to exceed any conceivable self-interest.) Passionate love, in the uniqueness of the relation which it posits between myself and the object, in its individuality, that is, its essentially solipsistic character, is to some extent the ideal example of passion *per se*. (So that it is not so much through analogy as through identity that it becomes, historically, the subsidiary subject of the mystical metaphor.) Yet all passion, on reflection, is marked by the same objective meaninglessness; I cannot explain its goal, even to myself. There it is, apparently directed, if only nominally volitive; blind but sure. It is something one suffers, sharing a common root with 'passive' in the Latin for 'suffer'. Venus impels.

Unlike a hope, a wish, a desire, even a love, it would be nonsensical to speak of a passion being fulfilled or consummated; when we try to imagine such a thing we find only an image of the cessation of the passion, unimaginable within that passion.[13] No image of a goal appears, but the object itself, the object as my yearning. For while this object is ostensibly an individual manner of being rather than any particular quality, it is only possible to perceive or conceptualise such a manner of being as a collection of qualities. Yet, in contrast to what affection or interest remain conscious of, we strenuously deny the contribution of qualities to the object of our passion, we constantly assert its ateleological character, thereby paralleling the 'mistake' which is intrinsic to beauty. The sum is beyond parts − until it dissolves, leaving behind only puzzlingly quotidian disjecta.[14] And as with all beauty, no matter how intense, in passion I somehow remain aware of the subjectivity of my response. The one who loves,

writes Ficino, 'loves love primarily'.[15] The requital I desire cannot take any concrete form. What I desire is what passion in itself gives me, though always only partly (hence the active character of passion), that is, that I should disappear into this beauty, be engulfed by this beauty. Passion, then, can become a way of life, but can never transform itself into living; it is a thirst that cannot be quenched in the river of matter.[16] ('I am suffering horribly', declares Gautier's d'Albert apropos a particular beauty; 'I cannot pass into it and make it pass into myself.'[17]) The great tales of passionate love are tragic in order to avoid tragedy: it is not the passion which is 'doomed' but those who feel it, for the passion itself can only survive by their death.[18] This incompatibility with life is its timelessness. For the same reason, however, passion is dramatic not because it has a plot, but because it consists of a direction, to which even the frustrations and deflections it encounters are essential.

The passion of the lover, writes Ficino, is not extinguished by the sight or touch of any body, for what he truly desires and unknowingly suffers is the splendour of God shining through the body.[19] It is a desire like that of Narcissus, that can never be satisfied. In the act of beauty I both possess and do not possess; beauty is before me but before its presence is the knowledge of a deprivation, the absence of that thing which has brought it into being for me. Hence the ecstasy and abandonment of the grand passion, and why people in love consider themselves both more fortunate and more unfortunate than anyone else.[20] The ultimate towards-this is itself present, not simply as an object but, ostensibly, as a possibility, as la vita nuova. (O pensée aboutissant à la folie!) It is all-consuming. How could it be otherwise – since that is its function? Likewise religion is not sublimated sexuality; the situation is far more commonly the reverse. But to talk of the transcending desire for beauty as a matter of sublimation at all is an error, for there is nothing aside from what beauty itself contains that is desired; though beauty cannot fulfil this desire, the notion of the fulfilment of desire being the very antithesis of the experience of beauty. Yet it is necessary to the existence of beauty that these two, desire and contemplation, should exist together, and exist in a state of tension; a tension which, historically, is 'resolved', as these pages everywhere show, only in the concept of the Absolute.[21] For the 'resolution' of the Absolute is no more than a new tension – separation and doubt.

Beauty, then, is, phenomenally, an instantaneous totality, only because of our realisation that the object of our real desire can never be such a totality, never here, now, completely, forever. Beauty is all-engrossing because it is always in the process of preventing its own disso-

lution, and so can have no referent but itself. Thus the 'beautiful object' appears as itself the object of the transcendental desire – we wish, impossibly, to be possessed by it – rather than merely as a symbol of such a desire. It is a desire for this thing, this beauty, to be, and for one's being to be thus. It is not, then, in any sense, a substitute for some real object, for it only exists because we realise that to objectify the end of the impossible desire would be to qualify and, therefore, destroy it. This end, then, could not have anything that would correspond to (fill the place of) itself, in the way that a substitute corresponds to (fills the place of) what it substitutes. This is something I cannot emphasise enough: it is not the end of the desirable impossibility, the vanishing point of all desires, which is beautiful, but rather our simultaneous consciousness of both the desirability of such a vanishing point and its impossibility.

Yet in some instances it appears possible to attain, or achieve, a beautiful object. And so it may be. But the beauty of the object is always in excess to anything that can be accomplished – this is the beauty of the object. (This appears both in the sterility of plastic phenomena and, retrospectively, when we consider those ideas which once filled our horizon, were our horizon, and yet are now no more than inert souvenirs – the very memory of which estranges us from the past.) In our attraction we are attracted beyond anything the object can render us. The lips, as Marcel discovered with Albertine, are not the eyes, nor the eyes the lips; every action qualifies the object. Lucretius went mad trying to achieve the impossible.

Earlier I alluded to the interest we presumably feel in preserving the beautiful instance as one of the possible ways in which beauty might imply action. Insofar as beauty involves pleasure, that is, a state which, by definition, we would seek to continue in, it would appear that there is an interest, and hence a potential for action, at least associated with beauty. (According to Kant we 'dwell on the contemplation of the beautiful because this contemplation strengthens and reproduces itself'.)[22] I once stayed on a tube train for several stops past my destination in order not to lose sight of a particularly beautiful nose. Insofar as doing so ran counter to my ostensible interests, it appears that it must in itself have been the expression of an interest. Though even in this case I now (almost twenty years later) have an inkling that while the perceived beautiful object was, if not the nose per se, then at most a particular woman's nose, the ground of this object was also constituted by the very idea of abandoning my ostensible interests in order not to lose sight of what I perceived as the beautiful object. This suppressed conceptual element will, I believe, be found in all

such instances. It is what gives the air of imposture to all aestheticism – in so far as its perceived object is obviously not its real object, that is, in so far as in praising it flatters itself, it pursues beauty. Whenever an action is involved, the impulse does not come from outside the beautiful instance, that is, as a response to the beautiful object; rather any action is already part of the ground of that object, and, as such, an intrinsic part of the beautiful instance.

Moreover, in the instance of beauty I am never conscious of this desire to preserve the continuance of the instance. Nor is the desire that something beautiful, but not present, should be present again actually part of the instance of beauty, for the mere thought of a beautiful object or idea is not itself necessarily beautiful. (In the case of the nose I can now recollect everything about the incident ... except the beauty of it.) By 'mere thought' I here mean that thought we have of the phenomenal conditions of the instance when we are simultaneously remembering and speculating on the future of what we remember, which is different from being so immersed in the memory that the beauty itself is the sole occupant of consciousness; this last is a new instance of beauty. By the time we have formulated the wish that the sunset should last longer the sunset is no longer beautiful; rather the consciousness of my enjoying it has become either beautiful itself (as with the nose) or even simply agreeable. This truth is obscured to some extent by those instances of beauty in which transience is, demonstrably, a necessary condition – cloud formations, rain, the smell of different seasons; 'demonstrably' because it is only necessary to imagine them becoming permanent features to realise how soon they would pall.

There are of course cases where the volitive aspect of the beautiful instance is, to reflection at least, more marked – as in, for example, reading – though, again, we may be no more conscious of this activity or of the necessity of sustaining it than we are of walking as we look, or even looking itself. Indeed it is often noted that the volitive aspect, far from appearing as an interest, tends itself to disappear – we dwell in rather than on the text; we do not look, we stare. The positing of an interest in continuance is, then, a rationalisation of beauty rather than part of our actual perception of it. That it should not be part of our perception follows from the necessary timelessness of beauty: as soon as we are able to introduce continuance as an interest we have made the beauty relative, that is, we have consciously introduced ourselves, as a finite condition, and thereby deprived the beauty of its timelessness, a quality which is essential to its existence. This timelessness is, indeed, the way we experience what reflection calls the 'disinterestedness' of beauty.

The falling down from sight to touch, the reaction to beauty, which is the impossible desire to possess beauty, to capture beauty, is simply a dream within a dream, the love of love.[23] In this sense each person continually enacts the Fall within themselves. For the soul is blood and light, deference to necessity and limitless desire, inextricably mixed, and thus the act of beauty cannot be otherwise. We cannot choose against beauty, for though the desire to embrace is intolerable, the thought of the desire to embrace is being itself. Beauty is not simply the anamnesis of the soul, not simply its history and destiny, for the very being of the soul is to be partly in time and partly in eternity, so that beauty is also a tribute to the nowness of life, the instantaneity of existence. The Golden Age, whether historical or personal, exists only in its relation to the present.

Until the light that is beauty enters the soul, writes Plotinus, the soul lies supine, cold to all, unquickened. Once awakened, however, it speeds its way elsewhere, its very nature bearing it upward.[24] Its path lies elsewhere because in the manifestation of beauty, in the beautiful, it does not possess what it seeks, that is, the becoming of beauty. The action I take can never be directly, decisively related to the beauty of the object, for if action were appropriate the object would not be beautiful. And this despite the fact that beauty is the end of every desire, or, rather, every desire is because its end is beautiful. We are never beyond beauty, for whatever that beauty is is already beyond beauty, as the beautiful, the phenomenal – which is the only way in which beauty can be. We cannot possess beauty but only be in its presence, a presence which is also a deprivation: the eye alone enjoys the beauty of the body.

7

The heavenly and vulgar Venus

My love is of a birth as rare
As 'tis for object strange and high:
It was begotten by Despair
Upon Impossibility.

Magnanimous Despair alone
Could show me so divine a thing,
Where feeble Hope could ne'er have flown
But vainly flapped its tinsel wing.

And yet I quickly might arrive
Where my extended soul is fixed,
But Fate does iron wedges drive,
And always crowds itself betwixt.

For Fate with jealous eye does see
Two perfect loves, nor lets them close:
Their union would her ruin be,
And her tyrannic power depose ...

As lines (so loves) oblique may well
Themselves in every angle greet:
But ours so truly parallel,
Though infinite, can never meet.

Therefore the love which us doth bind,
But Fate so enviously debars,
Is the conjunction of the mind,
And opposition of the stars.

Marvell, 'The Definition of Love', ll. 1–16; 25–32

No man is below or above beauty.
> Weil, 'Forms of the Implicit Love of God', in *Waiting for God*,
> pp. 137–215 (p. 165)

The continuous ardour of concupiscence, writes Ficino, impels some to music or painting, others to virtue of conduct, or the religious life, some to honour, some to money, many to the pleasures of the stomach and of Venus, with a fervour that is at once mortal and immortal; mortal because it changes its object, immortal because it is never extinguished.[1] Ficino explains the differences in choice in terms of astrology, which, in this area, seems a method no more unreliable than any other. I will make no attempt to explain these differences, for what I am concerned with here is beauty itself rather than the beautiful.

All values are ultimately rooted in beauty, in the sense that they finally rely upon what is desired for its own sake, what is absolutely, and therefore impossibly, desired. Such a vanishing point of desire is not amenable to formulation; it can appear only as an image, register its presence only as sensation. Santayana distinguishes 'aesthetic' from moral values on the grounds that while 'aesthetic judgements' are mainly positive, moral judgements are mainly negative.[2] But while it is true that morality is often a matter of power or reward through renunciation – as in the Neoplatonic tradition one renounces beauty in order to achieve Beauty – there is no such thing as a purely negative motivation, a motivation that does not ultimately aim at perfection. Even where the advantage which the precept was to bring is itself sacrificed to the observance of the precept (as, for example, with miserliness) idealism remains, may, indeed, become more obvious as such. However, to say that virtue is never its own reward would be as sophistical as saying that every human activity which bears some analogy to the behaviour of other animals is really just that behaviour in a different guise. Everything must appear as its own reward if it is to be the object of the continuous ardour of concupiscence. Everything becomes a matter of beauty, even morality, through the soul's fixing on it as a goal. This is why I have said that the ways in which the transcending desire for beauty is made manifest are not a matter of sublimation. The ardour is mortal because it may change or refine its object, may reconceive the beautiful, but it is immortal in that it is always the desire for beauty, which can only exist in the beautiful. Thus the finding of an object (thing, end) beautiful, the beauty of an object, cannot be spoken of as the displacement of a desire for something else, as sublimation, for it is a desire to bring Beauty, as the end of desire, into being in this.

Yet Ficino, though he places virtue and the religious life beside money and the pleasures of the stomach in his list of objects to which the desire for Beauty impels us, can also make a special plea for one form of this pursuit over another. For Ficino there is a true goal, a God who will complete what we are here, and consequently a falling short. He can speak of an adulterous emotion which falsely imitates the true amatory madness, a vulgar music which apes poetry, a vain superstition which apes religion, a speculation which pretends to prophecy, a lust which imitates love.[3] Exiled in the body and weighed down by the inclinations which this condition imposes, the soul neglects the treasure that is in its own heart.[4] (There is some truth in this, in so far as it is possible, for all practical purposes, to resign oneself, and consciously resign oneself – whether through presumption or despair – to what one feels to be only the relative.) Passion, for Ficino, is ruled by Necessity, is an infection of the blood caught through the eyes, and the desire for coitus, for the combining with the object of beauty through ejaculation, is the very opposite of love, or the desire for beauty.[5] This is not of course the case, except in so far as the beauty of a thing is always in excess to anything that can be achieved in the world of things, that is, in so far as Marvell's 'extended soul' is an oxymoron.

But the need to create a moral hierarchy within the experience of beauty, or even to make morality a condition of 'true beauty', is a persistent one. Ruskin, for example, writes that an 'idea of beauty' must be one that, though it inevitably begins in sensual pleasure, is accompanied by joy, then love of the object, then the perception of kindness in a superior intelligence, then thankfulness and veneration towards that intelligence itself.[6] The 'idea' cannot be obtained by any operation of the intellect, nor is it purely sensual, but depends upon a 'pure, right, and open state of the heart'.[7] There are some, he continues, who perceive the beautiful but make it merely a minister to their desires, sinking the sense of beauty to 'the servant of lust'.[8] The 'pure in heart', on the other hand, will see God.[9] Thus there are, for Ruskin, as for Ficino, 'distinctions of dignity' between pleasures of the senses, and these distinctions, which he also describes as degrees of healthiness in the perceptive faculty (thereby evoking also the aesthetics of psychoanalysis), depend ultimately upon a hierarchy which derives from the Deity.[10] But as there is always a context for specific values, an *ethos*, which creates a hierarchy, so there is, inevitably, always a God, a Beauty, behind and beyond all our means, whether piety or coition, beyond even our perceived ends.

Moreover, it is often a feature of beauty that it makes us feel edified, fills us with a sense of … something profound. This is due to the fact that,

as we have seen, our relationship to being itself becomes, in beauty, a matter of contemplation. As in many more quotidian instances when we find ourselves conscious, perhaps through contrast, of our own equanimity, we confuse our ability to consider something as an object with an ability to stand aside from it, or rise above it; we pride ourselves on resisting a temptation we do not feel. True, in beauty, we have, in one sense, risen above that Necessity which brings morality and value into existence, but we have not risen above it within the realm of Necessity itself. We are edified but not improved. We have risen above mundane considerations in the sense that, during the stasis that is beauty, we are temporarily beyond them, but what we believe is mastery is, in reality, simply detachment. It is only reflection which relates this feeling to our particular sense of values, to the God we are conscious of and profess.

So it is that special pleading is not confined to overtly theological aesthetics. Eagleton, for example, discovering the notion of taste to be present both in the bourgeois training of feeling into accord with a 'law' which henceforth no longer appears as a law, and in the 'utopian critique of the bourgeois social order', describes this ideological crisis – that either value is intrinsic and therefore 'aesthetic', or based on feeling and therefore 'aesthetic' – as an 'opportunity'; 'For what the aesthetic imitates in its very glorious futility, in its pointless self-referentiality ... is nothing less than human existence itself, which needs no rationale beyond its own self-delight, which is an end in itself and which will stoop to no external determination.'[11] And which will stoop to external determination. For to surrender to one's fate – a surrender which is what the word 'fate' signifies – is demonstrably one of the most beautiful ideas, in political terms. That humanity is intrinsically utopian is, then, no more the occasion for rejoicing than it is the reason for despair. Beauty no more holds out the promise of freedom than it does the threat of suppression; for the revolt which, as I have said, it may occasion, can as easily be against the former as the latter. As value itself beauty is neutral; it is, indeed, the space in which these conflicts of freedom and determination take place, and, as such, cannot be claimed for any side.[12] There is no place beyond it, no other realm of value, of desirability, from which it may be judged. That Eagleton should appropriate beauty to his side is, then, inevitable. All writers on the subject discover, with varying degrees of surprise, that beauty serves their cause, or is, at least, mysteriously coextensive with their ideal.[13] This can even issue in the supreme pleonasm of the beautiful being recommended for its beauty, as is the case with aestheticism. Indeed it is aestheticism that, in setting up beauty in contrast, and preference, to

morality or ideology, serves to demonstrate the absolute impossibility of such special pleading.

Pater insists that 'success in life' consists in being always present at those moments where 'some form grows perfect in hand or face; some tone on the hills or the sea is choicer than the rest; some mood of passion or insight or intellectual excitement is irresistibly real and attractive to us', that 'our one chance' (of what?) lies in always seeking 'the highest quality to your moments as they pass, and simply for those moments' sake'.[14] But this is all that anyone wants, or can want; to maintain ecstasy, to 'burn always with this hard, gem-like flame', is not a peculiar ambition – though few believe it can be achieved so directly. *Vita est longa, ars brevis.* The main, if implicit, thrust of his argument, however, relies on a contrast between beauty and ideology. Indeed his definition of the beautiful is made only by contrast with this last. Filled with a sense of the splendour and brevity of our experience, he continues, and 'gathering all we are into one desperate effort to see and touch', we shall have no time for theories, and should be rather 'forever curiously testing new opinions and counting new impressions, never acquiescing in a facile orthodoxy, of Comte, or of Hegel, or of our own'. Plainly he associates all ideology with a certain betrayal of the self, and, hence, of the beautiful *per se*. That his own argument is not the abjuration of ideology but rather the statement of an ideology is not (and cannot be) apparent to him. He proposes a 'good' and prescribes the best means of achieving it. His argument is distinctive because of the place he affords the pleasure derived from beauty in his felicific calculus, that is, at the top. What Pater is seeking to do is to assert the purity of beauty, to assert beauty: 'Not the fruit of experience, but experience itself, is the end.' But this cannot be done, for the fruit of experience is also an experience – the contrast is false. The beautiful cannot be prescribed; if it must be prescribed it is not beautiful.

Fashion too may play a part here; I adopt some way of looking at the world which comes to me from an external source and which, though for a little time it seemed to express what I was, in retrospect appeared to be half a matter of being true to myself and half a matter of lying to myself. Placing oneself inside any systematically ordered metaphysic, any style (aestheticism, for example), almost invariably requires the rationalising of some of one's sensations out of existence, and the rationalising into existence of others. While the analysis of sensation may lead to its refinement, to a change in what action arises from it, or what beliefs are held in conjunction with it, and, therefore, ultimately its actual strength, the sensation itself, as an immediate link with the world, and, perhaps more

indirectly, with ourselves, cannot be bullied or cajoled, rationalised or wished, into or out of existence, be it in the interests of coherence or poetry, without some part of that world or ourselves disappearing from view. But with retrospect comes illusion, for now I am aware only of the externality of the source, I view myself with the eyes of another. The contrast between rationalisation and desire is false, for the rationalisation itself expresses a perception of beauty; even the desire to conform is *your* desire. The metaphysic I chose, or, at least, my choosing of the metaphysic, was myself. The vanishing and reappearance of the world through the alternations of taste is not something that happens *to* the world, it *is* the world.

My intention, however, is not reductive; to say that all choice is a matter of taste is not to say that all choice is *just* a matter of taste. The extra word, and its redundancy, already contain a judgement on beauty that turns the statement into a self-contradiction. The feeling that the appeal to beauty is reductive remains only so long as one still confuses taste with what I have shown to be one of the forms of its attempted abrogation, that is, aestheticism. It is impossible to be true to the spirit of Pater's injunction and at the same time to follow it; one's only motive in making the attempt could be the desire to become like the author of the 'Conclusion' to *The Renaissance* – which was probably also Pater's motive.

A like reduction of beauty, the confusion of the very experience of beauty with aestheticism, is to be found in Kierkegaard's Judge William, a consideration of whose position (at first sight diametrically opposed to that of Pater) will help both to clarify why the dichotomy of beauty/ ideology is false and also to show that while I am not reducing everything to the beautiful neither am I stretching the sense of 'beauty' to the point of meaninglessness.[15] As the word 'aesthetic' is used throughout Kierkegaard's text I will, for convenience sake, use it in the following analysis. It is, however, to be understood as referring to that which pertains to beauty in general, rather than in its contemporary sense of that which pertains particularly to art.

With regard to the aesthetic there is, according to Judge William, no choice. So much we have already seen. But already at the beginning of his description of the aesthetic he implicitly defines it in an inconsistent manner: 'The aesthetic choice is either entirely immediate and to that extent no choice, or it loses itself in the multifarious. When a man deliberates aesthetically upon a multitude of life's problems ... he does not easily get one either/or, but a whole multiplicity.' Yet if the aesthetic is immediacy then the question of choice does not arise. Indeed this notion of the stasis

of immediacy, of life in the moment, is contained in Judge William's description of the aesthetic as that in a person 'by which he is immediately what he is'. If this is so then what he describes as the 'aesthetical life', a life in which one lives 'in and by and of and for the aesthetical', is an impossibility. For Judge William the aesthetical life encompasses almost all of the forms which the continuous ardour of concupiscence can take, including even the ethical (where it appears in the form of duty). Yet he conceives of this ardour as somehow imposed on, or at least foreign to, the individual; whenever we look at views of life which 'teach' that enjoyment is the most important thing, he writes, we always find that the conditions for this enjoyment lie outside the individual or are in the individual in such a way that they are not posited by the individual himself – wealth, glory, high station, love, the cultivation of a talent. It is a superstition, Judge William asserts, to believe that what is outside one is able to make one happy. A more refined egoism, he continues, will recognise that to live for the satisfaction of pleasure would be unsatisfying, and instead enjoys itself in enjoyment, enjoys reflectively. But still the condition requisite for enjoyment remains an outer one, not within the control of the individual, whose personality remains in its accidental immediacy, hovering above itself. And because the personality remains accidental, because the life is built upon the external and transient, and its centre lies in the periphery, 'every aesthetic view of life is despair, and everyone who lives aesthetically is in despair, whether he knows it or not'.[16]

What, then, of the alternative, the 'ethical life' which he sets up as a contrast to the aesthetical? First it must be considered in terms of its effects (indeed it may turn out that there is no other way it can be considered). If an aesthetic choice is no choice, according to Judge William, then, in contrast, choosing belongs essentially to the ethical: the ethical is 'that which makes a choice a choice'. A person who chooses only aesthetically chooses immediately and for the moment and so is free to choose something different in the next moment. But where the choice is conceived of as a choice between good and evil, the very act of choosing takes on an energy, an earnestness, a pathos: 'Thereby the personality announces its inner infinity, and thereby, in turn, the personality is consolidated ... For the choice being made with the whole inwardness of his personality, his nature is purified and he himself brought into immediate relation to the eternal Power whose omnipresence interpenetrates the whole of existence.'[17] The aesthetic, in contrast, can never, according to William, rise above a matter of mood, in which the personality is only dimly present. The person who lives aesthetically, he continues, seeks to be absorbed in

mood, to experience nothing of themselves that cannot be inflected into mood, for what is left over, that is, continuity, is disturbing. There is no absolute difference, no absolute contradiction, according to the Judge, except that between good and evil, so that for one who lives only for the aesthetic, that is, neutrality, no absolute choice, and, therefore, no freedom, is possible. The person who lives aesthetically develops by necessity, for such people can only become what they immediately are. In contrast the self as one chooses it ethically is freedom; it is that self which the person has always been aware of as an absolute in relation to everything else but which they have previously, and mistakenly, believed could be like an algebraic sign, able to signify anything; 'he who lives aesthetically sees only possibilities everywhere, they constitute for him the content of the future, whereas he who lives ethically sees tasks everywhere' – the life has continuity; it is no longer a toy but a task.

If the aesthetical is that whereby one is what one is then the ethical is that whereby one becomes what one becomes; 'in the ethical I am raised above the instant'. Ethical individuals too may experience moods but can view them from above, from that remainder or continuity which they have chosen. The distinction, then, between the aesthetical and the ethical appears to lie in an attitude to time, the way in which the attention is given to time. One cannot help feeling, however, that people impose the ethical choice on themselves precisely for the sake of this feeling of 'inner infinity', to receive themselves in their 'eternal validity', as people whose memory no lapse of time will erase. Indeed the Judge himself writes that 'nothing finite, not the whole world, can satisfy the soul of the man who feels the need of the eternal'. The question, according to the Judge, is one of under what 'determinants one would contemplate the whole of existence'. In placing these determinants in the ethical the individual receives the illusion that life is not simply a pressure from within but also a drawing forward – it is the imposition on oneself of, as it were, fate. The same circularity is to be found in the Judge's assertion that what ethical individuals accept as their task belongs to them essentially, for in this task they become aware of a responsibility towards themselves (in that what they choose will have a decisive influence on them) and in the sight of God. The ethical individual, according to Judge William, ennobles accidentality by choosing it. But does this not already place such a choice under suspicion of being aesthetic?

The ethical, according to the Judge, is always prohibitive; when it appears in the form of a positive command it already contains something of the aesthetical. Yet there must be a point at which one simply is what

one is and yet chooses the ethical. Moreover the Judge is writing specifi-
cally to urge the ethical course on another. His position is only tenable so
long as he continues to hold to an inconsistent notion of the aesthetic.
Indeed he does continue to treat the aesthetic as a matter of a view, a
theory, or an injunction, as aestheticism in Pater's sense, so that he can
contrast the ethical, which is 'consonant with reality and explains some-
thing universal', with the aesthetical, which 'propounds something acci-
dental and explains nothing', despite its being essential to the aesthetic,
even according to his own description ('immediacy'), to propound noth-
ing. It might be possible to say that he confuses the very existence of the
aesthetic with aestheticism were it not that we are all aesthetes, according
to any consistent definition of the aesthetic. This was probably what was
shocking about Pater for his contemporaries: that his is, in fact, the man-
ifesto of the average person – from this point of view the clause about art
was perhaps, for them, the redeeming one.

Rather disappointingly the Judge does make a direct appeal to the aes-
thetic: 'In choosing itself the personality chooses the ethical and absolutely
excludes the aesthetical, but, since this choice is a choice of the self, the
whole of the aesthetical comes back again in its relativity.' The aesthetic is
not lost but rather comes back in a ministering role, comes back 'transfig-
ured'. Indeed he implicitly places the ethical in a traditional aesthetic hier-
archy when he states that the 'poet-existence' is between finiteness and
infiniteness. Later he is more explicit: while the aesthetical individual
wanders like an unquiet spirit amid the ruins of a world which is lost to
them, the ethical individual 'sees beauty' all around; only the ethical indi-
vidual has a grace and decorum 'more beautiful than any other'; 'only
when one regards life ethically does it acquire beauty, truth, significance,
firm consistence'; Christianity is 'more beautiful' than the Greek view of
life, because the latter is no more immortal than the world whose temp-
tations it overcomes; the ethical is a 'higher beauty', the 'true beauty'.[18]

The ethical, then, even according to the Judge, is the completion of
the aesthetical (quod petis, hic est), affording peace, assurance, and security;
'Thus I love existence because it is beautiful and hope for an existence still
more beautiful.' The problem with the aesthetic conceived in terms of aes-
theticism is time. The ethical endures, it does not demand constant
renewal or reward, and, indeed, finds confirmation of itself in this very
lack of continuing reward. As the Judge says, if ethical individuals discover
they have been unfortunate in any specific choice they do not 'lose
courage', for their task is larger than a single choice; they know that 'the
art is not to wish but to will'. They have risen above mood, 'above' imme-

diacy.[19] The contrast with the aesthetic holds, however, only so long as beauty is seen either as a deliberately chosen option, which is impossible, or solely in terms of plastic beauty, that is, that which cannot be the object of ardour. The ethical cannot be the completion of the aesthetical unless the aesthetic is its beginning. So it is hardly a reverse when the Judge begins to fall into such tricks as recommending a course for its difficulty, thereby appealing to the external form (an aesthetic criteria) of an action. (Likewise he can say that the ethical is not a matter of fulfilling many duties but of 'intensity', and that 'aesthetical repentance' is detestable 'because it is effeminate'.) He asserts the beauty and dignity of the grocer's clerk over that of the 'hero', but even in setting up such a contrast, he undermines it, by appealing both to and against the aesthetic instead of ignoring both the attractive and the squalid – neither the grocer's clerk nor not the grocer's clerk – and concentrating only on that which he claims exists in contrast to them, that is, the ethical. (In a similar way, Pater, by insisting on the power of beauty, leaves one only with a sense of its diminution.) This is, indeed, the crudest kind of preaching, that which appeals to the very standards it appeals against; the grocer's clerk is the 'true hero', the 'truly extraordinary man is the truly ordinary man', earthly applause is nothing but God is a 'connoisseur'.[20]

The task of ethical individuals, according to the Judge, is to 'order, cultivate, temper, enkindle, repress, in short to bring about a proportionality in the soul, a harmony', that is, to make of themselves an aesthetic object 'in the sight of God'. But this God, it must be remembered, exists only in the sight of the individual.[21] If we accept the definition of beauty as 'that which has its teleology in itself', continues the Judge, then only the ethical can be considered beautiful, for only in the ethical is it the self itself towards which the self strives, and the consummation of this striving, its immanent teleology, appears to the self in every instant that it is willed. Here, in immediacy, we arrive once more at beauty; we have never moved beyond it.[22]

In asserting the aesthetic superiority of the ethical over the aesthetical, Judge William asserts the inseparability of form and content in the ethical, thereby transforming it into the beautiful. (For otherwise the ethical must appear as a separation of form and content, as the wish to do what what one does not wish to do.)[23] The Judge's standpoint is usually sharply distinguished from that of Kierkegaard himself, but it is the Judge's own motive, accompanied, however, by a consciousness of the contradictions of his position, that leads to the leap of faith, or rather, leads to the necessity of conceiving of faith in terms of a leap. As if aware

that beauty, far from being encompassed by the ethical, has in fact encompassed it, Kierkegaard moves on to the faith of Abraham, to the absolute distinction of form and content in the teleological suspension of the ethical. According to Johannes *de silentio* Abraham is prepared to commit an unethical act not out of resignation or to prove his faith in, or obedience to, God, or for the sake of the hereafter, or for any selfish motive.[24] Abraham's action arises from a faith that is beyond the ethical, and beyond explanation, it is absurd, ateleological. This striving for the absolute, the ateleological, within life could end only with the absurd. Only an action that goes against every mundane interest can rise above every mundane interest. But is this not its motive? It is the same with Lafcadio Wluiki's 'motiveless' crime; by imitating the ateleological we feel that we have risen above, escaped from, the teleological, but this imitation is made in defiance of (that is, deference to) the teleological and thus clearly betrays its teleology. Every interest is mundane. If this were not the case there would be no necessity for the concept of faith.

Judge William, like Pater, places beauty at a stage between motive and action, the former to belittle it (though, paradoxically, he appeals to it), the latter to aggrandise it (though, paradoxically, he sets it as a task) – both only succeed in misdefining it.[25] But if beauty, that is, that attraction which lies beyond my power to conceptualise or question it, determines every motive, is there no point at which a real question of choice may arise? In asserting the centrality of beauty do I not inevitably argue myself into a fatalistic form of determinism? This is not the case, for there is no point at which the question of choice might arise at which we can also say that choice is determined. This is, of course, a tautology, but our freedom lies in the very subjective feeling of freedom towards which the tautology points. Choice is always a matter of means rather than ends; the end may be obscure (the I-know-not-what), but it is our aiming towards it which creates the question of choice in the first place. The I-know-not-what is the only possible centre, and can exist (*contra* both Pater and Kierkegaard) only at the centre.[26] Two things leave us free: our ignorance (the sheer statistical impossibility of foresight), and the nature of our ultimate goal, which is unattainable. If choice, as it sometimes appears, were really a choice of goals, in any ultimate sense of 'goal', choice would be impossible for there would be no criteria for choosing.

Beauty, then, cannot be appropriated by any cause or course. We are free to choose anything except to not desire – this proviso being as much the cause of beauty as its result. I feel that I must once more stress that my intention is not reductionist, that I do not believe one can say that all

choice is just a matter of taste, and thereby assert anything about the sincerity of the choice. Such a position is only tenable if one begins from the inconsistent notion of beauty contained in Pater's aestheticism, and in the 'aesthetical life' of Judge William. What I am saying is that nothing is held up as desirable except in terms of its desirability, which is to make no claim about the relative value of the ethical, or about the reality of God. Time is always the problem, for, as religion is quick to point out, all joys evaporate, fail to measure up to anticipation, change, revert, or pass away. Religion solves the problem by postponing beatitude. If the motivation appears transparently aesthetical to one, it is because one's own beauty is served by different means, one's own beatitude lies elsewhere.

Perhaps this is the stage at which I too will reveal myself to be a moralist. (I am almost at the end of my exposition, and the time for such a gesture is drawing near.) For the difficulty of absolutely distinguishing the grounds of morality from taste gives rise to another, and perhaps more familiar, project, that is, the internal division of taste itself into a moral hierarchy. Moreover it is obvious that a great deal of what is ugly is created by the desire to bring certain kinds of beauty into the world; that beauty, for example, which is the end of greed. But to be a moralist I would have to fix the borderline between desire and greed, and this I cannot do – not here, in the abstract. Yet, as we have seen, even in those writers for whom the old alliance of beauty-truth-goodness is, at most, no more than a loose association, there is always a heavenly and a vulgar Venus, immortal longing and lust, art and its ape. For Neoplatonism this distinction is a matter of arrested development in the process that would lead to Beauty; for modern aesthetics it is a matter of what is, and what is not, properly beautiful, that is, the purity of either 'judgement' or perception itself.

An ascription of beauty, writes Kant, 'which is tinged with the slightest interest' cannot be a 'pure Judgement of taste'.[27] From the subjective side this is irrefutable, for disinterestedness is part of the very perception of beauty. But if we allow this condition to become a criterion of beauty itself, rather than the subject's experience of beauty, we become involved in a vicious circle: each instance of beauty in which an interest can be discovered ceases to qualify as an instance of beauty. As we have seen, this is not important with respect to our own experience. If introspection reveals an interest we can fall back either on a redefinition of what is the beautiful object (from 'bird's song' to 'bird singing'), or claim to have 'grown out of it', that is, to have made what several aestheticians call an 'aesthetic mistake'. Moreover, even from the viewpoint of my own theory, if it

could be demonstrated that we have mistaken the beautiful object, in so far as this positing of the beautiful in the specific object is the act of beauty itself, and part of beauty's strategy to preserve itself, such a 'mistake' is not grounds for saying that the perception was not one of beauty. For, given the abiding presence of desire in beauty, the retrospective discovery of some specific interest involved in the instance of beauty is irrelevant to whether or not it was an instance of beauty, to whether it was, or was not, a 'pure judgement'.

All perceptions of beauty are 'pure' in so far as they appear, to the subject, aconceptual and disinterested, that is, in so far as the subject attributes phenomenality to beauty. The problem that Kant discerns in the existence of 'aesthetic mistakes', and in the existence of bad taste, lies not in the purity or otherwise of the perception but in Kant's definition of 'aesthetic judgement', that is, his assumption that the perception of beauty must in some direct way reflect its actual structure. For, as we have seen, it is enough that the perception fulfil, for the subject at the moment of perception, all the conditions of beauty, for the term 'beauty' to be correctly applied, though this perception is itself the result of a process, the instance of beauty, which does not fulfil these conditions. (Indeed, every theory that begins from the premise that these conditions, while necessary, are yet insufficient, ends by emptying 'beauty' of all significance.) Whatever strikes the subject as an instance of beauty, that is, ostensibly fulfils, for that subject, the conditions characterising the sensation of beauty, is beauty.

In so far as the dynamic of desire and impossibility which the object expresses for me is objectively real, beauty is objective; it is really there. In so far as only a certain configuration – into which enter both the expressive powers of the occasion, and (their condition) the individual subject – can express this objective state of affairs, beauty occurs subjectively. Thus it is at once individual yet universal. There is nothing unique about such a situation: if I found, for example, that a certain object reminded me of my childhood I would not begin to doubt the soundness of my 'judgement' if a stranger were to tell me that it did not remind them of their own. The difference between the case of beauty and this analogy lies, of course, in beauty's appearing intrinsic to the object. This intrinsicality, however, is, as I have said before, a condition advanced by reflection rather than perception; the question of subjectivity or objectivity does not arise in the perception itself. I 'know' the object is beautiful, I do not debate the question with myself, only because I can assign no cause to my sensation other than this object, yet I am not dumbfounded if another

does not share my perception. (The cause of beauty, unlike the memory of childhood, is, as we have seen, necessarily ineffable.)

Beauty can only be constructed from the individual experience of the particular, so that it is not surprising that where a group speaks the same language of particulars their experience of the expressiveness of objects should achieve a certain uniformity.[28] Hence the uniformity of taste within historical periods, geographical areas, stages of life, sexes, classes, and so on – a uniformity which, where it is observably a matter of historical epochs, is quite naturally interpreted as proof of the stability of certain objects *qua* beautiful objects, that is, as proof of the objectivity of beauty. (This occurs especially with respect to objects the expressiveness of which appears, by virtue of their complexity, to remain correspondingly stable; beautiful art.) The differences between positing such an intersubjective continuity and positing the existence of objectively beautiful objects are, however, decisive. For what could be inferred from such an objectivity, principally, that is, the notion of right and wrong perceptions of beauty, the *a priori* beautiful, cannot be inferred from the loose, historically conditioned, parallelism between subject and object that such intersubjective continuity implies.

It is because our experience of the particular is the medium in which our beauties are grounded that the discovery of a shared taste, especially a minority taste, will create a quite sudden sense of intimacy between two people who might otherwise know nothing of each other. For the same reason, where the question of the objectivity or purity of perception becomes crucial is not in relation to our own experience, nor yet in relation to what others find beautiful but which is a matter of indifference to us, but rather in relation to bad taste. For that other's beauty in which we can, by virtue of detachment, discern an interest appears to us as something not simply 'not to our taste' but, on the contrary, as a misappropriation of 'beauty', as something positively taste*less*.

We have already met with hierarchies of beauty in the religious sphere. This is the legacy of Neoplatonism, which is separated from its source by the incurable sensuality of Socrates. For, while in Plotinus and his successors, that is, the whole of the European tradition of writing on beauty up to that point when religion was no longer considered admissible evidence, the way to Beauty lies around plastic beauty, beyond form as form, in Socrates the way lies ineluctably *through*. For Socrates – who could not remember a time when he was not in love with one of time's products – the way to perfection is not so much a ladder as a telescope.[29] Nevertheless, all subsequent hierarchies of beauty, and all theories of taste, have divided beauty into two fundamental categories – *caritas* and *cupiditas*:

the ascending, autonomous (spiritual) love of the timeless, and the descending, fleshly love of the temporal; a desire, as admiration, for what is essential, and a desire, as greed, for what is accidental.[30] Thus, even in modern times, the discernment of true beauty requires rare intellectual talents (Schopenhauer) or special training (the majority of modern aestheticians); its gentle voice creeps only into the most awakened souls (Nietzsche); joy may be its vulgar ornament but melancholy is its true spouse (Baudelaire).[31]

Because the kinds of phenomenon which are beautiful to us necessarily depend upon the language of particulars that we speak, our beauty is always bound up with the 'meaning of life', with what we hold to be the good and bad, the desirable and undesirable of existence. Hence the effect of education/time, as the delineation of the possible, on taste. 'What we like', says Ruskin, 'determines what we *are*, and is the sign of what we are; and to teach taste is inevitable to form character', for, though people may do what is right they are only in a 'right moral state' when they have come to like doing it: '[The] entire object of true education is to make people not merely *do* the right things, but *enjoy* the right things – not merely industrious, but to love industry – not merely learned, but to love knowledge – not merely pure, but to love purity – not merely just, but to hunger and thirst after justice.'[32] Yet the nature of the connection between morality and beauty is misunderstood. We look to beauty as the expression or revelation of our particular values, or as universally explicable in terms of them, despite the overwhelming evidence against a direct causal link between beauty and any particular morality. For, though what is expressed by beauty is universal, and intimately connected with an emotional sense of the world, this sense is one which transcends (or, it might equally be said, does not come up to) any particular morality or attitude, one in which particular values, the gods we profess, are involved not as an immutable essence but as a contingent medium. (So much, indeed, is fundamental to every phenomenological characterisation of beauty, to every distinction between the agreeable or desirable and the beautiful.) The intersubjective continuity mentioned above nevertheless leads us to believe that beauty *per se* is an expression of our deepest values, and hence encourages us to create hierarchies of beauty, to reify objects of good and bad taste. The notion of vitiated taste, and, even more so, the 'tasteless object', allows us to posit our experience of beauty as qualitatively different from those experiences that are, *to us*, obviously grounded in some limited interest, despite the fact that, since our values are simply the medium, there is no reason to presume that the beauty which is

expressed through them is qualitatively different from the beauty that is expressed through a different, even antithetical, set of values.

The notion of a hierarchy within beauty – difficult to illustrate let alone demonstrate – where the fundamental division lies between form and not-form, as in the religious equation, does, however, appear to find support once we begin to confuse the beautiful with that range of effects that can come under the heading of the aesthetic. For with art we have a more or less definite class of enduring objects, and the aesthetic itself, whether interpreted as the essence of art, the standard of artistic merit, or, more generally, the source of any affective interest, obviously admits not only of degrees in terms of the pleasure it gives the individual, but even negative evaluations. This is in contrast to beauty itself, which either is or is not, and the absence of which from an object is signalled by nothing in particular unless we were previously expecting that object to be beautiful.

Far from being a stimulus to repose, beauty is always an inspiration. We choose even to languish. But this is the realm of response to beauty (not an object but itself a response) and here, whatever is done cannot be retrospectively used to characterise the initial response of beauty itself. For, obviously, to be inspired to an action by my feeling about an object does not justify my calling that object the action's 'cause', or the action itself the object's 'effect'. Beauty is a powerful stimulus and though it only rarely appears in an object in such a way as seemingly to invite a course of action, whenever the subject does so experience it, action, as we saw in Chapter 6, will follow. The problem that action reveals, however, a problem which is intuited in the very experience of beauty, and one which gives rise to the notion of 'disinterest', is that beauty (as sensation) is a powerful stimulus but one with no appropriate response. (And this even when the response takes place within the apparent realm of the particular beauty – the individual is loved, the moral precept followed, the art studied, the landscape inhabited.) Beauty and desire, as we have seen, are not mutually exclusive events, they are merely ultimately incompatible in fact; the action always falls short, leaving beauty unassimilated, intact.

8
Aesthetics (in parenthesis)

There is no science of the beautiful, but only a Critique.
Kant, *Critique of Aesthetic Judgement*, §44, p. 165

In the event of the publication of this work it will undoubtedly be labelled a work on aesthetics. Before concluding, then, it would be appropriate to enlarge on what was said in the preface about the potential confusion such a classification might lead to, and thereby to justify the conspicuous absence of the very term 'aesthetic' from the preceding pages.

Beauty has passed into the guardianship of aesthetics, and, consequently, beauty has passed away; the word itself appears only as a rhetorical flourish occasionally made by aestheticians in unguarded moments. So much is obvious. What is perhaps less obvious is that some of the most fundamental problems of aesthetics (not least the definition of its eponymous hero) remain fundamentally confused by virtue of beauty's unquiet spirit. Yet it is not my purpose to define 'aesthetic' (property? attitude? experience?) here; if I can show that it is most commonly used in a way, or in ways, that preclude its identification with 'beauty', albeit that this last still lingers at the spot, then I will consider, this being a book on beauty, my obligation to the question is fulfilled.

Beauty and art

Why will this book be shelved under aesthetics? Every dictionary and every dictionary of critical terms begins its definition of 'aesthetics' with 'the study of the beautiful'. Whether this is a historical note, a piece of mischief, or plain ignorance is not clear, but all invariably proceed to expand on their initial definition by retracting it and replacing it with the

93

more demonstrable one that aesthetics is the branch of philosophy concerned with defining the nature of art and the grounds of its evaluation.[1] Philosophical dictionaries in general tend to fare much better, as they should, in defining the scope of modern aesthetics, though none I have looked at is clear as to where the break between the study of a very particular kind of sensation (beauty) became the study of that whole constellation of feelings which may be evoked by art; perhaps because modern aesthetics is not itself clear about this. After all, Kant's third critique, hitherto one of the central reference points in aesthetics, is principally a book about beauty, and only incidentally and intermittently a work on 'aesthetics' in this modern sense.[2]

This historical development has often been viewed as marking a shift away from concern with beauty as the artistic merit. The ground we have so far covered should make it obvious that this is not the case; beauty has always been one of the three transcendentals, art only a possible source.[3] So that beauty, far from being preserved by a certain attitude to art (or even a certain kind of art), only began to decline through becoming too closely associated with art.

Indeed beauty was long felt to be a burden to art theory even before it was finally all but excluded by that theory in the present century; Tolstoy, for example, had written that we will never come to understand the meaning of art until we cease to consider its aim to be beauty.[4] The association of art and beauty seems, in retrospect, and despite the fact that the inclusion of this particular chapter in this book is unremarkable enough, to have been simply an interlude. (It is almost half a century since Maritain prefaced his remarks on beauty and art with the acknowledgement that the association was 'old-fashioned'.)[5] Plutarch, in a period which saw, paradoxically, the birth of the author, appears to have been the first to associate the two (by dissociating what was once Fine Art from craft) in the word kallitechnia – the art of making beautiful things.[6] The hint was not, however, picked up and when Alberti, in the sixteenth century, defined the goal of art as the creation of beauty, he was declaring quite a novel standpoint.[7] Today, of course, this notion is obsolete, though some still find an incongruity between what comes to them as art and is yet not only not beautiful but even painful to the eye, or ear, or soul; the layperson echoes the experts' hierarchies with a distinction between 'real' and 'phony' art. However, even in the period in which beauty was deemed the essence of art and which seemed, if only in retrospect, to embody this conviction in its art, the theory of art was ambiguous as to the precise connection. Even Alberti writes that art moves the mind to laughter, weeping,

and sorrow – none of which seems particularly essential to beauty.[8] Cardona, in the same century, described *subtilitas* as a higher goal than beauty in art – a distinctly 'modern' notion.[9] Ruskin, though eloquent on beauty, nevertheless writes that the great school of art introduces only as much beauty as is consistent with the truth, and that when truth is sacrificed to beauty, and thereby deprived of its proper foil, the result is false art.[10]

This view of beauty as an ornament or an elaboration, a form of the aesthetic that can hit or miss – a view which is close to the common modern identification of beauty with a refined prettiness – reveals Ruskin's kinship with the aesthetes of the late nineteenth century: his estimate of the value of beauty is not so (deliberately) exalted, but his notion that beauty is a certain form that leaves us free to approve or disapprove, that beauty can be a matter of choice, is also, as we saw in the last chapter, the essential, if overtly denied, premise of aestheticism. Yet, so pervasive has this restricted notion of beauty become, it is now impossible to use the phrase 'beauty in art' without invoking the shade of aestheticism – albeit that there is no necessary connection between the tenets of aestheticism, or 'art for art's sake', such as they are, and the practice of aestheticism as exemplified by the likes of Baudelaire, Verlaine, Pater, or Wilde. The connection between the two, aside from the irrelevant consideration that it is an historical fact, is purely one of temperament.[11] Yet because of their theoretical emphasis upon 'beauty', their self-proclaimed monopoly over the concept, the word itself has become tinged with the atmosphere of the work associated with them, that is, it almost inevitably brings with it the suggestion of something elaborate, artificial, overblown, decadent perhaps, almost morbid.

If, however, we do turn to that age in which beauty and art seem, within aesthetics, inseparable, we discover that already beauty must be either divided within itself or made essentially a property of art. One way of dividing beauty within itself is to set up such hierarchies of beauty as we have already considered, but hierarchies in which art must necessarily occupy the highest place. Thus according to Schelling while the 'science of art' is usually concerned only with beautiful appearances, he himself is concerned with a more 'sacred' art, that art which is the tool of the gods, a proclaimer of divine mysteries, the unveiler of the ideas, the site of 'that unborn beauty whose undesecrated radiance only dwells in and illuminates purer souls, and whose form is just as concealed and inaccessible to the sensual eye as is the truth corresponding to it'.[12] In the philosophy of art, he continues, we attain to an intuition of eternal beauty and the archetypes of all that is beautiful.[13] Even when art was seen as the record or dif-

95

ferentiation of natural beauty, the obvious inadequacy of strictly mimetic theories of art led theorists to assert that the beauty of art was a development or completion of the rough sketches to be found beyond it. Knight, for example, writes that 'we soon discover that no natural object possesses Beauty except in fragment; and in consequence of this the mind is sent onward [towards Art] in quest of the ideal'.[14]

However, since artistic success is a matter of degrees and beauty is indivisible (hence the impulse to disqualify completely some ascriptions of it), if beauty is going to be either the measure of artistic merit, or even part of the definition of art, it soon becomes necessary to redefine 'beauty'. Thus Fry reports that in his youth all aesthetics had 'revolved with wearisome persistence' around a search for the criteria of beauty, a search which produced only either a 'tangle of contradictions' or 'metaphysical ideas so vague as to be inapplicable to any concrete cases'.[15] The liberation, he continues, came through a realisation that this was the result of a confusion between two distinct uses of 'beauty', that what the word meant in connection with art was quite different from what it meant in connection with women, sunsets, or horses.[16] Thus Collingwood, in rescuing 'the aesthetic' from beauty, writes that the beautiful is that which arouses some emotion or satisfies some desire; for Collingwood a 'beautiful woman' is a sexually desirable one, a 'beautiful day' is one that has the weather we need for some purpose, a 'beautiful sunset' one that arouses in us certain notions we find pleasant: 'The word 'beauty' wherever and however it is used, connotes that in things by virtue of which we love them, admire then, or desire them'; the 'aesthetic', in contrast, does not have this reference to use!'[17] Collingwood thus simply appropriates the traditional definition of 'beauty' and makes it apply to 'aesthetic' by asserting that it does not belong to 'beauty'.[18] This is, however, an extreme case, far more often this generation of aestheticians would rather claim that what they are talking about when they talk about 'aesthetic value' is really 'beauty' but that sloppy use of the latter has rendered it too imprecise. (Both Croce and Bell do just this – consciously renaming what they believe was once called 'beauty' *expression* and *significant form* respectively.)[19] A similar, possibly nostalgic, instinct accounts for the periodic, yet localised eruptions of the word in contemporary aesthetics.

However, simply appropriating the definition of beauty, and renaming it for use in connection with art, still leaves the problem of nature. For if it really is beauty that is now going by the name of 'aesthetic' or 'aesthetically valuable', yet these other names are those which must exhaust (under the title of aesthetics) the definition of 'art', how can beauty be

withdrawn from nature except, as with Collingwood, quite arbitrarily? For Hegel artistic beauty 'stands *higher*' than that of nature because it is 'born again' of the mind, which mind alone is capable of truth and, therefore, of creating the really and truly beautiful.[20] Croce allows, or appears to allow, beauty to remain a property of art but only by a similar manoeuvre; 'natural beauty', he writes, is only purely aesthetic when we neglect its actual and historical reality in favour of its pure appearance, when we look at it with the eye of an artist, for otherwise man faced with natural beauty is simply Narcissus at the pool.[21] The difference for Croce, then, is that we think the beauty of nature is real, though it is self-created, whereas the intentionality of art 'supplies an aid that is more ductile and efficacious' for the existence of beauty.[22] Why this should mean a qualitative difference in what is experienced by the beholder, that is, why the perception of beauty in nature alone is narcissistic, he does not make clear. What is clear is that a hierarchy of nature/art is created; likewise with Newton, who, though he describes the beauty of art as an extraction and clarification of the beautiful patterns existing in nature, evidently believes that this process of extraction and clarification somehow results in a 'higher' (purer? more beautiful?) beauty.[23] According to Newton art is far more complicated in structure than nature: nature presents a limitless but 'two-dimensional' area while art is varied by intention, points of view, comments, boredoms, preferences, all of which provide a greater complexity and therefore a higher degree of beauty.[24] (This despite the fact that, according to his own theory, the greater the contribution of elements resting on association, as opposed to pure form, the 'lower' the type of beauty.) Like nature, he concludes, art is beautiful because it obeys a law, but in this case the law is the artist's sense of order and harmony' – a source which must 'remain a mystery'.[25]

One alternative to considering the beauty of either art or nature as mimetic is to posit nature as art, that is, to admit that nature itself is exponible, or at least interpretable.[26] Nature can of course be interpreted in precisely the same way as art, but a realisation of the createdness of natural aesthetic merit diminishes, in practice, not only the usefulness of nature as a refuge from artificiality (a fabulous metaphysical homeland standing beyond, and thus redeeming, the limited self), but also the idea of art as statement, that is, the idea of being taught by art; for, unless we opt for the Neoplatonic line, it reveals that such knowledge is self-engendered.[27] The beauty of nature does, of course, rest on expressiveness, and, therefore, concepts, just as much as the potential beauty of art. They are the same beauty. The problem here is no problem for the theory of beauty

itself; it is only a problem for that aesthetics which wants to commandeer the 'disinterest' of beauty and yet is obliged by its subject matter to admit a conceptual element.

The meaning of 'beauty' has, then, been principally eroded by aesthetics where it has sought to appropriate aspects of the traditional definition yet combine them with incompatible qualities taken from the experience of art (the situation being further confused by the fact that art, like anything else, can be beautiful, and valued in virtue of just this beauty). Thus Croce, in seeking to identify aesthetic value, expels from consideration such 'psychological' concepts as tragic, comic, sublime, pathetic, attractive, elegiac, idyllic, and so on, because they are 'external to the aesthetic fact, to which is linked only the feeling of aesthetic value and disvalue, of the beautiful and the ugly'.[28] Lorand too, though starting from the viewpoint that, since art exists for our sake, it must answer a need, seeks to identify aesthetic value with an explicitly Kantian definition of beauty.[29] Free beauty, she argues, and pure judgements of taste (in a Kantian sense) cover only part of aesthetic experience, 'and not necessarily the significant part'. Representational art, for example, always involves the concept of the thing represented, that is, something external to the work. Yet Kant speaks of art as a 'beautiful representation', and not just the representation of something beautiful, so that whatever characterises beauty (non-conceptuality, disinterestedness) must also belong, in some way, to art. If we concentrate on the notion of 'purity', according to Lorand, we unrealistically divorce art from experience; if we concentrate on its connection with experience we are 'forced to abandon originality and uniqueness in art, as the object is reduced to previous concepts'. If, then, we take the connection to life as self-evident, in what sense, she asks, can we nevertheless say, as seems justifiable, that aesthetic values are 'pure'? Her answer is that, first, every value (moral, economic, aesthetic) is pure if it is irreducible to another set of values; secondly, even if every evaluation is governed by certain conditions, this is not the same as being governed by rules, since the former may be unique to a single case, while the latter must be general and universally applicable. This distinction preserves the traditional meaning of 'pure' as characterising a judgement that is autonomous and cannot be determined *a priori*, while allowing that this judgement can also be determined by experience external to the work: 'Being affected by beliefs and conventions is not the same as being consistently governed by rules [that could be generalised].' The aesthetic judgement, she continues, is also pure in the sense that it is a judgement of this unique object as a unique object, though in order to experience

anything as unique, a previous familiarity with its components is required. Thus while the value is a product of the object's unique structure, we experience this structure only in a continuum of similarities, that is, as Art.

This argument establishes a parallel between one kind of evaluation of art (and morality and economics) and the experience of beauty, but in no way establishes an identity of the sensation accompanying that evaluation and that experience. Indeed the parameters of evaluation Lorand assumes to apply to art are quite inimical to beauty. She uses 'beautiful' as synonymous with 'expressive of ... ', and makes 'boring' its antonym, also asserting that training and frequent listening are necessary to 'be able to evaluate' a piece of music, thereby abandoning the identification of aesthetic value (however conceived) and beauty; since whether a thing is beautiful or not is, if the word is to have any distinct meaning even as a species of liking, something I can confirm, no matter what my acquaintance with the object, only by reference to my own feelings.[30] To say 'I found it beautiful but I'm probably wrong since this is the first time I heard/saw/read it' is nonsense. And if I find a piece beautiful and the experts do not, do I strive to not find it beautiful, or if they do and I do not, do my feelings defer to their 'judgement'?

The desire to keep the autonomy of the perception of beauty within aesthetics, even while everywhere denying its autonomy, arises here, as elsewhere, from the desire that the grounds of evaluation in art should not be reduced to previous concepts, despite the fact that everything is, presumably, so reducible or else ineffable. Why such a desire exists in connection with art is something I shall turn to shortly. For the moment, however, it is only necessary to note that this is the problem which dogs every attempt to identify artistic value with beauty; we can point to the conditions, in either the object or the beholder, governing the reception of art but not to those governing the perception of beauty in general.

Before turning to an explanation of why aesthetics has sought to keep aesthetic value autonomous, after the manner of beauty, even when that value is not posited as like beauty in any other respect, let us look at how 'the aesthetic' itself has been characterised. For here we see that while some of the traditional attributes of beauty are posited as attributes of our experience of art, this latter experience is rarely described in a way that is compatible with the experience of beauty. According to Fry, for example, an art object, that is, an object of any kind created not for use but rather to subserve 'the imaginative life' must be 'adapted to that disinterested intensity of contemplation' which cuts off responsive action and is the

characteristic of the 'aesthetic attitude'.[31] That is, it must have 'order' and 'variety', and (in contrast to nature) it must make us conscious of a purpose to the extent that we sympathise with its creator:

> The perception of purposeful order and variety in an object gives us the feeling which we express by saying that it is beautiful, but when by means of sensations our emotions are aroused we demand purposeful order and variety in them also, and if this can only be brought about by the sacrifice of sensual beauty we willingly overlook its absence.[32]

There are, says Fry, two distinct uses of the word 'beauty' – 'one for that which has sensuous charm, and one for the aesthetic approval of works of imaginative art', one which refers to 'only the perceptual aspect' of the imagination, and one which refers to the 'appropriateness and intensity of the emotions aroused', the delight we feel at their fitness to the needs of the imaginative life. A great deal of confusion would, of course, be saved if he simply referred to the latter as, for example, 'aesthetic merit' rather than 'beauty'. Also he would not then find it necessary, as aesthetics so often has since the eighteenth century, to disparage beauty itself.

Beardsley too describes the 'aesthetic object' as the occasion not of beauty but rather of a 'concentration of experience'.[33] The aesthetic experience, he asserts, is one in which 'attention is firmly fixed upon heterogeneous but interrelated components of a phenomenally objective field', differing from daydreaming or fancy in having a 'central focus; the eye is kept on the object and the object controls the experience'. This experience is one 'of some intensity' in which 'the emotion is characteristically bound to its object, the phenomenal field itself – we feel sad *about* the characters'. The pleasure that attends it may not be comparable in intensity to that we feel in the satisfaction of ordinary appetites but it is more exclusive; 'the concentration of the experience can shut out all the negative responses ... that so often clutter up our pleasures'. It is an experience, according to Beardsley, that is 'unusually complete in itself', which is to say that, the impulses and expectations aroused by elements within the experience are felt to be counterbalanced or resolved by other elements within the experience, so that 'some degree of equilibrium or finality is achieved and enjoyed'. Aesthetic objects are, then, objects *manqués*, make-believe, 'and upon this depends their capacity to call forth from us the kind of admiring contemplation, without any necessary commitment to practical action, that is characteristic of aesthetic experience'. Aesthetic experiences, he concludes, may differ from one another in point of unity (coherence or completeness), intensity, or complexity, and 'aes-

thetic magnitude' (value) is a function of these qualities. This is, self-evidently, a description not of perceiving beauty but, quite properly, as befits its subject matter, of being entertained.

Indeed one way to define 'aesthetic' that would be true to a large proportion of its current usage would be as any emotion/interest aroused in the absence of a pragmatic goal[34] (pity and helpless terror, though not sentimentality, being excluded on the grounds that they would issue in action if they could). If we wish to restrict the use of 'aesthetic' to art this definition can be extended to those emotions or that interest felt in the presence of, and in some way referable to, an object either created for that purpose or customarily used for that purpose. 'Aesthetic properties' would then denote those properties potentially capable of arousing such emotions or disinterested interest, and 'aesthetic value' the measure of the intensity or exclusiveness of the emotion/interest aroused, or, according to a different standard, what we believe to be the effect on the perceiver of entertaining the kind of emotion/interest aroused, that is, the way in which it modifies, or the degree to which it modifies, perception. Such is the informal use of the word 'aesthetic', though its boundaries are always shifting to exclude whatever comes under the speaker's personal notion of 'bad taste'. Nevertheless the main business of aesthetics is still, indubitably, to define 'aesthetic', and here, where precision becomes important, the question of properties, object, or attitude (and what kinds, and their relationship to art) becomes hopelessly tangled.

Indeed, while an uncritical use of the term is enjoying a certain vogue at the moment in other disciplines (notably in literary theory), within aesthetics itself the use of 'aesthetic' to refer to either a stable set of objective properties or a specific mental state, such as is implied by that uncritical use, is becoming more and more rare.[35] The veteran aesthetician Joseph Margolis, for example, has recently written that he finds 'no benefit at all in the technical use of the term "aesthetic" in any of its combinations', and would recommend its complete dismissal.[36]

The aesthetic?

Definitions of 'aesthetic' have tended to follow the same patterns as those of beauty – formalist, cognitive, psychological – and have fallen to the same objections. If we are restricting 'aesthetic' to art then the formalist option becomes even more problematic than it was with beauty, while the psychological ('aesthetic attitude') has, aside from the problems already mentioned in connection with 'disinterested contemplation' (Chapter 5),

the further problem of needing to transform itself into some kind of formalism in order to explain why this state should be evoked only by a certain class of objects.[37] One advantage that the 'aesthetic attitude' theory does, however, enjoy in connection with art that it does not enjoy in connection with beauty is just this — that art is a class of objects. So that the question of why this (involuntary and deliberate, disinterested and active) form of attention occurs receives a simple answer, that is, that we attend to art in this way because it is art. If we had hoped (as aesthetics often has) that 'aesthetic' would help us to define 'art' better then the circularity of such explanations is, on the face of it, alarming. Moreover, even if it is the frame which compels us to approach the space in a particular way, the notion that this frame removes all questions of function, consequence, and reference, in short, all meaning, is difficult to sustain.[38] Life, after all, is not an option, not something that can be excluded. Every frame is also the boundary of an inset, is, necessarily, the outline of what is not the work.

Thus we come to the most common implicit definition of 'aesthetic', that is, that the word refers to either an object or a process of some cognitive significance; a process which, though it contains a great part of emotion or intuition, is not identifiable with either of them. (Gide, for example, defines the work of art as 'the exaggeration of an idea'.[39]) This line of thought has been forced on aesthetics, as the philosophy of art, not only by the obvious internal weaknesses of those formalistic arguments (borrowed from the theory of beauty) which rely on the notion of autonomous aesthetic values, but also, perhaps principally, by changes in art itself. What, after all, would Winckelmann have made of Yves Klein's *Le Vide*, or Hanslick of John Cage's 4′33″? (This is not to say that art has, in some way, ceased to be aesthetic but rather that so long as it kept within certain parameters the definition of what it was had merely to run alongside and could thus remain, in one sense, arbitrary.[40]) 'We cannot appeal to aesthetic considerations', writes Danto, 'in order to get our definition of art, inasmuch as we need the definition of art in order to identify the sorts of aesthetic responses appropriate to works of art in contrast to mere things.'[41] This leads us, naturally, to that definition of 'art', and by implication 'aesthetic', which, of all aesthetic theories, most rigorously excludes the concept of beauty, that is, the 'institutional' definition. A work of art, writes Dickie, is 'an artefact … upon which some person or persons acting on behalf of a certain institution (the artworld) have conferred the status of candidate for appreciation'.[42] This makes art, then, a matter of the conscious interpretation of artefacts, so that, aside from artificiality, and perhaps not even aside from this, there need be no property

of the object nor, more importantly, of our response to it, that is *a priori* a limiting condition on the use of the word 'art' or the subject matter of aesthetics. For the notion of the rule of interpretation, and in particular the symbol, a magical thing which allows the interpreter to go from anywhere to anywhere else at will, reduces the object of interpretation to a cipher – any variable in the appropriate place (the gallery, museum, literary magazine, and so on) will serve.

The artwork is, then, as Danto has asserted, principally a statement, a statement which presupposes 'a body of sayers and interpreters'; 'There is no art without those who speak the language of the artworld.'[43] The difference between an artwork and a thing is that the artwork is subject to an interpretation, not by virtue of any intrinsic properties but because ... it is subject to interpretation. Thus Danto can go on to talk of art, through its analytical concern with the relationship between the world and its representation, transforming itself into philosophy. What is interesting is how this 'institutional' account, despite its ostensible radicalness, explains many features of the common sense, or unexamined, attitude to art: the (from an 'aesthetic' point of view?) totally unreasonable attitude towards fakes and the work of chimpanzees; the fetishistic attitude towards the artist; how even the repellent, monotonous, and banal can all be the object of artistic 'consumption' providing they can be, or have been, explained as the 'surface' of an idea about repellence, monotony, and banality, and so on. Indeed Danto's position is the logical outcome of the general trend of artistic theory and its emphasis on 'expressiveness' since the end of the eighteenth century. When, in 1972, the German *artist*, Joseph Beuys, gave a lecture on his political views as his contribution to an exhibition at the Tate Gallery, he was similarly within, if not the tradition of western art objects, then at least that tradition as described by western art theory.

What is called 'art' today? What is called 'art' today. The question is also the answer. It is for this reason that the contemporary discourse of art can often be such a dull subject – at least when it deals with generalities, that is, its fundamental subject matter.[44]

Eco, reflecting on this trend, in criticism and theory at least, for art to become its own subject matter asks himself if 'aesthetic pleasure has gradually changed from the emotional and intuitive reaction it once was to a much more intellectual sort of appreciation', from concern with beauty to concern with poetics.[45] But that art was ever conceived of, particularly by those who had care of its definition, in terms of intuitive reaction (in an absolute sense) is, at best, not proven. What is more interesting about Eco's assumption is that he describes such a change in an essay devoted to

103

the 'death' of art, that is, he describes the process taking place within art. Only those with the courage of common sense (a courage born of freedom from the restraints of reasoned argument) can, when faced with a piece of x they do not like, simply assert that it is 'not art'.

Nevertheless there is something decidedly counter-intuitive about the institutional definition of art. There must, we feel, be some minimum of essential qualities in either the object or its perception, some aesthetic degree zero, which serve as the artworld's criteria for electing an object to be art, or at least a continuity in the criteria that have hitherto been applied in such elections. Art, after all, does not seem so heterogeneous. Eaton has advanced a variation or extension of the institutional theory which, by removing the suggestion of arbitrary judgement, makes that theory appear more reasonable. Something is a work of art, she writes, if and only if it is an artefact, 'treated in ways that bring an audience to attend and reflect upon' those properties of the object that are 'identified as aesthetic properties within a particular cultural tradition':[46]

> A is an aesthetic property of a work, W, in a culture, C, if and only if A is an intrinsic property of W and A is considered worthy of attention in C, that is, in C it is generally believed that attending to A (perceiving and/or reflecting upon A) will reward attention.[47]

This reward, continues Eaton, may be simple sensuous pleasure, interesting but trivial information, the feeling that one's life has been changed, bonding with other members of the community, and so on. Being a work of art, then, is a relative concept; the same object may be a work of art at some times and in some places but not in others, depending on whether it is discussed in terms of its aesthetic properties or not: 'Whatever directs attention to intrinsic features aesthetically valued is aesthetically relevant.'[48] Almost any fact or question, or even poor interpretation, may serve to draw us to the work and prompt the 'intense, singleminded, and highly focused perception and thought' that characterise aesthetic attention. Thus any piece of extrinsic information can be defined as necessary to aesthetic appreciation if knowledge of it is indispensable to the perception of an intrinsic fact about the object, and this intrinsic fact is necessary for aesthetic appreciation. But 'aesthetic', according to Eaton, does not simply mean an intrinsic property; it must also be a property that is valued within a particular cultural tradition. There is no reason, she continues, to rule out any kind of value (formalistic, emotional, economic, political, and so on) so long as it is attached to the work by virtue of a focusing on 'intrinsic properties traditionally identified as worthy of

attention within a particular culture'.[49] The better the art, she concludes, the more it repays sustained attention, the more various the rewards it gives, and the more likely it is to stand the test of time.

Nevertheless Eaton does lean towards ineffable formalism (beauty's legacy), as she must having made 'intrinsic' a key but unexamined term in her definition. What is relevant to the object, she says, is what leads back to the object. But the object as what? Line, form, statement? What is intrinsic to an object depends on the definition of the object, and this we still do not have, at least not over and above the original definition of art as the product of the artworld's interpretation of artefacts. Of course, if 'aesthetic' depends on the temporal and cultural context this is not a question she needs to resolve. Such a reduction, however, appears to rob 'aesthetic' and therefore 'intrinsic', as she uses it here, of any definite content. For what is intrinsic or relevant is, notoriously, a function of what is 'aesthetic', and it is the definition of this last, depending in turn upon the definition of 'art', which is the issue.[50]

In fact, of course, some definition of 'art' must be at work every time an example comes into being. Moreover, if one wants to avoid linguistic solipsism ('It's not what I call art'), this definition must be, for each person, descriptive rather than evaluative, that is, it must be a variation on the institutional definition.

The institutional definition, then, appears to avoid the difficulties of history (what art has been or will become) and taste by making the concept ('art' is a status) independent of the criteria that determine its application to specific cases. The strange feature of such a theory, as Ludeking points out, is that, in detaching the meaning of the concept 'art' from particular criteria, it would not allow us to make a decision about whether something is or is not art in a particular case, particularly if the object in question is presented as art but not yet generally accepted as art![51] Ludeking goes on to argue that we do, in fact, use normative, descriptive criteria to decide if a thing is an artwork, though these criteria change over time, and are not determined by some eternal essence. (That is, art is not merely a certain space constantly filled anew by different forms conforming to its shape, but rather a space the very limits of which are constantly shifting.) The criteria for the use of 'art', and hence 'aesthetic', may, then, change from case to case, and different people may use different criteria for the same case, so that the general meaning of 'art' is indeed independent of all these floating criteria, though it would never be used in any particular case without the employment of some of them: '[The] class of artworks has to be understood as an unintended and

unforeseeable overall result of all the divergent and conflicting applications of the concept of art by all the different speakers who all use different normative criteria.'[52] That the resulting class of objects called 'art' is not more heterogeneous is best explained by recourse to Levinson's account of one of the necessarily limiting conditions of such criteria. According to Levinson art is bound together by an 'internal historicism'. To be art is to be an object connected in a particular manner, through the intention of the maker or profferer, with preceding art or art-regards; 'the agent in question intends the object for regard (treatment, assessment, reception, doing with) in some way or ways that what are acknowledged as already artworks, are or were correctly regarded or done with'.[53] The one necessary feature of art, he concludes, is its intentional invocation of preceding art, and the reception of that art.[54]

There is, however, every reason why the institutional definition should at least strike us as counter-intuitive when we come to think of 'aesthetic properties'. For each of us does have normative criteria for recognising what is art. Moreover, if we value certain kinds of art it is almost inevitable that our paradigm for the aesthetic, as what justifies art's existence, should merge with these normative criteria, thereby making 'art' an evaluative term. But to say that there is an aesthetic essence, that is, a quality which appears to define 'art' or is a measure of its value, now or for me, is not to say that there is an aesthetic essence *per se*. Indeed, this is precisely the difficulty in aesthetics: 'aesthetic' has several current yet, if normative, incompatible meanings. The institutional definition leads, naturally, to sighs of relief all round. But its function is only provisional. It is, as it were, a safety measure against future contingencies – most particularly that one's aesthetic theory should be disproved by a new instance of art.[55] But it should not be allowed to do what it appears to do, that is invalidate *a priori* every aesthetic theory, to become an excuse not to theorise. It would still be useful to know why everything up to now that has been called 'art' has been so called, no matter how loose a ragbag of philosophy, psychology, and sociology might be involved. Moreover new instances need not necessarily modify such a theory let alone make it obsolescent, for, being avowedly time-dependent, what has not yet happened cannot be part of the subject matter of such a theory. (In practice, of course, the present of art is constantly illuminating its past.) That every aesthetic theory should henceforth come with the subtitle 'Aesthetics Now' does not seem an insurmountable problem.[56] No one has ever blamed history or science for inevitably carrying such a disclaimer. Indeed a theory of what art has been would seem a necessary basis for defining

the peculiar properties of the new instance; for how can we extend the definition of art if we have not got one?

Beauty and aesthetics

Has beauty, or at least the beauty of an artefact, ever been the criterion of art? Certainly, as we have seen, aesthetics has often claimed as much, but only after first making distinctions within beauty that must all but abolish the meaning it might have beyond the sphere of art. There must be, then, something constant, or at least widely prevalent, in the aesthetic (hitherto) which was felt to be explicable only in terms of something in the experience of beauty.

There is obviously a continuity between the great majority of artworks, and between the various roles which artworks have been expected to play: aesthetics did not arise through mistakenly identifying entirely heterogeneous phenomena.[57] Art is, at least, some kind of chain complex, each new member of the class interpretable in terms derived from preceding conventions, even if perhaps unimaginable in terms of the conventions from which those conventions grew, and generating new conventions which could not be inferred even from its immediate inspiration. The question 'What has art been until now?' is not, then, a priori unanswerable. Indeed in almost every use of 'aesthetic' up to the present time there has been the implication, albeit often paradoxical in the context of the use, that whatever the quality's proper definition, its proper realm is that of taste. Even where the artwork is quite self-consciously defined in such a way as to make it merely the occasion for sociological or pseudo-philosophical comment, it is presumed that it is in the emotional response to this comment that the 'aesthetic' lies. (I have endeavoured to demonstrate elsewhere that it is precisely the existence of taste, that is, the structure of feeling which manifests itself most emphatically in the beautiful instance, that alone accounts for the existence of art/the aesthetic.)[58] More specifically it is the notion, inextricably bound up with taste, of 'disinterest' which aesthetics has sought to preserve, despite, as we have seen, the difficulties which this inevitably entails; indeed the rise of aesthetics is almost inseparable from the concept of autonomous aesthetic qualities or values – only recently has it been realised that the one does not necessarily imply the other.

Given this rather tenuous connection between beauty and art on the (problematic) grounds of 'disinterest' it might seem surprising, if we leave aside for the moment the fact that art can be beautiful, that beauty

was ever so closely associated with art at all. Yet the institutional defini-
tion of art has only recently been formulated, and is unlikely to become
popular (even where it is already implicitly held) beyond aesthetics pre-
cisely because each person does have an aesthetic standard, or aesthetic
standards, which appear, to the person, autonomous ('disinterested'). It is
perhaps part of the same impulse which leads us to make an artefact aes-
thetic that makes us, at the same time, demand that what satisfies us in
works should be part of the definition of what works are, that is, whatever
leads us to value the work also requires that the responsibility for this
value should reside in the work itself. There is room here only to sketch
out a possible explanation of this state of affairs. Nevertheless such a sketch
should at least begin to account for the strange relationship that has held,
and still sometimes holds, between 'aesthetic' and 'beautiful'.

Hitherto the essence of the aesthetic value of art has lain in this: the
extent to which we may unify the mess of reference which is to be found
in any artwork into a single text empowered, by virtue of its autonomy,
with an expressive function peculiar to itself, and unaffected by questions
of truth or falsity. (Duchamp's *Fountain*, that favourite touchstone of mod-
ern aesthetics, is nothing, except a latrine, if not a text.)[59] The 'purity' of
aesthetic value is, then, the result of our desire that the work's power of
expression should be absolute, that is, beyond the reach of those qualifi-
cations, that relativisation, that must occur were its propositions allowed
to exist on the same plane as ordinary propositions about the world. An
artefact prompting or (apparently) allowing such an exemption we say
has 'aesthetic value', or, more simply, that it, or our interest in it, is 'aes-
thetic'. The exemption itself is inspired by the same interest that keeps the
real beautiful object ineffable, that is, the pleasure to be derived from the
entertainment of the idea of a state of affairs that is desirable to the point
of impossibility. (Like beauty, too, this exemption may be either escapist
or the product of profound insight depending on whether it is you or I
who is granting it.) The object as text is made autonomous by the subject
so that, paradoxically, in being autonomous, in coming from outside, it
may become objective, equal to life. The aesthetic, then, appears disinter-
ested for the same reason as the beautiful appears disinterested; they share
in the same fundamentally metaphysical structure; they are both, in those
instances when I value the art, that which I wish to remain ineffable. The
work is given a propositional force and yet we insist that it cannot be
reduced to any proposition, or, if it can, that there is nevertheless an irre-
ducible and essential residue which is to be found *only in the object itself*. In
the case of art we do not like, of course, we are only too happy to make

explicit the relative nature of what is expressed, quite ready to be explicit about precisely what the work is 'saying'.

What principally seems to distinguish aesthetic merit in general (not only in art) from beauty, within the realm of taste to which they both belong, is that, in the case of the former, we are conscious of an ability to refer our pleasure, or admiration, to some *idea* of the object involved, though we are, as with beauty, unable to deduce the pleasure or admiration logically from that idea. (It is just such an idea that Kant is, I believe, describing when he talks of an 'aesthetic idea' as 'that representation of the imagination which induces much thought, yet without the possibility of any definite thought whatever, that is, *concept*, being adequate to it, and which language, consequently, can never quite get on level terms with, or render completely intelligible'.)[60] I may say that I admire this work because it is profound, and even that its profundity lies in its expressing this or that proposition, in this or that way, about the world (or that it is exciting, or graceful, or funny, or tragic, and so on, because it possesses these or those properties), yet there is still something in the experience which leads me to attribute my pleasure or admiration to the object itself. That is, we feel that the idea somehow justifies our pleasure or admiration, and may indeed even assert (if we are critics) a necessary connection between the two, yet, as with beauty, we can ultimately point neither to an objective principle, nor to the satisfaction of a universally intersubjective desire, that would establish such a necessity.

The *je ne sais quoi* is still at work in art, even when it is apparently approached through analysis. It remains only by being postponed, or remaining out of sight, even, though not necessarily, to the extent of not appearing in connection with the ostensible object at all. Every poem, says Arnold, should contain the reason why it is so and not otherwise. Which is to say that good poetry is impenetrable, is that which we do not wish to penetrate, because it only exists so long as, and because, it is on the way to something like beauty. Likewise Bell's definition of 'art' as not a means of suggesting emotion and conveying ideas but an actual 'object of emotion' points to the same willed unity of value and existence, the perfection of which is beauty.[61] His notion of 'significant form' is an excellent definition of 'beauty'; that he does not offer to explain what the form signifies confirms this.[62] For aesthetics the indivisibility of form and content is essential to art. What this signifies is the resistance of desire to thought. There is, indeed, within the theory of art, for all its historically justified shyness of the 'notion', a certain nostalgia for beauty, for the glamour of its inviolability; the aspiration, which Pater spoke of, towards the obliter-

ation of the distinction, demanded by the understanding, between matter and form, pure perception independent of 'mere intelligence', to become that 'language we speak and understand, but which we are unable to translate'.[63] In any explanation of the aesthetic, or the function of art, there is always a vanishing point, a 'so what?', an inability to relate the sum to the parts, that points to the origin of beauty.

Adorno links art to beauty in so far as the artwork, 'by the sheer weight of its hermetic unity', becomes, like natural beauty, a being-in-itself.[64] But there are ways of appearing as being-in-itself other than beauty. That 'disinterest', which is really the poise between desire and renunciation, which grounds beauty also lies within the aesthetic. It is misleading, however, to speak of the beautiful in what does not appear beautiful, since, aside from appearance, beauty has no reality: that embodied yearning which has not condensed into an experience of beauty is not beauty. Art is susceptible to beauty because its very existence posits a hermetic unity, but merely claiming or being granted this unity, that is, appearing as a thing-in-itself, is not a being beautiful unless other conditions are satisfied. Beauty may be grounded in a vain wish, but every vain wish is not experienced as beauty.

Despite, then, this fundamental kinship, beauty and the aesthetic are not to be conflated. (Not least because the subject can only deliberately make art equal to life, that is, can only do so through a medium that is already intended.) Art is on the way to beauty but, except in those cases where the work is beautiful, the class of artworks, even 'aesthetically valuable' artworks, differs fundamentally from the class of beautiful objects with respect to the relationship between the sensation and its ostensible object. The object, qua artwork with aesthetic value, is privileged but not in the same way as the object qua beautiful object is privileged, that is, not as itself a medium, but rather as the point of access to a medium. The object is rendered inscrutable by vain wishing, but only at a remove. There is no reason why the artwork should appear beautiful, even though, as I have said, it ultimately exists only for the sake of what the existence of taste implies. For it is in exactly the same situation as every other object in the world which I use in aiming towards my ultimate goal. Art is distinguished as a class among these other objects not because it is a thing-in-itself, but because these others (except when they are beautiful) are apparently not. It is in this way that art is inset.

In aesthetic value the unity of effect and object is more consciously willed by the subject, its 'dependent' nature remains to the fore, and its object is consequently far more diffuse than is the case with a 'beautiful

object'. For this aesthetic object is not, as the evaluation often supposes, the artwork itself, but may be almost any form of shifting association between the object, its interpretation, the idea of the object's interpretability, the idea of this interpretation appended to this object, and so on. (Indeed whenever it is the propositional value of a work that is held up as the essence of the work the ground of value has already retreated from 'the work itself' to the idea of works.)

However, despite the great variety of immediate causes of aesthetic value, all such evaluations must (according, at least, to what the many current uses of 'aesthetic' do have in common) necessarily depend upon the notion that what is valued is an intrinsic property of the artwork (albeit that what is intrinsic to an object *qua* artwork is a function of that object's context). Hence the notion of the autonomy of aesthetic value. That it has, naturally, proved impossible to divide the intrinsic from the extrinsic in any aesthetic instance (and thus to define 'aesthetic' in terms of properties) is a consequence of the fact that what is intrinsic is decided by the evaluation itself, made intrinsic by that evaluation, and thus subjectively conditioned in a way that is peculiar to each specific instance.

This, indeed, is the very motive for the decline of the use of 'taste' in the explanation or evaluation of art; taste is not amenable to that 'systematic structure of knowledge' which could justify, through theory, the role which art plays.[65] It was in the interests of this aspiration to science, which parallels the very creation of aesthetic value, that taste was made something external to the study of art, an afterthought, a hanger-on.[66] The inevitability of this state of affairs, in which we seek to rescue art from that very sphere – taste – which alone gives it meaning, is something I sought to describe at the end of my *Literature, Rhetoric, Metaphysics*.

Despite, then, the common grounding of beauty and aesthetic value in the 'disinterest' of taste, in art, no less than in any other phenomenon, beauty requires a certain concatenation of events to come forth, to appear as a beautiful object. The more intimate connection between art and beauty lies in the fact that beauty so often breaks though art, because of the fundamental nature and function of art, of the aesthetic (in all its prior or present forms at least), its concern with just those matters closest to the heart of being, and therefore to the aspiration for beauty to be. Indeed the more complete the absolutisation of the text, the more inscrutable becomes the grounds of our admiration, and the closer to beauty the object itself approaches.[67] Music has an obvious advantage here, and it is also the art form which even now most readily invites the elsewhere rather quaint epithet of 'beautiful'.

Beauty is simply not a serious enough concept to belong to aesthetics – it is too irreducibly subjective to be the object of a discipline. (I am not here talking only about its modern identification with prettiness, though often something like this identification is implied in its dismissal.) Indeed, for the greater part of this century it has been orthodox to disallow whatever belongs solely to the individual subject from entering into the description of the art object, on the grounds of irrelevance. Richards comments that until 'This is beautiful' is translated into '[This] causes an experience in us which is valuable in certain ways' it remains a 'mere noise signalling that we approve of' the object we have so designated.[68] Adorno is even more austere:

> [The] very idea that enjoyment is of the essence of art deserves to be thrown overboard. … What works of art really demand from us is knowledge, or, better, a cognitive faculty of judging justly: they want us to become aware of what is true and what is false in them.[69]

Osborne, without any intention of being severe, many years ago recommended that a sharper distinction should be drawn between taste and aesthetic judgement; the former being the domain of those objects that we like, and the latter of those objects we 'seek contact' with 'for the expansion of awareness and deepening of experience or insight that appreciative commerce with them brings'.[70] The drawing of such a distinction within theory would, indeed, be no more than a just recognition of one of the presumptions upon which the present discourse of art rests.[71] Such an attitude was, however, always incipient in aesthetics even when it preserved some esteem for 'beauty'. According to Schelling, for example, simply to be moved by art is not enough; such a pleasure is 'passive and to that extent rather lowly'; only crude people take their merely sensual response, the pleasure elicited by the work, to be the effect of art as such. A far more 'sublime' pleasure, according to Schelling, is the 'active perception and reconstruction of the work of art by the understanding'.[72] The effects of art, he concludes, are 'merely effects of nature' for a person who does not make such a reconstruction, and while such people may appreciate individual moments of beauty, they will never appreciate the 'true' work of art, in which only the whole is 'beautiful'.[73] Between Schelling's rejection of lowly, partial beauties and Danto's objection to the idea of *les beaux arts* (on the grounds that, like the epithet 'fair sex', it is a means, of 'political translocation', of trivialising), stands a host of aestheticians who, very rightly, do not want what they call 'aesthetic response' to be confused with anything as crude as the ubiquitous perception of beauty.[74]

Even when pleasure is posited as in some way essential to the aesthetic, the model for the type of pleasure involved is not taken over from the experience of beauty. Levinson's view is typical in this respect. According to Levinson if the value of art is related to the provision of pleasure then it must be related to an 'enduring *capacity*' to yield a certain kind of pleasure, that is, not a passive sensation but an active enjoyment, a pleasure that is often indirect, the basis of which is actively listening, viewing, attending, organising, projecting, imagining, speculating, hypothesising.[75] It is an informed pleasure, based on the understanding of the provenance, intentions and accomplishments of its object.[76] (Levinson does not even propose calling this 'aesthetic value', since he gives 'aesthetic' its traditional definition as disinterested experience of the object for its own sake.)[77] Moreover the value of the experience of art may be, and often is, that it is 'worthwhile' rather than enjoyable:

> Much art is disturbing, dizzying, despairing – and is in fact valuable in virtue of that. We are glad, all told, that we have had the experience of such art, but not, once again, because such experience is, in any natural sense, pleasurable. Such art, like castor oil, is good for you, though not immediately pleasant, yet unlike castor oil, the good of it may not be conceptually separable from the experience of imbibing.[78]

It is, of course, quite conceivable that an anachronistic individual might use some sort of immediate pleasure as a yardstick of artistic value – the most general definition of 'kitsch' presupposes that many do. When Levinson uses 'we' he means it, and, on a personal note, I do not share his standard. However, such a disagreement in no way indicates that I would dissent from his view of what art is. What we value art for is as much a matter of taste as what works of art we value.[80] A more problematic case, and one closer to my own concerns, is that of Mothershill, who, even after absolutely identifying aesthetic value and 'beauty', still finds the pull of connotation too strong for such an identification and ultimately makes the very distinction which elsewhere she has explicitly suppressed, that is, the distinction between what is not '*only* beautiful' but also 'complex, difficult and profound'.[80]

The modern attempt, exemplified by Mothershill's *Beauty Restored* and Savile's *Test of Time*, to resurrect 'beauty' as a blanket term for aesthetic merit is naturally, and fortunately, doomed to failure: 'naturally' because the use of the word 'beauty' (excluding its figurative, that is, hyperbolic use) remains, outside aesthetics, far more specific than the sum of adjectives that cover the properties for which art is valued or enjoyed; 'fortu-

nately' because the identification could only be accomplished by the loss of any term to describe beauty. Indeed, this latter consideration is my main reason for including this discussion of aesthetics in this book. For the problem is not that 'aesthetic merit' is identified with beauty – there is, as far as I know, no aesthetician writing in English today who actually wants to make such an identification – but rather that 'beauty' is identified with aesthetic merit.

According to Mothershill beauty is a 'standing concept' in aesthetics, one that is tacitly understood and indispensable; all works of art, she writes, 'lay claim to beauty' by being art, and all critical remarks are made against the background of this claim and take it for granted.[81] Likewise Savile writes that 'beauty' is the most general term of aesthetic praise, and explains its notable absence from critical discourse on the grounds that the critic's main concern is with showing not that but why a thing is beautiful.[82] This idea that beauty can be demonstrated (as perhaps aesthetic merit can), that 'x is beautiful' is a proposition that can be proven, leads to some startling absurdities. Mothershill, for example, writes that the perception of 'great and serious beauty' may require prolonged study and critical analysis, a correct 'assessment' only being possible where the subject allows for and removes whatever may be 'prejudiced', that is, subjective in 'his' response.[83] Likewise Savile (who specifically says that his analysis is intended to cover 'natural' cases of beauty) writes that, since beauty is a satisfactory answer to a problem in style, only a response to an object that derives from a proper understanding of this problem is fit to enter into a judgement of its 'beauty', so that appreciation cannot be divorced from clarity of vision and accuracy of understanding, both of which may be corrected by the intellect.[84]

Dutton, reflecting on the problem of reconciling Kant's notions of 'free' and 'dependent' beauty, and noting that Kant explicitly states at one point that all artistic beauty is dependent beauty (the former being beauty and the latter aesthetic merit), arrives at the conclusion that we should abandon the idea of free (pure) beauty as described in the *Critique of Aesthetic Judgement*.[85] Like Mothershill and Savile, however, Dutton is primarily concerned with 'aesthetic appreciation' in all its forms, and ultimately wants a theory of 'beauty' that will explain why Duchamp's *Fountain* is a work of art:

> Where then does this leave that sense of free beauty with which Kant began the *Critique of Judgement* – the presuppositionless, 'self-subsistent' form to be experienced in a conceptual vacuum, known only through its power to excite the otherwise empty faculties of mind? One could almost say, nowhere. It

virtually drops from sight, except as an unrealizable, limiting condition of aesthetic experience. [In] the fullness of his investigations, Kant comes to the view that experience of decontextualized beauty is not only impossible for a cultivated, intelligent human being, it is unnecessary. Free beauty still has a place in the later sections of the Third Critique, but it is as an aspect of works of art, rather than as a general kind of object.[86]

This ignores the fact that Kant's description of free beauty, whatever the adequacy of the teleology he proposes for it, is the definition of 'beauty' as it is commonly used – how many people, even among admirers of Duchamp's work, would say they considered *Fountain* a work of art because every time they saw it they were struck by its beauty? Indeed Dutton summarises the rise of modern aesthetics in his remark that 'the concept of a bare, self-subsistent free beauty is ultimately lost in the infinite complexities of art's dependence on its human context'.[87] And so it should be, in so far as we are dealing with the aesthetic, though that experience which Kant describes as the experience of 'free beauty' does not cease to exist just because it is so obviously an inadequate model for the experience of art.

Many terms which might be called terms of aesthetic commendation – graceful, exciting, intriguing, moving, erotic, profound, and so on – are, obviously, relative. Thus Mothershill, in identifying just such aesthetic merits with beauty, is led to state explicitly that beauty itself 'admits of degree'; the more beautiful the item, the greater (more intense) the pleasure derived from it, and the more prolonged the duration of that pleasure, that is, the more 'rewarding' the beauty.[88] (If Kant had not neglected this 'scale', she writes, he would more easily have discovered that beauty is a concept.)[89] But although beauty, could be included in a list of aesthetic merits it does not, unlike most other aesthetic merits, come in fractions.[90] We often fall into the mistake of thinking that it does because we take it that if an object can be beautiful, then it is the class of objects which determines the beauty, and that there can be degrees of beauty within, and determined by, that class. So that it is not uncommon to hear that we cannot 'judge' a poem or a mountain until we have a wide experience of the classes to which they belong – which is true if we want to make an estimate of its profundity or impressiveness in terms of the total class of poems or mountains, but irrelevant to whether or not the sensation I feel in its presence arises from beauty (or even from admiration or awe). Beauty is not a 'judgement' in this sense.

Of course class-specificity is essential to beauty in so far as a beautiful woman is beautiful as a woman, that is, not independently of belonging

to a certain category – a fish with Cleopatra's nose would not be a fish with a beautiful nose. But with respect to the feeling that is registered as the beauty of the object this categorical grounding falls away, that is, the woman is not 'beautiful for a woman' but simply beautiful. For what we experience is not ultimately determined by this object being a woman, by 'the beauty of a woman', but rather by that which is expressed by this particular beauty. What is expressed is universal and uniform – beauty. Beauty, as an impulse, is necessarily static precisely because the very act of making an object beautiful involves removing it from its place in a category, that is, removing it from pragmatic consideration. The category itself is only the (indispensable) medium. Beauty, as a sensation in the subject, does not vary in kind according to its object; whether the object is a particular woman, the sea, a line of poetry, or the smell of newly turned earth. Hence the natural intimation of preciosity whenever we encounter the question of which of any two objects, even from the same class, is 'more beautiful'.[91] The sensation is distinct and uniform to the extent that, where a standard is, as a matter of convention, assumed, there is felt to be nothing strange in identifying (through simile or metaphor) the most disparate of objects on the grounds of their common beauty. So that, for example, when, in the *Thousand and One Nights*, a woman is said to be as beautiful as the moon shining on the sea, this is obviously intended as a description of the woman.

The aesthetic, as a group name for the qualities that we value art for, is, in contrast, far from indivisible. So that any process of making 'beauty' the subject of what are perhaps quite defensible characterisations of the experience of art (depending, that is, on how we define 'aesthetic') eventually requires that even the most fundamental defining characteristics of the perception of beauty be denied. Thus Mothershill writes that 'although I know what I *intend* to do in uttering the words "This rose is beautiful", the question whether my intention has been executed, that is, whether I have actually *made* a judgement of taste, must remain open'.[92] It seems that it is not simply taste that is a function of temperament, but also our very perception of our taste. For Mothershill can describe the thesis that beauty is a projection of one's own feelings onto an object as 'counter-intuitive', and holds rather that when she perceives beauty she is actually perceiving a property of the object as objectively present as colour or size.[93] So that, for example, she believes another may 'confirm' our opinion of an object, and that there are canonical works of art (as objects of beauty) 'whose claims on our admiration and reverence are beyond dispute'.[94] Savile finds that he can easily solve the difficulty of

accounting for those 'beauties [canonical works] that do not attach but leave us indifferent or even repel' by asserting that since pleasure is not an intrinsic quality of our experience of beauty it is irrelevant to the analysis of that experience: 'Non-normal beauty can be set aside as of little theoretical interest or importance.'[95] Normal beauty, in this scheme, is as near to objective as makes no matter. (He can divide the beauty of art from the beauty of nature on the grounds that while the latter is really in the eye of the beholder the former is a function of the intention/structure of the object.)[96] For Savile the beauty of an object is established by the 'test of time' – a useful practical principle, in the absence of immortality, when entering a library, but obviously irrelevant to taste, value, or proof. This objectivist line of thought reaches its apotheosis in Mothershill's statement: 'Not everything that people take to be beautiful is beautiful.'[97] 'Beautiful' here has completely lost its meaning.

Consequences

There are, then, two fundamental points about the relationship between beauty and art which I hope I have made clear in the preceding. First, despite the fact that the desire to make the value of art transcendental, and consequently intrinsic (we want our interest to appear to terminate in the work), has often brought the definition of 'aesthetic' close to that of 'beauty', it is obvious that if 'aesthetic merit' is to mean 'what art is valued for', and 'aesthetic' to mean 'the cause of this value', it is not possible to identify 'beautiful' with 'aesthetic'. The latter term has, as we have seen, no settled definition, but whatever common denominators, arising from its association with 'art', we can find among its various uses, these are obviously not identifiable with the properties of beauty per se. Indeed, though art has often been the expression of a desire to make certain beauty timeless, and therefore, in one sense, objective, the story of aesthetics' attempt to convince itself that art can succeed in this impossible endeavour is precisely the story of all aesthetics' fundamental errors. Secondly, it is, at best, confusing to use 'beauty' for two disparate areas of experience; while it may be possible to find other terms for the kind of 'judgement' that is the subject of aesthetics, if we renounce the use of 'beauty' for that form of perception of which simply feeling is the necessary and sufficient condition we will be hard put to replace it. I am not merely defending Kant (or Aquinas) – common usage also preserves this meaning. (What would we make of 'Is this beautiful?', 'I don't know, let's ask'!) While I may dissent from the explanation, by Kant and others, of the grounds of

this sensation, I do nevertheless recognise, from my own experience, the perception/sensation which is their starting point, which I have always called 'beauty', and which is absolutely incompatible with the predicates used of it when it is made to stand, as even recently it has been, for 'aesthetic merit'.

9
Beyond nothing

Là tout n'est qu'ordre et beauté
Luxe, calme et volupté.
[Everything there is harmony and beauty,
Luxury, tranquillity, and delight.]
> Baudelaire, 'L'Invitation au voyage' (1855), ll. 13–14

Des rêves! toujours des rêves! et plus l'âme est ambitieuse et délicate, plus les rêves s'éloignent du possible. Chaque homme porte en lui sa dose d'opium naturel, incessamment sécrétée et renouvelée. [Dreams, forever dreams! And the more the soul is aspiring and fastidious, the more do dreams outdistance the possible. Every man bears within him his measure of natural opium, incessantly secreted and renewed.]
> Baudelaire, 'L'Invitation au voyage' (1862)

La beauté n'est que vent, la beauté n'est pas bien:
Les beautez en un jours s'en vont comme les roses.
[Beauty is like the wind, beauty is no good;
Beauty vanishes with the roses.]
> Ronsard, *Sonnets for Helen*, I. lxii, ll. 13–14

But it will be asked, whether this method of analysing metaphysically matters of feeling and sentiment, will not be attended with many inconveniences? Whether it will not often engage us to enquire into the reasons of things which have no reason at all, damp our pleasure by leading us into the custom of discussing coldly what was designed by nature to touch and to inflame, and put such shackles upon true genius, as to render it servilely timorous, and check its enterprising ardour?
> D'Alembert, 'Reflexions', pp. 225–6

Nature, like art, is careful to hide the cause of unusual impulses: we see the machine, and with pleasure, but we do not see the spring which makes it work. A woman may be pleasing to us, or inspire love at first sight without our knowing why she has this effect. You will say that in these circumstances nature sets traps for our heart so as to catch it unawares, or rather that since she knows it to be proud and as sensitive as it is in fact, she spares it and treats it gently by hiding the dart which is to wound it. ... It is certain that this mysterious something belongs to that class of things which are known only by the effects they produce.

Let us say the same of that charm and of that peculiar fascination we are discussing: it attracts the hardest hearts, it sometimes excites violent passions in the soul, it sometimes causes very noble sentiments; but it is never known except in that way. Its importance and its advantage lie in its being hidden; it is like the source of that Egyptian river, the more famous for not having yet been discovered, or like the unknown goddess of the ancients who was adored only because she was not known. ...

The *je ne sais quoi* is like those beauties covered with a veil, which are the more highly prized for being less exposed to view, and to which the imagination always adds something. Hence, if by chance we were to see clearly the nature of this mysterious something which astonishes and overwhelms the heart at first glance, we should perhaps be less charmed and touched than we are; but it has not yet been unveiled and perhaps never will be since, as I have already said, once unveiled it would cease to be what it is. ...

The *je ne sais quoi* is almost the only subject about which no books have been written and which the learned have never taken the trouble to elucidate. Lectures, dissertations and treatises have been composed on very odd subjects, but no author, as far as I know, has worked on this one. ... And perhaps even if [such an] academic discourse were to see the light we should not be much more informed than we are, the subject being one of those which have an impenetrable core and which cannot be explained other than by admiration and silence.

I am very glad, said Aristo laughing, that at last you have come to the proper conclusion and that you are satisfied to admire what at first you wanted to understand. Take my advice, he added, and let us stop here without saying anything further about a thing which continues to exist only because no one can say what it is.

<div align="right">Bouhours, 'The je ne sais quoi', pp. 231–8[1]</div>

But now I have said what beauty is, have brought it within the theoretical, and must come to some conclusion. In the particular, of course, that is, when I see the beautiful, what I see is, even to reflection, the 'I-know-not-what', still outside theory. Yet beauty and action remains the question, the inevitable goal of any analysis, and my subject here. This, after

all, is the function of a 'Conclusion' – to bring out the consequences, to indicate certain 'rules' for the use of this book. But my conclusion, given that all the action that belongs essentially to beauty is already contained, and inevitably contained, within the manifestation of beauty, must be that there are no consequences, that my analysis has no pragmatic value whatsoever. (Those actions, on the other hand, which arise in association with beauty are a matter for psychology, anthropology, or ethics.) Indeed, so fundamental a force is beauty that it is no more vulnerable to murder by dissection than, for example, the laws of gravity. Yet I have named the end or even use of the beautiful-in-itself, disclosed the spring which makes it work. So that, even if what was beautiful is still beautiful, is there not a sense in which beauty itself has changed? Sextus Empiricus, remember, on concluding that the world is not ordered according to harmony, so that the effects of music cannot be due to any of its intrinsic properties but must rather depend on our feelings, was moved to declare that there is no such thing as music.

What is to be done with this new-found knowledge that in beauty, behind beauty, is nothing, the abyss, dust, and dust of dust? Well, before answering this question, or perhaps in order to answer it, we must begin by resisting this temptation to fall, or 'fling' ourselves, into a posture of despair.[2] In the universal darkness which pessimists pronounce, their own light, whether it be integrity, or superior knowledge of the darkness, shines twice as bright and is, indeed, a cause for rejoicing. For Schopenhauer life is a tragedy, that is, a piece of literature; for Unamuno, too, it is a tragedy but the 'tragic sense of life' is ennobling, Existentialism has, and indeed exists for, its consolations – 'authenticity', 'good faith', 'rebellion', the becoming of a 'Knight of faith', or an übermensch. Everything, and most markedly so in discourse, returns to the moment, the image (Camus's invincible summer of Tipasa), the beautiful. The religious 'Existentialists' – Kierkegaard, Unamuno, Marcel – are at least honest in this respect: they do not offer the consolations of religion in a secular form. The first thing to note about the Abyss, then, is that it is a piece of melodrama, as are all figures that claim to define life or summarise being. But, more importantly, there is the fact that there can be no 'in beauty', that there is no 'behind beauty', except in the (mercifully circumscribed) world of the intellect.

When the emperor Hadrian asked Secundus 'What is beauty?', the philosopher answered as follows; 'A picture drawn by Nature, a self-made blessing, a short-lived piece of good fortune, a flower that withers,

something good which one has from oneself, a possession that passes away, an unstable comfort, the corruption of intelligence, the loss of understanding.'³ Wherever there is beauty there is a compromise of the intellect (which desires nothing so much as this compromise) so that here especially, that is, in dealing with beauty, we should beware of distinctions and consequences that belong solely to the isolated intellect – if such an intellect were possible – and of overestimating the domain of this intellect. The pesimists' response – *en polvo, en sombra, en nada* – is as much an aspiration towards beauty (the beauty of renunciation) as the aspiration towards beauty they are renouncing, for, as I have said, we cannot choose against beauty, we cannot move beyond beauty; in finding a thing beautiful we have already irrevocably acted. So it is that while beauty is the emblem of the war between the finite and the infinite within the soul, it is the emblem of both factions; though the reflective consciousness may take sides with one or the other. Beauty is refracted into as many hues as there are reflective consciousnesses; it may be regular, irregular, fluid, intense, enduring, transient, revelatory, sad, convulsive, serene, exuberant, divine; it may mingle with reflection to become a promise, a balm, or an anguish.⁴ Unamuno, for example, describes beauty as a 'tragic consolation', in that the anguish we feel at the consciousness that everything passes away itself reveals the consolation at that which does not pass away: the beautiful.⁵ This is half true, or rather, half the truth, for the beautiful itself passes away and it is rather the whole of the 'consciousness', that is, the contrast, the impossibility of enduring, that constitutes the beautiful. Great happiness moves us to tears because great happiness appears as a contrast – 'This is too much to lose.' Parting is such sweet sorrow because parting causes the plenitude of the soon-to-be-lost presence to come forth. This is the fundamental oxymoron of beauty. It is the desire alone that endures and, in enduring, itself provides that which is its end – beauty ('something good which one has from oneself'). Pleasure may be along the way but it is no less pleasure for that.

We fly from one glamour to another. Anatole France defined beauty as dependent upon the self, as the sensible form of all that we love; 'To love is to beautify, to beautify is to love':⁶

> Beauty is the supreme artifice of that wondrous and essential mirage we call Love. But truly we must not distrust it, for if we do, in what shall we put our faith? No; let us, on the contrary, yield ourselves up to Beauty, let us behold in it a religion, a rule of life, a recipe for happiness. In Beauty we shall find

salvation, for in it we shall find oblivion. Of a surety it is no easy matter to escape from ourselves, but if there is any hope of doing so, it will surely be with the aid of the beautiful. In the contemplation of Beauty, we cast off the burden of life. It is as though we were eating of some enchanting lotus, as if we were being wafted into another sphere where all pain, all sorrows are forgotten. The crowning opiate, the source of art and letters, of every worthy thing that man has created, of everything in which he may take a legitimate pride. Beauty is the ransom of the Universe.[7]

But France is not advocating willed illusion, which would be impossible anyway. It is a mistake, he writes elsewhere, to oppose the real to the ideal, for the ideal is the only form of the real we can grasp. And since there are no 'things themselves' but only 'states of our own soul', it is only reasonable to seek and enjoy appearances that inspire charm, beauty, and love: 'Dream for dream, why not choose the pleasanter?'.[8]

Now, glamour for glamour, I prefer that of Anatole France: it is lighter, more and less self-conscious, than those pessimistic responses which deny they relish their 'despair'.[9] But to be able to choose the pleasanter, beauty would have to be a matter of deliberate choice – which it is not. We choose our actions but not our goals, our means but not our ends. This is not to say that we are determined by beauty *per se*, for it does not exist '*per se*'; we construct it from, and experience it only in, the particular. That this construction is unconscious signifies only the way in which we are determined by ourselves.

Is it possible to seek to go beyond beauty, or rather, could there be a subject who can no longer rest in the beautiful? Aestheticism, in choosing the beautiful object as a terminus, certainly appears to be such a going-beyond, but, as we have seen, in practice this becomes a matter of notional assent to the beautiful, a matter of cultivation. Thought, according to Judge William, takes everything from the aesthete but leaves nothing in its place.[10] (Nothing but that resignation, that reconciliation with death that is death itself.) Yet it is not possible to be a spectator, one can only *play the part* of a spectator. Almost all have a faith – the materialist in matter, the cynic in cynicism. Even when the means are forced upon people, they so rapidly come, out of necessity, to love the means that the border between submission and desire is hard to discover. For those who are without faith only *aventure* remains, which is not so much faith as a deductive gamble from past experience. But *aventure* has its providential aspect as well: they hope one day, if only the next day, to be content; they dream of the possibility of dreaming.

Whenever we try to define what is ultimately desired, it eludes us; we cannot even fix its vanishing point. Each for-the-sake-of empties itself into another still vaguer and, compared to our original undefined *image*, still more trivial. Perhaps there is something fundamentally uncongenial, even alien, in the concept of teleology applied to a life. The antithesis of this concept is not, however, another concept but rather the abjuration of concepts, the ateleological that is beauty. Beauty thus always brings with it, in contrast to the withering track of cause and effect, the desire to live, a sense of the abundance, the plenitude of life. For the same reason it is always a surprise. For even though beauty is self-engendered it cannot be sought by the self. Moreover it leaves no wake; the nostalgia for beauty is merely the beauty of nostalgia. Hence I do not simply recognise a beauty I once knew, rather I am 'struck again' by it. And a new beauty is unforeseeable; it cannot be deduced from past experience. Indeed when I try to so deduce beauty, to arrive at a mental average, the result is lifeless. This is why the power of beauty is easily dismissed, once out of its presence, and why, try as we might, we cannot take beauty 'into account'.

I have described beauty, and told how the beauty of a thing is always in excess to anything we can hope from that thing, but there will still be beauty. For there is nothing beyond beauty. Everything is as it was. I have nothing to prescribe.

Fag ai lo vers, no say de cuy.

Notes

Chapter 1

1 Voltaire, *Philosophical Dictionary*, pp. 63–64. Though he himself did write an 'Essay on Taste'.

2 When I write about the beautiful instance or object it must be understood that I am also including beautiful thoughts. Now the phrase 'beautiful thoughts' (as in 'thinking beautiful thoughts') has, undeniably, something rather precious about it, a suggestion of Sensibility. This is largely a matter of the same associations with the refined, over-cultivated and pretentious which have unfortunately also gathered about 'beauty' itself. However, beyond the rather clinical examples, no doubt chosen for the best of philosophical reasons, that theoreticians of beauty have usually presented, there is obviously a much greater range of instances in which 'beauty' is the only appropriate word to describe what is experienced. I refer to that atmosphere which surrounds not so much any definite image involved in, as the very intimation of such things as, a journey to somewhere new, a dream, a memory, or which appears at that moment when, among the familiar and banal, an objectless and calm euphoria suddenly comes into being. It is a feeling not simply of well-being (for it can appear in connection with situations that should, by all rights, be depressing) but rather of the timelessness of the moment together with a sensation that is neither pleasant nor painful, happy nor sad, yet in some way all of these simultaneously. It is unfortunate that such an impressionistic, not to say oxymoronic, description should have to be admitted into what purports to be a sober philosophical account, but I can hardly hope to clarify the subject simply by leaving out of consideration whatever in the subject itself is not clear. Perhaps it will help the reader who instinctively rebels at the idea of a 'beautiful thought' to consider the way in which we experience the beauty of a piece of music. If such readers imagine the site of the beauty of music as halfway between that of the beautiful thing and the beautiful thought they will perhaps be able to form some idea of what I mean by the latter. Such beauty is not, ostensibly, a response to any material object, or even any conscious image, and yet, in so far as the feeling must have an object, the phrase 'beautiful object' as it is used throughout this work must be understood to include whatever it is (whether subliminal perception of some material object, or effect of unconscious process of thought) in these apparently purely mental instances which inspires the feeling of beauty.

3 As the sceptic Sextus Empiricus, holding that, since the world is not ordered according to harmony, so that the effects of music cannot be due to any of its intrinsic properties

but rather must depend on our feelings, concluded that there is no such thing as music; *Against the Professors*, VI, 20, 37, pp. 381–3; 391.

4 According to Newton any enquiry into the nature of beauty must examine two sets of phenomena: the quality itself and the emotion it produces. This quality, however, is only revealed by the presence of the emotion. But to turn to the emotion itself is to fall into the same 'pit' as most writers on beauty who have ended up writing about psychology rather than beauty. 'To write a book on the aesthetic emotions in the hope that it will shed light on the nature of beauty seems ... rather like examining the construction of a mirror in the belief that by so doing the nature of the universe reflected in it will be revealed'; *The Meaning of Beauty*, p. 17. But we have tried the phenomena and failed, failed most spectacularly. We fail because the object will not keep still. This is not to assert that it would be *a priori* impossible to say when such and such objective properties would be beautiful to such and such a state of mind (despite the fact that the efforts of a whole line of materialist aestheticians – the incorrigible in pursuit of the intangible – stand as a monument to the futility of trying to establish such a prescience on even a local scale), but only that the individual, fortuitous, immanent, inscrutable (or unconscious) nature of every instance of beauty makes the establishment of such a science statistically improbable to the point of impossibility. That is to say that even starting from the assumption that beauty is determined, we must allow that the properties of the objects involved (where objects are involved!) are irreducible, simply because it would be impossible to measure accurately all the variables involved in any particular instance, that is, to decide even on what constitutes the 'instance' of any particular instance of beauty. (Newton himself says that nothing is universally acknowledged to be beautiful.) Only by turning to the emotion can we find, by definition, a constant, that is, the feeling that registers the presence of beauty. Only after we have seen what this constant really is can we begin to account for the properties of the variables that go to make up the rest of the equation. Newton does say that we must consider carefully what processes take place in the beholder, but that this is 'merely a preliminary step' (p. 17). The problem is, rather obviously (and his account is no exception), that this step has never been taken carefully enough. Even Kant, who worried the question more than most, was not satisfied with his 'preliminary step'.

5 Nietzsche, for example, for whom the desires and passions are 'given', can feel he is somehow belittling beauty when, taking the modern common-sense view, he writes that nothing is more conditional than our feeling for beauty, that what we take to be beautiful might seen quite otherwise to a 'higher arbiter of taste'; *Twilight of the Idols*, §19, p. 78. If man had forgotten, then philosophers certainly had not. Thus Kames; 'Beauty ... which for its existence depends upon the percipient as much as upon the object, cannot be an inherent property in either'; *Elements of Criticism*, I, p. 261 (no more nor less, he means, than is colour). For Reid beauty dwells in moral and intellectual perfection of mind, and in its active powers, though language attributes beauty to externals, transferring signified to sign, cause to effect, end to means, agent to instrument; 'those who look for grandeur in mere matter, seek the living among the dead'; *Essays on the Intellectual Powers*, pp. 500; 498. Even for Schelling it is the creative life which brings forth beauty from dead matter, alchemically; 'We must engraft on them our own feelings and mind, if we would they should respond to us'; *The Philosophy of Art: An Oration*, p. 4. According to Santayana beauty is a species of value, not something that is in the object, as colour, proportion, or size are in an object. Beauty is rather 'pleasure objectified', and it is only our prejudice against ourselves which leads us to seek some

law, independent of our own emotions, that governs its appearance; *The Sense of Beauty*, Introduction and Part I *passim*. Mather writes that beauty is a quality of human experience rather than of any object: 'The accurate statement of any experience of beauty is never: this is a beautiful object, and I am enjoying its beauty, but rather I am enjoying an experience of beauty apropos of this object'; *Concerning Beauty*, p. 9. For a further, contemporary, discussion of whether beauty is a property of objects or of our response to them see Zemach, *Real Beauty*, Chapters 1–5, and Goldman, 'Realism About Aesthetic Properties'. Neither of these works is, in fact, directly concerned with beauty, but their treatment of other aesthetic qualities does bear on this question.

6 Hume, *A Treatise of Human Nature*, pp. 546–7. According to Addison we 'immediately assent to the Beauty of an Object, without enquiring into the particular Causes and Occasions of it', since it 'immediately diffuses a secret Satisfaction and Complacency through the Imagination'; *Spectator* No. 411; *Spectator* No. 412. Du Bos writes of how 'the heart is agitated of itself, by a motion previous to all deliberation', so that taste 'runs before our reasoning, as the action of the eye or ear precedes it in their sensations'; *Critical Reflections*, II, pp. 239–40. The author of the article 'Taste' in Chambers's *Cyclopaedia* writes that taste observes none of the 'formalities' of judgement: 'e're it has time to consult, it has taken its Side: As soon as ever an Object is presented it, the impression is made; the Sentiment formed; ask no more of it ... Taste opens itself at once, and prevents all Reflection' (p. 181). Edwards writes that it is 'implied in a person's being heartily sensible of the loveliness of a thing, that the idea of it is pleasant to his soul; which is a far different thing from having a rational opinion that it is excellent'; 'A Divine and Supernatural Light' (1734), in *Basic Writings*, pp. 123–34 (p. 129). Likewise Burke: 'It is not by the force of long attention and enquiry that we find any object to be beautiful; beauty demands no assistance from our reasoning; even the will is unconcerned; the appearance of beauty as effectually causes some degree of love in us, as the application of ice or fire produces the ideas of heat or cold'; *A Philosophical Enquiry*, p. 92.

7 This account of the phenomena of beauty is fundamentally Kantian: Kantian not, however, because it in any sense originated with him, but simply because he is the writer who most conscientiously formulated it.

8 Schiller, *On the Aesthetic Education of Man*, 25.5: or as Stace later put it: neither conception nor pure perception, but a concept fused with a percept so as to disappear in it; *The Meaning of Beauty*, pp. 43–66.

9 Kant, *Critique of Aesthetic Judgement*, §22, p. 89.

10 This is a consideration that does not seem to worry Mothershill. According to Mothershill a case such as that of the bird's song would prove that it was not the 'aesthetic properties' of the sound which had pleased us. She concedes, however, that, since association is always causally operative it must also be so in situations which the subject takes to be beautiful, and this is a contingent truth which 'must simply be accepted'; *Beauty Restored*, pp. 398–9. The problem which she sees arising from this is that if, as she believes, the predicate 'x is beautiful' is either true or false for any given object, how can we claim one person's judgement of the beauty of that object is true and another person's false, if personal association is operative in those judgements? It seems that either Kant's thesis – that beauty is a 'mindless pleasure' (Mothershill's term) – is correct, or that beauty is 'trivialised' into relativism or subjectivism (p. 400). She concludes that to arrive at a true judgement, that is, a judgement that is really a judgement of the beauty of the object (and so meaningful when publicly avowed), the critic must identify, measure and filter out from the personal judgement whatever can be discov-

ered to belong to personal memory or imagination (pp. 402–3). This is useful advice to a critic who does not want to be accused of eccentricity, but it is hard to see how it solves the difficulty in question. Note, however, that the difficulty arises only if we wish to assert, as Mothershill does, that 'x is beautiful' is either universally (objectively) true or false for any given object.

11 Thus Kant writes that it is only what is natural, or 'mistaken by us for nature', that arouses an immediate interest in its beauty; *Critique of Aesthetic Judgement*, §42, pp. 161–2. Rousseau reflects, in his *Confessions*, that his memory of his aunt's songs would probably not so move him if he ever learnt that they were not unique (*Confessions*, p. 23). (For Rousseau's convictions about the role of association in the appreciation of music see his *Essay on the Origin of Languages*, XIV–XV, pp. 56–61, and Chapter 2, note 23, below.) Jeffrey gives an excellent example: 'The noise of a cart rolling over the stones is often mistaken for thunder; and as long as the mistake lasts, this very vulgar and insignificant noise is actually felt to be prodigiously sublime. It is so felt, however, it is perfectly plain, merely because it is associated with ideas of prodigious power and undefined danger; and the sublimity is destroyed, the moment the association is dissolved, though the sound itself, and its effect on the organ, continue exactly the same'; 'Essay on Beauty', p. 284.

12 This process may find an analogy in Freud's account of the dream-work, especially in the mechanism of 'displacement' (*Verschiebung*), whereby the most significant element appears as something unimportant or even senseless; *The Interpretation of Dreams*, pp. 414–19. Likewise a parallel might be drawn between the positing of the beautiful object by the subject and Freud's account of 'secondary revision' (*sekundäre Bearbeitung*), that process whereby the dreamer rationalises the latent dream-thoughts (pp. 628–49). I am not sufficiently familiar with Freud's work to know how pertinent such analogies might be, and offer these parallels merely for their suggestiveness. Pacteau has interestingly applied Freudian psychology, and its Lacanian extension, to male and, to a lesser extent, female constructions of feminine beauty in her *The Symptom of Beauty* (*passim*). Paglia, by contrast, crudely holds that this same type of beauty is an 'Apollonian revision of the chthonian', an editing of the fearful female that 'allows man to act by enhancing the desirability of what he fears'; *Sexual Personae*, pp. 15–32.

Chapter 2

1 Bruno, ahead of his time in this as much else, noting that beauty is of many different kinds and that nothing appeals to all people in equal measure, concluded that nothing is beautiful in itself; if it is beautiful then it is beautiful in relation to something (*Nihil absolutum … sed ad aliquid pulchrum*); *De vinculis in genere*, quoted in Tatarkiewicz, *History of Aesthetics*, III, p. 295. He did nevertheless believe that there was something essential to beauty, even though we cannot discover what this something is (p. 295).

2 Pope, *An Essay on Criticism*, ll. 8–9. Pascal had declared that it is knowledge of the rules of composition that constitutes such a 'watch', though Du Bos, employing the same metaphor, says that it is 'the impression we receive from the work', and that 'our watch goes right, in proportion as our sense is delicate'; Du Bos, *Critical Reflections*, II, p. 241.

3 Testelin, *Sentimens … sur la pratique de la peinture et sculpture* (1696), quoted in Tatarkiewicz, *History of Aesthetics*, III, pp. 411–12. Even earlier Browne had written that beauty is 'determined by opinion, and seems to have no essence that holds one notion with all; that seeming beauteous unto one, which hath no favour with another; and that unto

every one, according as custome hath made it natural, or sympathy and conformity of minds shall make it seem agreeable', and that even its 'two foundations, Symmetry and complexion' receive 'such various apprehensions; that no deviation will be expounded so high as a curse or undeniable deformity'; *Pseudodoxia Epidemica*, VI, xi, p. 474.

4 Jean Pierre de Crousaz, *Traité du Beau* (1715), quoted in Tatarkiewicz *History of Aesthetics*, III, p. 438.

5 Spinoza, 'Letter to Hugo Boxell' (September 1674), in *Correspondence* (Letter LIV), pp. 276–81 (p. 279). See also *Ethics*, I, Appendix, p. 35, and 'Letter to Henry Oldenburg' (November, 1665), in *Correspondence*, (Letter XXXII) pp. 209–14 (p. 210).

6 Hume, 'The Sceptic' (1742), in *Essays*, pp. 159–80 (pp. 162–6); Montesquieu, 'An Essay on Taste', pp. 258–9. According to Hume beauty depends upon the 'proportion, relation, and position of parts', though it is not a property of any thing in the sense that certain geometric properties belong to a circle. Beauty, he asserts, is not a quality but 'only the effect which the figure produces upon the mind whose peculiar fabric or structure renders it susceptible of such sentiments'; *Enquiries Concerning Human Understanding*, pp. 291–2. Hutcheson had already written that beauty 'like other names of sensible ideas, properly denotes the perception of some mind'; *An Inquiry into the Original of Our Ideas of Beauty and Virtue*, p. 13. As we shall see in Chapter 5, however, this does not mean that Hutcheson did not consider beauty was a quality, or relationship between qualities, that an object could really possess.

7 Significantly it is the action of changes in temperature on a specimen of sheep's tongue that Montesquieu brings forward as experimental evidence in support of his thesis that 'imagination, taste, sensibility, and vivacity' are all dependent on climate; *The Spirit of Laws*, XIV, §2, p. 103. In 1756 Mr Town, writing in the *Connoisseur*, declared that taste was the 'daily idol of the polite world', though many who use the word 'throw it out as a mere expletive, without any meaning annexed to it'.

8 Hume, *Enquiries Concerning Human Understanding*, p. 165.

9 Montesquieu, 'An Essay on Taste', pp. 258–9.

10 Burke, *A Philosophical Enquiry*, p. 17.

11 Ibid., p. 11. Burke pursues the parallel by arguing that just as differences of opinion in matters of reason do not lead us to suppose that there are no settled principles of reason so 'wrong Taste' can also be attributed to those very same passions and vices that pervert sound judgement, namely weakness of understanding, 'want of proper and well-directed exercise', ignorance, inattention, prejudice, rashness, levity, obstinacy, and so on (p. 24). The analogy with reason breaks down, of course, in that it is taste itself which determines what is 'wrong Taste', which passions are legitimate and which are not. The imagination, or whatever name we wish to give to that process by which the real and the wished for are combined, can safely be presumed to be the least uniform human attribute.

12 Voltaire, 'An Essay on Taste', pp. 213–14.

13 Addison, *Spectator* No. 409; *Spectator* No. 411.

14 Voltaire, 'An Essay on Taste', pp. 215–16. Among well-known writers of the period Mandeville appears alone to believe that, in the light of the great variety of taste, the search for a standard, for the *Pulchrum*, is 'not much better than a Wild-Goose-Chace'; 'A Search into the Nature of Society' (1723), in *The Fable of the Bees*, pp. 327–71 (p. 335).

15 Hume, *Enquiries Concerning Human Understanding*, p. 137.

16 Kames, *Elements of Criticism*, III, pp. 357–9.

17 Smith, *The Theory of Moral Sentiments*, p. 19. He accounts for differences in taste in terms

of different degrees of attention or different degrees of 'natural acuteness'.

18 Kant, *Critique of Aesthetic Judgement*, §35, p. 143.

19 Gerard, *An Essay on Taste*, pp. 207–8. Kames puts forward precisely the same argument in his *Elements of Criticism* (III, pp. 401–2).

20 'In what sense we can talk either of a *right* or a *wrong* taste in morals, eloquence, or beauty, shall be considered afterwards, in the mean time, it may be observ'd, that there is such a uniformity in the *general* sentiments of mankind, as to render such questions of but small importance'; Hume, *A Treatise of Human Nature*, p. 547n. (One might compare this with James's similar treatment of the relationship between aesthetic and moral principles; *Principles of Psychology*, II, pp. 1264–8.) A similar argument is advanced by Addison (*Spectator* No. 409), and Burke (in his 'Introduction on Taste' in the second edition of *A Philosophical Enquiry*). Hume, Addison, Burke, and Gerard all acknowledge differences in taste in practice but remain assured that there are certain principles that will produce a 'correct' consensus and allow us to reason about taste.

21 'All tastes ... are equally just and true, in so far as concerns the individual whose taste is in question; and what a man feels distinctly to be beautiful is beautiful to him, whatever other people may think of it'; Jeffrey, 'Essay on Beauty', p. 292. He does, however, add that, since beauty consists in the reflection of our affections and sympathies, the perception of beauty will be 'nearly in proportion' to the degree of the individual's sensibility and 'social sympathies', so that we can speak of a taste being, if not actually 'bad', then at least 'peculiar' (pp. 292–3).

22 Alison, *Essays on the Nature and Principles of Taste*, II, ii, VI, vi, p. 416. This is, of course, the line that Kant took in defining the sublime.

23 Jeffrey, 'Essay on Beauty', p. 281. Hutcheson had also written of how inanimate objects may attain a beauty from their resembling (or bringing to mind) 'the passions and circumstances of human nature', though, according to Hutcheson, it is the resemblance, or bringing to mind, rather than *what* is brought to mind, which is, in itself, the grounds of the beauty; *An Inquiry into the Original of our Ideas of Beauty and Virtue*, pp. 37–8. Rousseau takes a more purely associationist line in Book III of *Emile*, where he writes that it is futile to simply present the child with the beauty of nature and expect the child to feel what you yourself feel; while the child may perceive the same objects, 'he cannot perceive the relations linking them', since, in order to be able to do this 'he needs sentiments he has not had'; *Emile*, p. 169. Though these beauties may appear merely physical, continues Rousseau, in fact they are a matter of association: the songs of birds remind us of the 'accents of love and pleasure', a beautiful day is one which brings to mind the pleasures it may contain, the spectacle of nature in general touches us because it leads us to the thought of 'the hand responsible for adorning it' (p. 169). He enlarges on this thesis in his *Essay on the Origin of Language*. If, he writes, 'those who philosophize about the power of sensations would begin by distinguishing pure sense impressions from the intellectual and moral impressions received through the senses, but of which the senses are only the occasional cause, they would avoid the error of attributing to sense objects a power they do not have, of that they have only in relation to affections of the soul which they represent to us': form, colour, sound, and even texture impress us with beauty only in so far as we take them as 'representatives and signs' of our affections and feelings; *Essay on the Origin of Language*, pp. 59–61. It is not, he concludes, the senses which convey pleasure to the heart, rather it is the heart which conveys pleasure to the senses (p. 61).

24 Jeffrey, 'Essay on Beauty', p. 282.

25 Ibid., pp. 284–5.

26 Alison rather vaguely attempts to answer this objection by saying that the 'delight' of beauty is distinct from the simple 'pleasure' inspired by the original in that it involves an 'additional train of thought'; *Essays on the Nature and Principles of Taste*, I, i, II, pp. 158–72.

27 Leibniz, 'Remarks on Three Volumes Entitled *Characteristiks of Men, Manners, Opinions, Times*' (1715), in *Philosophical Papers and Letters*, II, pp. 1022–32 (p. 1031). According to Coleridge, too, the 'sense of beauty is intuitive'; *A Course of Lectures* (1818), in *Essays and Lectures*, pp. 213–385 (p. 314). Johnson wrote that 'To convince a man against his will is hard, but to please him against his will is … above the realm of human abilities'; *Rambler* No. 93.

28 Montesquieu, 'An Essay on Taste', p. 265.

29 Burke, *A Philosophical Enquiry*, pp. 129–30.

30 Schiller *On the Aesthetic Education of Man*, 1.5.

31 Kant, *Critique of Aesthetic Judgement*, §57, pp. 207–9. And this is precisely the point where we have remained. Santayana, for example, writes that aesthetic values and preferences 'spring from the immediate and inexplicable reaction of vital impulse, and from the irrational part of our nature'; *The Sense of Beauty*, p. 19. Frye holds that the sense of aesthetic value is 'individual, unpredictable, variable, incommunicable, indemonstrable'; 'On Value-Judgements' (1968), in *The Stubborn Structure*, pp. 66–73 (p. 66). 'The attribution of a property termed "beauty"', according to Steenberg, 'is founded in a value experience; that is, a unique and fickle psychic event caused by neurological processes in the brain's pleasure–displeasure centres. Hence "beauty" … can neither be conceptually defined nor ostensively identified. And it is impossible to state a generally valid theory of necessary and sufficient features of something to justify ascribing to it the properties termed "beauty", "ugliness" and cognates'; 'Verbalizing the Aesthetic Experience', p. 364. That is to say, beauty is in the eye of the beholder.

32 Hume, *Enquiries Concerning Human Understanding*, p. 267.

33 Ibid., p. 294.

34 Firenzuola, *On the Beauty of Women*, pp. 13–14; 19.

35 Ibid., p. 14. In fact Firenzuola specifies every detail of what constitutes beauty in a (sixteenth-century Italian) woman – from the mathematical relationship between the length of the face and that of the body, to the depth of the lines in the palm of the hand – not excluding complexion. Stephen Marquardt, a Californian plastic surgeon, has recently made a similar mathematical deduction from the average proportions of publicly admired Caucasian faces of the twentieth century. This deduction was announced in some sections of the media as a solution to the mystery of beauty – a claim which ought to make a cat laugh.

36 Bruno, *De vinculis in genere*, quoted in Tatarkiewicz, *History of Aesthetics*, III, p. 295. Durer constantly sought to find the perfect, and perfectly beautiful, proportion, though he also held that such was our state of ignorance that it would never be found; 'Aesthetic Excursus', pp. 320–2. Thus when he writes that we do not know what beauty is, he does not mean that he does not believe it to be a real or potentially real property of some object (pp. 326–7). Pascal, *Pensées*, 90; 9. Diderot, too, though he holds true beauty to be a matter of reason, writes that taste 'has made its judgement long before it knows the motive for it'; *Isolated Thoughts on Painting* (1798), in *Selected Writings*, pp. 327–41 (p. 329).

37 Hume, 'Of the Standard of Taste' (1757), in *Essays*, pp. 226–49 (p. 241).

38 Plato, *Philebus*, 51c; 64e. Despite the difficulties concerning precisely how *kalon* is to be translated, in this instance the parallel seems justified, for he has just defined the word to mean that property which a thing possesses which gives us a pure, as opposed to

impure, pleasure, that is, pleasure the want of which is painless and unconscious, pleasure which is an end in itself. Or, to speak more plainly, as he does himself, the pleasure of contemplating order, measure, proportion, consonance, and harmony is quite unlike the pleasure of scratching. See also Plato, *Republic*, 476b–c.

39 Augustine, *On Free Choice of the Will*, II, 16, pp. 60–1. See also *Letters*, I, 18, pp. 43–4, and *Of True Religion*, in *Earlier Writings*, pp. 225–83 (xli, 77, p. 265). The transition can be discerned in Aristotle. For Aristotle the *kalon* is what is either desirable for its own sake and laudable, or both pleasant and good. Its properties are, however, the familiar Pythagorean ones – order and size, that is, proportion or *symmetria*; *Poetics*, 1450b. He adds, that if a creature were a thousand miles long it could not be beautiful because its unity would be lost to the beholder; thus allowing for the notion of *eurythmy*. Aristotle's definition applies, of course, to the making of plots. (Elsewhere, however, he applies the same standard, with the same qualifications, to the beauty of the city-state, of animals, of plants, and of tools; *Politics*, 13261–b.) Thus, as with Plato and his 'virtue', this proportion cannot appear, to us at least, as something of geometrical purity. Later the Stoics also found the essence of beauty in *symmetria*, though in applying it preeminently to spiritual beauty the supposed grounding in mathematics became more problematic.

40 Augustine, *City of God*, XI, 18, p. 449.

41 Unless one is a saint; see Augustine, *Confessions*, X, 34, pp. 239–41.

42 Boethius, *De institutione musica*, quoted in Tatarkiewicz, *History of Aesthetics*, II, p. 87. Eriugena likewise believed that music was judged by the inner sense of the soul which by instinct responded to 'rational intervals', that is, to proportion; *Periphyseon*, III, pp. 367–8.

43 Jacob of Lierge, *Speculum musicae*, quoted in Tatarkiewicz, *History of Aesthetics*, II, p. 134.

44 The notion of *kanon* is still alive in the Gothic cathedrals, the architects of which were often known as 'geometers' or 'master geometers'. All proportions, from whole to detail, were based on those simple figures which were held, after Pythagoras, to be most perfect. This notion of perfect forms explains what might otherwise, given the general beauty of creation, seem to be a redundancy in the concept of a beautiful thing in the world. Thus the scholastic Robert of Melun wrote that even formlessness (*informitas*) is form of a kind, but is called such because it is not beautifully formed (*pulchre formatum*); *Sententiae*, quoted in Tatarkiewicz, *History of Aesthetics*, II, p. 211. Beauty is 'harmony in proportion' (*Proportionum concordia pulchritudo est*), wrote Robert Grosseteste (*On the Six Days of Creation*, II.x.4, p. 99); beauty is based on proportion which in turn rests on musical relationships, wrote Bonaventure (*The Soul's Journey into God*, 2; 4–6, pp. 71–2); beauty is a certain *proportio* in accordance with the essential form of a thing, wrote Aquinas (*Summa Theologiae*, 2a2ae. clxxx. 2); according to Alberti, beauty is 'a harmony of all the parts, in whatsoever subject it appears, fitted together with such proportion and connection, that nothing could be added, diminished or altered, but for the worse' (*Ten Books on Architecture*, VI, ii, p. 113; see also *On Painting*, III, pp. 92–3); whoever can point to geometry in putting forward a certain proportion as the most beautiful should be believed by all, writes Durer ('Aesthetic Excursus', p. 322); beauty infuses itself into matter that is of the correct order, mode, and form, writes Poussin (*Observations on Painting*, pp. 144–5). And so we find ourselves almost at the end of the seventeenth century, with near universal agreement on the definition of the objective qualities of beauty. (Only Bacon, who describes Durer as a 'trifler' for wishing to 'make a personage by geometrical proportions', holds that there is 'no excellent beauty that

hath not some strangeness in the proportion'; 'Beauty' in *Essays*.) Alberti's psychologically accurate, but conceptually empty, claim that beauty is a harmony which cannot be altered without ceasing to be beauty has reappeared in a variety of guises. Wolff, for example, writes that 'True beauty arises from perfection. Apparent beauty arises from apparent perfection'; *Empirical Psychology* (1732), quoted in Carritt, *Philosophies of Beauty*, p. 81. Schiller writes that the 'highest ideal of beauty is ... to be sought in the most perfect possible equilibrium of reality and form' (though this equilibrium can never be fully realised); *On the Aesthetic Education of Man*, 16.1. Hazlitt describes beauty as some 'conformity of objects to themselves' ('On Beauty', in *The Round Table*, II, pp. 1–10 (p. 2)), Coleridge as 'the unity of the manifold, the coalescence of the diverse ... the union of the shapely (*formosum*) with the vital' ('On Poesy or Art'), Emerson as that 'which has no superfluous parts; which exactly answers its end; which stands related to all things; which is the mean of many extremes' (*The Conduct of Life* (1860), in *Essays and Lectures*, pp. 937–1124 (p. 1103)), and Newton as a perfect balance between sensation and perception, the sensuous and the intellectual (*The Meaning of Beauty*, p. 143). (Something of this confusion between the 'perfection' of beauty and perfection as beauty also lingers in aesthetics' perennial claim that in aesthetic interest every feature of the object is intrinsically relevant.) Apropos the two eighteenth-century tracts which are often held up as examples of proportionalist theories of beauty; Hogarth's *The Analysis of Beauty* is not (it is quite self-consciously an analysis of grace), while Reynolds's *Discourses* is a work in aesthetics.

45 Ficino, *Commentary on Plato's Symposium*, VI.14–15, 17–18. Symmetry, as his mentor Plotinus says, 'owes its beauty to a remoter principle'; *The Enneads*, I.6.1.

46 Cicero *De Officiis*, I, 98, p. 101. The definition of 'beauty' as a certain disposition of bodily parts combined with an agreeable colour will certainly not apply to virtue; Cicero, *Tusculan Disputations*, IV, xiii, 31, pp. 359–61. Repeated by Augustine; *City of God*, XXII, 19, p. 1060; see also XXII, 24, pp. 1073–5.

47 Cicero, *De Natura Deorum*, II, 37–8, p. 159.

48 Bonaventure, *The Soul's Journey into God*, 2, 6–10, pp. 72–5.

49 Augustine, *Confessions*, IV, 13, p. 83.

50 Augustine, *Of True Religion*, in *Earlier Writings*, pp. 225–83 (xxxii, 59, p. 255).

51 Augustine, *On Music*, in *The Immortality of the Soul Etc.*, pp. 169–379 (VI, 2–17, pp. 326–79).

52 Ibid., VI, 11, pp. 355–8. Boethius, *The Consolation of Philosophy*, III, viii, p. 92. This idea went back to the Greek Church Fathers; Basil of Caesarea, for example, had held that our judging things by sensory pleasure is a sign of our human limitation. God, in contrast, judges all things by appropriateness; *Exegetic Homilies*, III, 10, p. 53.

53 John of the Cross, 'The Ascent of Mount Carmel' (1579–85), in *Collected Works*, pp. 41–292 (p. 259).

54 Bonaventure, *The Breviloquium*, Prologue, 3, 3, p. 13.

55 Hutcheson, *An Inquiry into the Original of Our Ideas of Beauty and Virtue*, p. 96. This 'internal sense' has an affinity with the other senses in so far as it does not arise from any knowledge but rather from pleasure, and is distinct from them in so far as it responds to the 'complex ideas of objects' (pp. 4–11). Education and custom may influence this internal sense, he continues, but this itself presupposes that the sense of beauty is natural (p. 84). Blair similarly ascribes the existence of beauty and sublimity to the 'benignity of our Creator'; *Lectures on Rhetoric and Belles Lettres*, III, p. 29. (The connection between the beautiful and the divine did, however, more than merely 'linger' in another cor-

ner of the eighteenth century – it positively effloresced in the work of Edwards; see Delattre *Beauty and Sensibility in the Thought of Jonathan Edwards, passim*.)

56 Ruskin, *Modern Painters*, I, Pt I, Sect. I, Ch. VI, §1.

57 Ibid., §§1–2; 5. Burke is more circumspect, admitting himself unable to account for the giving of beauty to some women and animals rather than others, though he does not doubt that providence made this distinction with a view to some great end; 'his wisdom is not our wisdom, nor our ways his ways'; *A Philosophical Enquiry*, pp. 42–3.

58 Schlegel, *The Philosophy of Life*, p. 510.

59 'This thirst belongs to the immortality of man. It is at once a consequence and an indication of his perennial existence. It is the desire of the moth for the star. It is no mere appreciation of the Beauty before us – but a wild effort to reach the Beauty above. Inspired by an ecstatic prescience of the glories beyond the grave, we struggle, by multiform combinations among the things and thoughts of Time, to attain a portion of that Loveliness whose very elements, perhaps, appertain to eternity alone. And thus when by Poetry – or when by Music, the most entrancing of the Poetic moods – we find ourselves melted into tears – we weep then – not as the Abbaté Gravina supposes – through excess of pleasure, but through a certain, petulant, impatient sorrow at our inability to grasp now, wholly, here on earth, at once and for ever, those divine and rapturous joys, of which through the poem, or through the music, we attain to but brief and indeterminate glimpses'; Poe, 'The Poetic Principle' (1850), in *Poems and Essays*, pp. 91–113 (97–8); Baudelaire, 'Further Notes on Edgar Poe' (1857), in *Selected Writings*, pp. 188–208 (pp. 204–5).

60 'The form of the beautiful appeared to us to be so transcendent in itself that it glided with perfect continuity from the natural into the supernatural world. ... Crossing these boundaries so forgetfully, however, belongs to the essence of the beautiful and of aesthetics almost as a necessity. More than either metaphysics or ethics, aesthetics tends toward an immanental self-transfiguration on the part of the world even if it is only for the moment when the beautiful first catches the eye'; Balthasar, *Seeing the Form*, pp. 34–5.

Chapter 3

1 Plotinus, *The Enneads*, I.6.1; VI.7.22. 'Whence do we derive our standards of proportion, shape, or colour? Unless we can refer to some such standard, who has the right to assert that a pig's legs are too short? Too short for what? For the pig? ... It is easy to say that a horse's neck is nobly curved, but what constitutes nobility of curvature? Can one kind of curve be noble in its own right and another lacking in nobility? And what if one were to discover, on looking more closely, that the curve of a horse's neck was identical with the curve of a pig's backside?'; Newton, *The Meaning of Beauty*, pp. 28–9.

2 Plotinus, *The Enneads*, I.6.9. A symmetry, a poetic justice, is, of course, discoverable in the beauty of many of these things, but it is not a matter of quantity, for it is the beauty which makes them symmetrical rather than vice versa.

3 Plotinus, *The Enneads*, I.6.2–3.

4 Ibid., I.6.2.

5 Ibid., I.6.3; IV.3.31.

6 Ibid., I.6.7.

7 Ibid., I.6.6.

8 Ibid., I.6.2.

9 Ibid., I.6.5; V.8.13.

10 Ibid., I.6.3–4.

11 Ibid., V.8.2. On the necessity of abjuring the delights of this world in order to be ravished by God see also St John of the Cross, 'The Ascent of Mount Carmel' (1579–85), in *Collected Works*, pp. 41–292 (pp. 254–60).

12 Plotinus, *The Enneads*, I.6.4.

13 Pseudo-Dionysius, *The Divine Names*, in *Complete Works*, pp. 47–131 (4.2).

14 Ibid., 4.4.

15 Ibid., 4.7.

16 Ibid., 4.7. This is the primordiality of beauty we shall encounter again in Chapter 5.

17 Ibid., 4.9–10

18 The writings of Philo of Alexandria, with their synthesis of Jewish theology and Greek philosophy, both anticipated Neoplatonism and, indirectly, influenced early Christian writers.

19 Clement of Alexandria, *Christ the Educator*, III. i, pp. 199–200.

20 Methodius, *Three Fragments from the Homily on the Cross and Passion of Christ*, p. 400.

21 Basil of Caesarea, *Exegetic Homilies*, I.2; II.2; I.11.

22 Gregory of Nyssa, *On Virginity*, X–XI, pp. 354–56.

23 John Chrysostom, *Homilies on the Statues*, X.10, p. 111.

24 Augustine, *Confessions*, X, 34, pp. 239–241.

25 Augustine, *Expositions on the Book of Psalms*, CXLV.9, p. 659. He here calls beauty the voice of the dumb earth.

26 Eriugena, *Periphyseon*, IV, p. 479.

27 Hugh of St Victor, *Expositio in Hierarchiam Coelestem*, quoted in Tatarkiewicz, *History of Aesthetics*, II, p. 197.

28 Guibert of Nogent, *Memoirs*, I, 2, pp. 39–40.

29 *Summa Alexandrii*, quoted in Tatarkiewicz, *History of Aesthetics*, II, p. 224.

30 Robert Grosseteste, *On the Six Days of Creation*, VIII.i.2, pp. 221–2.

31 Nicholas of Cusa, *The Vision of God*, pp. 25–6.

32 Ficino, *Commentary on Plato's Symposium*, I.4.

33 Ibid., V.2.

34 Ibid., V.8.

35 Ibid., II.6.

36 Ibid., II.3, 5 .

37 Ibid., II.1. Firenzuola later described the beauty of women as 'an image and a semblance of the treasures of Heaven'; *On the Beauty of Women*, p. 19.

39 Ficino, *Commentary on Plato's Symposium*, V.2. The Pseudo-Dionysius uses the same word play, taken from either Plato or Proclus, in *The Divine Names* (4.7).

39 Ficino, *Commentary on Plato's Symposium*, IV.4.

40 Ibid., VI.17.

41 Ficino, *Commentary on Plato's Symposium*, V.5; 8; 11. 'In general one can say that with the removal of that which does not belong to the essence, beauty emerges automatically, since beauty is the absolute first element of a thing, its substance and essence whose appearance is only disturbed by empirical conditions'; Schelling, *The Philosophy of Art*, p. 133. Elsewhere, however, he says that the absolute cannot be beautiful except as intuited within limitation, that is, within the particular, for to remove all limitation is to remove form (p. 40).

42 Ficino, *Commentary on Plato's Symposium*, VI.16.

43 Ibid., VI.2.

44 Pope Clement VIII excised Clement of Alexandria's name from the martyrology in the sixteenth century because of the Gnostic leanings of some of his writings. When, in Genesis, God sees what he has created, he sees that it is good, that it is successful. This had, however, been translated by the Greek *kalos*, which, though it can refer to anything deserving praise and affording pleasure, is nevertheless ambiguous in that, as we have already seen, it also refers to phenomenal beauty. (The Latin translation was *bona*, not *pulchrum*, despite Ficino's identification of the latter with *kalos*.) Phenomenal beauty, for the Hebrews, was vanity, and the idea of representing the deity anathema; Prov. 21:31; Exod. 20:4, 23; 34:17; Deut. 4:15, 23; 5:8; 28:15. In the New Testament the word *kalos* occurs, but not in an overtly aesthetic sense; it is used of 'works', as they are seen, in Matthew (5:16), and in John (19:11, 14) 'the good shepherd' is *ho poimen kalos*.

45 It would be misleading to portray the notion of Beauty as in anyway central to Christian theology; if the Scholastics discussed the subject it is because the Scholastics discussed everything eventually; it is fundamentally a Platonic and Neoplatonic concern and, moreover, one which has aroused some theological suspicion against its champions. Nevertheless, it must be remembered that for more than a thousand years Dionysius's books enjoyed a status almost equal to that of the Bible itself.

46 Balthasar, *Seeing the Form*, pp. 11, 41. For example, in contrast to Dionysius's attitude, Balthasar consistently speaks of Christ as the 'exteriorisation', *eidos*, or 'form' of God. While he defends the essential Christianity of Dionysius's work he nevertheless speaks of a 'Neoplatonic pathos' that diffuses it, and warns that its style is such as easily to invite a negative, non-Christian form of mysticism (pp. 551–2). Weil too, who holds that beauty and affliction are the two main ways in which we are drawn to God, and who laments mainstream Christianity's failure to acknowledge beauty, nevertheless writes that, excepting God, 'nothing short of the universe as a whole can with complete accuracy be called beautiful'. Those things in the world, she continues, that indirectly share in, or imitate, this beauty 'are of infinite value as openings to universal beauty. But if we stop short at them, they are, on the contrary, veils; then they corrupt'; 'Forms of the Implicit Love of God', in *Waiting for God*, pp. 137–215 (pp. 160–5).

47 Plato, *Symposium*, 210–11.

48 Augustine, *Confessions*, IV, 13, p. 83. The pagan Maximus of Tyre had argued in favour of statues to the gods on the grounds that it is only through our concept of beauty that we can approach the concept of divinity; *The Philosophical Orations*, 2.10, p. 23.

49 See, for example, Jacopone da Todi's ninetieth laud; *The Lauds*, pp. 257–65. Curiously Burke too defines beauty as 'that quality or those qualities in bodies by which they cause love, or some other passion similar to it' (*A Philosophical Enquiry*, p. 91), though undoubtedly he means by 'love' something more narrow than did these earlier writers. He could be said to be taking the Protestant viewpoint when he makes the idea of God sublime rather than beautiful on the grounds that 'to our imagination' the most striking attribute of God is 'power' (p. 68).

50 Pseudo-Dionysius, *The Divine Names*, in *Complete Works*, pp. 47–131 (1.4).

51 Augustine, *Confessions*, X, 6, 25–7, pp. 212, 230–2. 'But what do I love when I love my God? Not material beauty or beauty of a temporal order; not the brilliance of earthly light, so welcome to our eyes; not the sweet melody of harmony and song; not the fragrance of flowers, perfumes, and spices; not manna or honey; not limbs such as the body delights to embrace. It is not these that I love when I love my God. And yet, when I love him, it is true that I love a light of a certain kind, a voice, a perfume, a food, an embrace; but they are of the kind that I love in my inner self, when my soul is bathed

in light that is not bound by space; when it listens to sound that never dies away; when it breathes fragrance that is not borne away on the wind; when it tastes food that is never consumed by the eating; when it clings to an embrace from which it is not severed by fulfilment of desire. This is what I love when I love my God' (X, 6, pp. 211–12).

52 Aquinas, *Summa Theologiae*, 1a. xiii. 5.

53 Ficino, *Commentary on Plato's Symposium*, II.4.

54 Philo of Alexandria, *The Embassy to Gaius*, 5, p. 5.

55 Pseudo-Dionysius, *The Divine Names* in *Complete Works*, pp. 47–131 (4.7).

56 'Theology', writes Balthasar, 'is the only science which can have transcendental beauty as its object, provided, that is, we may posit such an object in the first place. A philosophy which is specifically distinguished from theology in the narrower sense can envisage the absolute only as ... the limiting concept of a worldly ontology – and can, consequently, make only the most formal statements about it'; *Seeing the Form*, p. 70.

57 Longinus, *On the Sublime*, 35, p. 146. (This idea is echoed by Addison in the *Spectator* No. 413.) As Castiglione writes, in the presence of beauty the soul 'taketh a delite, and with a certaine wonder is agast, and yet enjoyeth she it, and (as it were) astonied together with the pleasure, feeleth the fears and reverence that men accustomably have towarde holy matters'; *The Book of the Courtier*, VI, p. 316. Firenzuola draws a comparison between the reaction to a beautiful woman (that 'foretaste of heavenly things') – shuddering, sweating, and shivering – and the reaction of one who 'unexpectedly seeing something divine, is possessed by divine frenzy'; *On the Beauty of Women*, p. 11.

58 Balfour, *Theism and Humanism*, p. 63. Darwin had said that while we seem biologically predisposed to find symmetry, among other properties, attractive, nevertheless many of our tastes must be acquired through culture, and 'depend on complex associations'; *The Descent of Man*, pp. 301–2.

59 Ruskin, *Lectures on Architecture and Painting*, p. 26. Otto appeals to the example of beauty in order to illustrate the immediate *a priori* nature of 'the numinous consciousness at its outset', and again in connection with the recognition, the 'divination', of the holy. While he does not identify the two, in describing them both as the sudden ascription to the object of an attribute which professes to interpret it, a meaning which I ascribe by a spontaneous judgement of my own, yet arising from an obscure *a priori* conception, he emphasises their affinity. (Moreover, he holds that beauty, like the holy, is really there – a person of crude taste can 'misapply' the term.) No intellectual, dialectical dissection or justification of such intuition is possible, he continues, nor indeed should any be attempted, for the essence most peculiar to it (the beautiful/holy) would only be destroyed thereby; *The Idea of the Holy*, pp. 134; 144; 147.

60 Ficino, *Commentary on Plato's Symposium*, VI.7.

61 Schelling, *Bruno*, pp. 121–7.

62 Ibid., pp. 121–7. A similar argument is to be found in his fellow Romantic Schlegel, who writes that the soul of God is 'the inner charm, the spiritual flower of nature, the hidden germ of all that paradisiacal loveliness which, though veiled in this terrestrial shroud, still gleams forth occasionally. It is even that sacred beauty which fills to the full the true artist's soul, even though he is never able fully and completely to realize it'; *The Philosophy of Life*, p. 509. More surprisingly, and evidence of how pervasive Neoplatonism has been, is Fichte's statement that 'only the religious eye penetrates to the realm of true Beauty'; *The Vocation of Man*, p. 151.

63 Ficino, *Commentary on Plato's Symposium*, II.6. Schelling's account is not, of course, merely

a repetition of Neoplatonic doctrine. Beauty, according to Schelling, exists wherever the real and the ideal come into contact; it is 'the only complete interpenetration or mutual informing' of the ideal and the real, the rational and the sensuous. Beauty exists wherever the particular (real) is so commensurate with its concept that the latter, as infinite, enters into the finite and is intuited in *concreto*. It is likewise the 'absolute synthesis' of necessity (truth) and freedom (goodness); *The Philosophy of Art*, pp. 29–31. It is the absolute intuited in (though not 'through') reality (p. 40). Thus although he too describes God as the 'source of all beauty' (p. 32), he also asserts that the absolute cannot be beautiful at all except as intuited within limitation, within the particular, since to remove all limitation is to remove form (p. 40). There is some truth here in so far as every medium is an aspect of necessity, so that every imagining, whether conscious (in art) or unconscious (beauty), is a rebellion against necessity.

Chapter 4

1 Santayana, *The Sense of Beauty*, pp. 44–52. 'What pleases is called beautiful, what displeases ugly'; Wolff, *Empirical Psychology* (1732), quoted in Carritt, *Philosophies of Beauty*, p. 81. Even Levinas, for whom the content of life *per se* is fundamentally enjoyment, speaks of art as the immersion of objects in 'the beautiful, where every going beyond enjoyment reverts to enjoyment'; *Totality and Infinity*, pp. 112–17; 140. This is not, however, the differentia of beauty, according to Santayana, for all pleasures are ends in themselves; though this appears peculiar to beauty in so far as we seem to 'discover' the pleasure of beauty rather than to seek it out. He explains this as a vestige of an animistic and mythological habit of thought that was once more general and included all pleasure and pain; *The Sense of Beauty*, pp. 37–39, 44–52. But in the absence of an explanation why this sense alone should remain so 'objectified', this in no way accounts for beauty in the way that other pleasures can be accounted for.

2 Democritus from Stobaeus, *Florilegium*, quoted in Tatarkiewicz, *History of Aesthetics*, I, p. 95.

3 Aristotle, *Rhetoric*, 1366a.

4 This is, at least, the perhaps unfair interpretation made by Maximus of Tyre, *The Philosophical Orations*, 32, pp. 254–61; 21.4, pp. 182–3.

5 See, for example, Hugh of St Victor, *Expositio in Hierarchiam Coelestem*, quoted in Tatarkiewicz, *History of Aesthetics*, II, p. 197.

6 Aquinas, *Summa Theologiae*, Iae–2ae. xxvii. 1.

7 Ibid., 1a. v. 4, 6, 1a–2ae. xxvii. 1. Kant too, of course, defines the delight that is peculiar to beauty by contrasting it with the delight, arising from interest, that is given us by the agreeable or the good; *Critique of Aesthetic Judgement*, §3, p. 44.

8 Plato, *Philebus*, 51b–d.

9 Aristotle, *Eudemian Ethics*, 1230b.

10 Eriugena, *Periphyseon*, IV, pp. 484–5; V, p. 659. Maximus of Tyre makes the same distinction between the philosopher's and the wicked man's love; *The Philosophical Orations*, 19.4, p. 4. Berkeley's account of beauty is rare in so confidently stating that the beauty of an object can be apprehended by knowing its use, that it is one thing to see an object and another to discern its beauty – though this last clause would have become a commonplace in aesthetics had it chosen to preserve 'beauty'. According to Berkeley there is no beauty without proportion, and this proportion is esteemed only relative to a cer-

tain use or end; this he calls the 'subordinate relative nature of beauty'; *Alciphron, or the Minute Philosopher* (1732), in *Works*, III, pp. 21–329 (III, 8–9, pp. 124–8). According to Burke, since proportion, like every idea of order, is almost wholly related to convenience it must be considered as a 'creature of the understanding, rather than a primary cause acting on the senses and imagination'; *A Philosophical Enquiry*, p. 92. Beauty cannot, therefore, depend upon proportion, since in beauty the effect is previous to any knowledge of the use, while 'to judge of proportion, we must know the end for which any work is designed' (p. 108). If beauty were a matter of mensuration, of calculation and geometry, he continues, then it would be possible to demonstrate beauty, to 'call in those natural objects for whose beauty we have no voucher but the sense, to this happy standard, and confirm the voice of our passions by the determination of reason' – which we cannot (p. 93). (Burke makes all of the intuitive and justified objections to proportion as the cause of beauty in Pt III, §§II–V.) His main target appears to be Hutcheson.

11 Beauty has also been characterised as whatever, through mere contemplation, 'excites pleasurable emotions', what 'pleases' the eye or ear, or what awakens 'admiration' or 'approval'. As an example of the total vapidity of the traditional and still current phenomenology of beauty take Savile's 'We are pleased as an effect of perceiving the beautiful thing'; *The Test of Time*, p. 160. Savile, however, is identifying beauty with aesthetic pleasure. Such an identification must lead to a very strange characterisation of beauty, for not all pleasures are of so conscious or durable a nature as the enjoyment that often belongs to the experience of art.

12 Indeed we might characterise beauty as a sense of pleasure in search of an object. Derrida's normally irritating beating of everything but the bush is peculiarly apposite in this particular instance: 'almost nothing remains (to me): neither the thing, nor its existence, nor mine, neither the pure object nor the pure subject, no interest of anything that is in anything that is. And yet I like: no, that's still going too far, that's still taking an interest in existence, no doubt. I do not like, but I take pleasure in what does not interest me, in something of which it is at least a matter of indifference whether I like it or not. I do not take this pleasure that I take, it would seem rather that I return it, I return what I take, I receive what I return, I do not take what I receive. And yet I give it to myself. Can I say that I give it to myself? It is so universally objective – in the claim made by my judgement and by common sense – that it can only come from a pure outside. Unassimilable. At a pinch, I do not even feel this pleasure which I give myself, by which I give myself, if to feel means to experience: phenomenally, empirically, in the space and time of my interested or interesting existence. Pleasure which it is impossible to experience. I never take it, never receive it, never return it, never give it to myself because I (me, existing subject) never have access to the beautiful as such. I never have access to pure pleasure inasmuch as I exist. And yet *there is* pleasure, some still remains'; *The Truth in Painting*, p. 48.

13 Kant, *Critique of Aesthetic Judgement*, Introduction, p. 16n.1.

14 One might, for example, see metaphysics in Freudian terms, as a conflict between the timeless id and some unconscious part of the ego, a deadlock in the struggle between the pleasure and reality principles – if one finds such allegories useful.

15 Kant makes a similar point when he writes that reason has a strong interest in nature showing or suggesting that it 'contains in itself some ground or other for assuming a uniform accordance of its products with our wholly disinterested delight'; *Critique of Judgement*, §49, p. 161. His mistake is to see this interest as unconnected with the 'dis-

interested' nature of the delight.

16 Kant *Critique of Aesthetic Judgement*, §35, p. 143. I do not, of course, believe that Kant's own deduction from these 'formal peculiarities' was a valid one. But I intend to deal with this at length in another book.

17 I use 'eudaemonia' here in the Platonic rather than Aristotelian sense, that is, as bliss, beatitude, perfection, fulfilment; see *Phaedo*, 81–114, *Republic*, 516–26.

18 Spinoza, *Ethics*, III, Propositions VI–IX, pp. 91–2.

Chapter 5

1 In the first chapter of this book I wrote that perhaps the most consistently beautiful objects are people, by virtue of their entailing so many associations and implications. There is no contradiction here, for in the case of the person the associations are open, not necessary, and therefore, in the absence of misanthropy, these associations, rather than fixing the object, as is the case with the merely plastic, lend it an amplitude, an ambiguity, that can still be felt as a promise.

2 Muratori, *The Perfection of Italian Poetry* (1706), quoted in Carritt, *Philosophies of Beauty*, p. 61. Maritain, *Art and Scholasticism*, pp. 26; 23. The Neoplatonic tradition, mediated by Scholasticism, is strong in Maritain, for whom beauty is the principle determining the peculiar perfection of everything which is, constituting and completing things in their essence and qualities, the ontological secret of their innermost being. The mind rejoices in the beautiful, therefore, because in it it finds itself again, comes into contact with its own light, impressed into what is external to it by the creative Mind from which all things arise (pp. 24–5). However, for Maritain, the ontological splendour, or 'brilliance of form', that beauty manifests is not conceptual clarity; rather the more substantial and profound the secret significance of a thing the more concealed from us it is; the artist is on the track of wisdom, pursuing its perfume, but never possessing it (pp. 28–9, 36).

3 Hutcheson, *An Inquiry into the Original of Our Ideas of Beauty and Virtue*, pp. 95–6.

4 *Ibid.*, p. 97.

5 I intend to deal with Hutcheson at greater length in a work on Kant.

6 Diderot, 'The Beautiful', p. 138. Tastes vary, according to Diderot, as a result of differences in knowledge, experience, practice in judging, contemplativeness, natural scope of the mind, interests, passions, prejudices, usages, manners, climates, customs, the continual flux of the senses, the association of disagreeable ideas with objects that are in themselves beautiful, and so on (pp. 143–5); 'Despite all these causes of the diversity of our judgements, there is no reason to infer that real beauty, the beauty which consists in the perception of relations, is an illusion' (p. 146).

7 Santayana, *The Sense of Beauty*, pp. 192–3. (Bradley describes the 'aesthetic attitude' as 'the perceived equilibrium' of thought and will; *Appearance and Reality*, p. 419.) Sircello advances a similar thesis in making the adjectival form 'beautifully' (as it applies to adjectives) 'the basic linguistic form for the subject matter of a general theory of beauty'; *A New Theory of Beauty*, p. 16. According to Sircello, we enjoy beauty because it is, or seems, a particularly clear perception of qualities, and from this felt clear perception arises the pleasure of knowing, and of 'feeling that our faculties are in excellent order'; 'In perceiving beauty we are filled, if only for a moment, and if only in a limited respect, by a feeling of transcendent well-being' (pp. 129–38). According to

Kant, too, the determination of an object, which is indispensable to forming a representation of it, is invariably coupled with delight because it is the solution to a problem. However, this delight, he continues, arises from the value set upon the solution it is not the product of a free and indeterminately final contemplation as is the delight of beauty; *Critique of Aesthetic Judgment*, §22, p. 88. This is a good answer to those who see beauty as the result of the efficient functioning of ordinary perception, or this functioning at its most self-reflective. However, in my own theory, the idea of solution exceeds any particular instance of solution: the solution is not itself beautiful, since beauty is not simply transcendence or the desire for solution but rather a consciousness of this combined with a consciousness of the vanity of this desire – so that it is only in the case of certain solutions that the correct conditions will exist for an instance of beauty. Solution in itself is not beautiful because the idea of solution exceeds every instance of the particular, though certain instances, as tokens, do create the beautiful, for precisely this reason.

8 Spencer, *The Principles of Psychology*, II, ix, §536, pp. 635–8. A similar explanation can be found in Mitchell's *Structure and Growth of the Human Mind* (XVIII, §17, pp. 501–6), and, on a more metaphysical level, in Whitehead's *Adventures of Ideas* (Ch. XVII passim). Elsewhere Whitehead defines 'aesthetic' in a way that has affinities with Diderot's definition of 'beauty'; see *Modes of Thought*, pp. 60–2.

9 Allen, *Physiological Aesthetics*, p. 34. According to Allen every state of consciousness is a reflex or outcome of the physical state of the nervous system. Moreover, such is the consensus produced between the organs by natural selection that whatever is prejudicial or beneficial to the organism is generally painful or pleasurable respectively to the separate organs (p. 29). 'Aesthetic feeling' is an activity for the eyes and ears not undertaken for any 'ulterior life-serving object' but 'merely for the sake of the pleasure which the exercise affords us' (p. 34). 'The aesthetically beautiful', he concludes, 'is that which affords the Maximum of Stimulation with the Minimum of Fatigue or Waste, in processes not directly connected with vital functions' (p. 39). Lee and Anstruther-Thomson explain aesthetic phenomena in terms of 'formal–dynamic empathy': we 'make form exist in ourselves by alteration in our respiratory and equilibratory processes, and by initiated movements of various parts of the body'; *Beauty and Ugliness*, p. 236.

10 Ogden, Richards, and Woods, *The Foundations of Aesthetics*, pp. 72–9. Read, too, writes that the sense of beauty is satisfied 'when we are able to appreciate a unity or harmony of formal relations among our sense perceptions'; *The Meaning of Art*, §1.

11 Richards, *Principles of Literary Criticism*, Ch. VIII passim.

12 Newton, *The Meaning of Beauty*, p. 31.

13 Ibid., p. 49.

14 Ibid., pp. 39–41; 68.

15 Ibid., p. 69.

16 Several writers have grounded beauty in sexual desire. Nietzsche, for example, holds that the peculiar 'sweetness and plenitude' characterising the feeling of beauty may have its origin in sensuality, that beauty may be transfigured sexual excitation; *On the Genealogy of Morals*, III, §8, p. 111. Burke, unusually among theorists of beauty, allows that while the perception of beauty (love) and the feeling of desire are separate, they may operate together with respect to the same object; though it is to desire 'that we must attribute those violent and tempestuous passions, and the consequent emotions of the body which attend what is called love … and not to the effects of beauty merely

as it is such'; *A Philosophical Enquiry*, p. 91. His description of the characteristic effect of beauty as a sinking, melting languor, a passion 'nearer to a species of melancholy, than to jollity and mirth', suggests something nearly akin to female sexual arousal (pp. 122–3): 'The head reclines something on one side; the eyelids are more closed than usual, and the eyes roll gently with an inclination to the object, the mouth is a little opened, and the breath drawn slowly, with now and then a low sigh: the whole body is composed, and the hands fall idly to the sides. ... [It] is almost impossible not to conclude, that beauty acts by relaxing the solids of the whole system. There are all the appearances of such a relaxation; and a relaxation somewhat below the natural tone seems to me to be the cause of all positive pleasure' (pp. 149–50).

17 See Johnston and Franklin, 'Is Beauty in the Eye of the Beholder?', *passim*.

18 Plotinus, *The Enneads*, VI.7.22; I.6.2. Santayana indicates how there may be some justification in such a teleology, even while himself rejecting the idea of beauty as an adumbration of divine attributes: a blue sky may please because it seems the image of a serene conscience, or the purity of nature, but this expressiveness is due to certain qualities of the sensation which bind it to all things happy and pure, and where happiness and purity are embodied in the idea of God so also this idea will follow in train; *The Sense of Beauty*, p. 8. 'There is, then, a real propriety in calling beauty a manifestation of God to the senses, since, in the region of sense, the perception of beauty exemplifies that adequacy and perfection which in general we objectify in an idea of God' (p. 10).

19 Lactantius, *The Workmanship of God*, *passim*; Basil of Caesarea, *Exegetic Homilies*, III, 10, p. 53; Athanasius, *Against the Heathen*, in *Select Writings*, pp. 1–30 (§§34, 47, pp. 22, 29).

20 Eriugena, *Periphyseon*, I, p. 118; IV, pp. 502–3.

21 According to Heidegger beauty is 'the advent of truth, truth's taking of its place', and lies in form by virtue of that form's taking its light from 'Being as the isness of what is'. Heidegger's main concern here is beauty as the happening of unconcealedness in the work of art; 'Beauty does not occur along side and apart from this truth [the truth of Being]. When truth sets itself into the work, it appears. Appearance – as this being of truth in the work and as work – is beauty'; 'The Origin of the Work of Art' (1960), in *Poetry, Language, Thought*, pp. 15–87 (p. 81).

22 Cardano, *De subtilitate* (1550), quoted in Tatarkiewicz, *History of Aesthetics*, III, p. 160. For a detailed discussion of the place of the relationship of sight to knowledge in the Renaissance see Summers, *The Judgement of Sense*, *passim*.

23 This raised some problems with respect to the definition of beauty as a harmony or proportion between parts. Robert Grosseteste surmounted this difficulty by stating that it is what is simple that possesses the most perfect, that is, uniform and internally harmonious, proportion; *On the Six Days of Creation*, II.x.4, pp. 99–100. Moreover the material world, according to the Bible, had first appeared as light and thus geometrical aesthetics could be saved by pointing out that, since light radiates in straight lines, the harmony and geometrical beauty of the world are attributable to its origins in light.

24 Basil of Caesarea, *Exegetic Homilies*, II, 7, pp. 32–3; Aquinas, *Summa Theologiae*, 2a–2ae. clxxx. 2. See also Aristotle's *Metaphysics*, 980a.

25 Ficino, *Commentary on Plato's Symposium*, I.4; V.2. Alison, apparently disregarding his own associationist theory, states that smells and tastes cannot be called 'beautiful' because they produce 'agreeable sensations' rather than 'agreeable emotions'; *Essays on the Nature and Principles of Taste*, I, ii, 1, pp. 176–8. Kant, equally inconsistently, asserts that the beauties of nature must belong only to modifications of light or sound, since these are not merely sensations but also permit reflections upon themselves; *Critique of Aesthetic Judge-*

ment, §42, p. 161. Schiller and Hegel likewise accept only the eye and ear as aesthetic organs; On the Aesthetic Education of Man, 26.6; Introductory Lectures on Aesthetics, p. 43. Sight occupies the highest position in Schopenhauer's account of beauty, as light is 'the correlative and condition of the most perfect kind of knowledge through perception, of the only knowledge that in no way directly affects the will'; The World as Will and Representation, I, p. 199. In contrast, tones can excite pain or pleasure 'immediately', while, at a still lower level, touch, as intimately connected to the feeling of the whole body, is still more subject to the direct influence of the will. Smell and taste are most closely related to the will and 'hence are always the most ignoble' (pp. 199–200). Coleridge writes that since beauty is a harmony and subsists only in composition, only those senses that can discern parts can appreciate it; 'On the Principles of Genial Criticism Concerning the Fine Arts' (1814), in Selected Poetry and Prose, pp. 401–16 (pp. 403–7). Knight, after a very sceptical introduction indeed, which dismisses reason, consensus, or custom as any guarantee of the objectivity of beauty, concludes by saying that hearing and sight alone are the proper realm of taste 'as used to signify a general discriminative faculty arising from feeling and correct judgement implanted in the mind of man by his Creator, and improved by exercise, study and meditation'; An Analytical Enquiry, p. 18. (Paglia preserves this standpoint in her own theory: beauty, she writes, is our weapon against nature, our 'escape from the murky flesh-envelope that imprisons us'; Sexual Personae, p. 57.) Despite common usage this distinction persists into modern aesthetics, the 'higher' senses now being dignified with the apparently neutral 'contemplative', 'intentional', or 'cognitive'. Prall, for example, allows that smells and tastes can be beautiful, though they will always remain only 'elements of the aesthetic', being, in themselves, unamenable to relational structures, or movements, or processes, and, hence, 'aesthetically elementary'; Aesthetic Judgement, pp. 57–75. Likewise Sheppard suggests that gustatory taste is a matter of aesthetic appreciation – though it could hardly fit into the scheme she develops for aesthetic appreciation in connection with art; Aesthetics, p. 56. Burke is almost alone in the history of beauty in allowing a beautiful of touch; A Philosophical Enquiry, p. 120.

26 Schelling, System of Transcendental Idealism, p. 229.

27 Ibid., p. 231. Schelling fixes on the beauty of art, and for him beauty is the sine qua non of the work of art, rather than nature because he sees our ascription of beauty to nature as inspired by our response to art, and natural beauty as thus 'altogether contingent' on that response (pp. 226–7).

28 Schelling, System of Transcendental Idealism, pp. 5, 225.

29 Schelling, Bruno, pp. 121–7. This is Anselm's thesis.

30 Schopenhauer, The World as Will and Representation, I, p. 195; see also Essays and Aphorisms, pp. 157–81.

31 Schopenhauer, Essays and Aphorisms, pp. 160–1. Turner, too, plays a variation on this theme of beauty giving 'access to the objective reality of the universe', though, like his predecessors, he can support the claim only by way of analogy and rhapsody; 'The beauty experience is as much more constructive, as much more generous to the outside world, as much more holistic and as much more exact and particularizing than ordinary perception, as ordinary perception is than mere sensation'; Beauty: The Value of Values, pp. 15; 58.

32 Hegel, Introductory Lectures on Aesthetics, p. 80. Unusually for an idealist philosopher, Bradley rejects the idea that the 'aesthetic attitude' is a transcending of 'the opposition of idea to existence'; Appearance and Reality, pp. 410–11. Since pleasure belongs to the essence of

beauty, he writes, we must allow that beauty is determined by a quality in the subject. On the other hand, even if the beautiful object could be taken as 'independent' it would still be a finite fact, and therefore 'no more than appearance' (p. 112).

33 See Schopenhauer, *The World as Will and Representation*, I, pp. 196; 199.

34 Ibid., II, p. 368. Could it not rather be that we so completely identify with the external as to appear to disappear, even while remaining conscious of this, the happiness being a product of the will satisfied in self-abnegation rather than simply the abnegation of the will in itself?

35 Nietzsche, *On the Genealogy of Morals*, III, §6, pp. 104–6.

36 Croce, *Aesthetic*, pp. 11; 17.

37 Prall, *Aesthetic Judgement*, p. 57. Hegel, too, had written that we are not regarding a thing as beautiful so long as we consider its necessary connections with other things; 'Beauty has its being in appearance'; *Introductory Lectures on Aesthetics*, pp. 4, 6. He specifically connects this attitude to art rather than nature. The subject allows the work to subsist as a free and independent object, appealing only to the theoretical side of the mind, and can do so only because the sensuous presence, while not ceasing to be sensuous, is nevertheless 'liberated from the apparatus of its merely material nature', that is, is semblance (pp. 41–4). Findlay describes the 'aesthetic field' as 'one of suspended conception, of pure having something before one for contemplation: it is a field essentially divorced from the Yes–No of belief and conviction, as it is divorced from the other Yes–No of practical concern with its necessary involvement in reality'; 'The Perspicuous and the Poignant', p. 94. (I have argued, in *Literature, Rhetoric, Metaphysics*, that the aesthetic is an unqualified 'yes, yes, yes'.) This notion of disinterest is further discussed in Chapter 8 below.

38 The problem with this theory is that it is quite possible to operate cognitively in the world without being in this divided state and yet not to experience beauty. When I locked the door which I later cannot recall if I locked I was not struck with a sense of beauty ... I was not struck by anything. It is difficult to see how this efficient or harmonious functioning of the mind necessarily gives rise to anything other than either unconsciousness (as in the case of locking the door) or a sense of well-being (which sense sometimes, but not invariably, gives rise to a feeling of beauty).

39 See note 33 above, and also Schopenhauer, *The World as Will and Representation*, II, p. 291.

40 Stolnitz, *Aesthetics and Philosophy of Art Criticism*, pp. 33–42.

41 According to Bevan the feeling called up by intense admiration for the beautiful contains 'something akin to intellectual apprehension; you seem to take knowledge of some world of reality there behind the object, or spreading out like a halo from the object', there is 'the sense of a world of reality for which the beautiful things stands', a world 'without any definite concept attached to it, characterised simply by the emotion it excites'; *Symbolism and Belief*, pp. 244, 246. Beauty gives us a sense of 'immense' but undefinable meaning, similar to what we experience with sex, insanity, and religion (pp. 253–6).

42 On the contrary, the cessation of the beauty of an object is often experienced as a coming into focus, a sudden ability to discern components where before there was only a whole.

43 Ficino, *Commentary on Plato's Symposium*, I.3. Thus, according to Ficino, it is Love that immediately follows Chaos and precedes World – Love is the oldest of the gods.

44 Ibid., II.3.

45 Heidegger, *Being and Time*, §§12–24 *passim*.

46 Hence his assertion that 'All the motions of the soul have their cause in the Beautiful which is beyond motion and rest.'

47 Aristotle, *Metaphysics*, 1078a–b.

48 Like Augustine and Boethius, Traherne believes that the world is 'the beautiful frontispiece of Eternity', but that, like all beauty, being a 'silent and quiet object of the eye', it eventually 'grows common and despised'; *The Centuries*, I.20; II.20 (spelling modernised). 'The universe', according to Schelling, 'is formed in God as an absolute work of art and in eternal beauty', so that all things, viewed as a totality or 'in themselves', are absolutely beautiful: 'Perverted or ugly things, however, just as error or falsity, consist of mere privation and belong only to the temporal view of things'; *The Philosophy of Art*, p. 31.

49 Kant, *Critique of Aesthetic Judgement*, §40, p. 152n1. Hume declares that 'Reason being cool and disengaged, is no motive to action, and directs only the impulse received from appetite or inclination, by showing us the means of attaining happiness or avoiding misery: Taste, as it gives pleasure or pain, and thereby constitutes happiness or misery, becomes a motive to action, and is the first spring or impulse to desire and volition'; *Enquiries Concerning Human Understanding*, p. 294.

50 'What is man before beauty cajoles from him a delight in things for their own sake, or the serenity of form tempers the savagery of life? A monotonous round of ends, a constant vacillation of judgements; self-seeking, and yet without a Self; lawless, yet without Freedom; a slave, yet to no Rule. At this stage the world is for him merely Fate, not yet Object; nothing exists for him except what furthers his own existence; that which neither gives to him, nor takes from him, is not there for him at all. Each phenomenon stands before him, isolated and cut off from all other things, even as he himself is isolated and unrelated in the great chain of being'; Schiller, *On the Aesthetic Education of Man*, 24.2.

51 Schopenhauer, *The World as Will and Representation*, I, p. 197. For Pascal each of us contains a model (*modèle*) of beauty which accounts for the relationship between our nature and what pleases us; *Pensées*, 931. This notion of an ideal is a popular conversation piece whenever the question of beauty arises, but never having possessed such an ideal I have not addressed the notion directly in my work. Of course, one shapes one's life towards what, on reflection, is no more than an image, but such an image is inseparable from the happiness it portends (or signifies the absence of) and is distinguished by its very lack of stability as an image (like Chateaubriand's sylph – a kaleidoscope of this and that woman, portraits, religious pictures). I see a place, I feel a moment of joy, and project them to infinity, to what life will become – but this process never works in reverse, that is, it cannot start from a deliberately conjured image of what is not and thereby cause a perception of beauty in the present. It is essential to the nature of beauty that it should strike; it is impossible to remember an object as beautiful – as opposed to remembering an object and remembering that you found it beautiful, that is, remembering the displacement created by the sensation – let alone hypothesise a beauty. Beauty belongs exclusively to the present, and a beautiful thought, whether inspired by the past or the future, is beautiful only because it is thought *now*.

52 Knight expresses this well in his paradoxical statement that 'those things in Nature and Humanity are most beautiful which most of all suggest what transcends themselves'; *The Philosophy of the Beautiful*, p. 15.

53 In precisely the same way as people recently bereaved, and apparently dwelling on nothing but their bereavement, will suddenly 'break down' over some detail, some association which brings the import of the event to them in a way that transcends mere awareness of it.

Chapter 6

1 Shelley describes how with the death of the power of love 'man becomes the living sepulchre of himself'; 'On Love', in *Essays and Letters*, pp. 51–4 (p. 54). 'And it is, after all, as good a way as any of solving the problem of existence to get near enough to the things and people that have appeared to us beautiful and mysterious from a distance to be able to satisfy ourselves that they have neither mystery nor beauty. It is one of the systems of mental hygiene among which we are at liberty to choose our own, a system which is perhaps not to be recommended too strongly, but gives us a certain tranquillity with which to spend what remains of life, and also – since it enables us to regret nothing, by assuring us that we have attained to the best, and that the best was nothing out of the ordinary – with which to resign ourselves to death'; Proust, *Remembrance of Things Past*, I, p. 1011.

2 Ficino, *Commentary on Plato's Symposium*, VI.9. A more relaxed attitude to the matter may be found in Castiglione's *Book of the Courtier* (IV, pp. 303–22). The element of gallantry in Renaissance Neoplatonism makes it difficult to deduce a consistent notion of the relationship between beauty and religion from it. Firenzuola, for example, talks of a beautiful woman as, 'through her virtue', directing the soul to contemplation and thus ultimately to God. Yet he adds that the effect of this beauty is to make the beholder adore it, 'recognizing it as something like a god', and 'give himself to it as a sacrificial victim of the altar of the beautiful woman's heart'; *On the Beauty of Women*, p. 11. The relationship between the woman's beauty, her virtue, her heart, and the reaction of the beholder to any or all of these, and God, is very far from clear.

3 Ficino, *Commentary on Plato's Symposium*, VI.19; VIII.15.

4 Plato, *Symposium*, 203b.

5 Ibid., 202e.

6 Taylor, commenting on this passage, writes that the quality referred to, partly possessed but wholly desired, is rationality; *Plato*, p. 226. According to Huet the faculties of the mind are of too great an extent to be filled by and satisfied with present objects, 'for which reason she searcheth into what is past and to come, into truth and falsehood, into imaginary spaces and even impossibilities, to find out wherewithal to exercise and satisfy those faculties'. This, he continues, is what Plato represents in the figures of Poverty and Plenty (who correspond to the faculties and the world, respectively), for the result of this lack and concomitant searching is pleasure, a pleasure 'equal to that one finds in appeasing a violent hunger or in drinking after having been long under an impatient thirst'; 'The Original of Romances', pp. 199–200.

7 Plato, *Symposium*, 204d.

8 Ibid., 206a.

9 It is interesting to note that the Platonic ascension from the beautiful young man to the Form itself is an ascension from the temporal to the eternal. That beauty is incomplete in itself is not a separate issue from this.

10 Plato, *Symposium*, 210e–211b.

11 'If love be the fever which you mean, kind heaven avert the cure. Let me have oil to feed the flame and never let it be extinct, till I myself am ashes'; Congreve, *The Old Bachelor* (1693), Act II, scene ii.

12 'In the lover's realm, there is no *acting out*: no propulsion, perhaps even no pleasure – nothing but signs, a frenzied activity of language'; Barthes, *A Lover's Discourse*, p. 68.

13 Lest you should fall into the error of taking what follows as an account of unrequited

146

love I must emphasise the obvious, that is, that beauty does not diminish on one's learning that the feeling is 'returned'.

14 As in the case of a sudden, overwhelming attraction which as suddenly departs: we had not conjectured any accent, we had not made accent a condition of the beauty, we had not even thought of accent, and yet, strangely ... this is the wrong accent!

15 Ficino, *Commentary on Plato's Symposium*, V.8.

16 The phrase is Ficino's; *ibid.*, V.3.

17 Gautier, *Mademoiselle de Maupin*, p. 178. 'When I see something beautiful, I should like to touch it with my whole self, everywhere at the same time. I should like to sing it and paint it, sculpt it and write it, to be loved by it as I love it myself. I should like what cannot be and cannot ever be' (p. 178).

18 The great age of beauty was the age of courtly love. Lancelot and Guenever, Tristan and Isolt – how little all this has to do with love! An idle speculation; did the focus of men's passionate love shift to women in the eleventh century precisely because Christianity had, through prohibition, given such (metaphysical as opposed to merely social) weight to the sexual act that it began to appear as a consummation in itself, began to be what it is to us now, that is, principally a transcendental symbol?

19 Ficino, *Commentary of Plato's Symposium*, II.6.

20 'I cannot get out of my mind that love's great sadness may be a certain and much nobler fate than any other pleasure, since pleasant languor is involved in it. ... One cannot know, except by experience, the great pleasure which exists in the mere intention of him who is a true lover and loves himself for being of such a mind'; March, *Selected Poems*, p. 57 (Poem XXXIX).

21 It is hard, writes Benson, 'to resist the belief, when one is brought into the presence of perfect beauty, in whatever form it may come, that the deep craving it arouses is meant to receive a satisfaction more deep and real than the act of mere contemplation can give. I have felt in such moments as if I were on the verge of grasping some momentous secret, as if only the thinnest of veils hung between me and some knowledge that would set my whole life and being on a different plane. But the moment passes, and the secret delays. Yet we are right to regard such emotions as direct messages from God; because they bring with them no desire of possession, which is the sign of mortality, but rather the divine desire to be possessed by them; that the reality, whatever it may be, of which beauty is the symbol, may enter in and enthral the soul'; *From a College Window*, p. 96.

22 Kant, *Critique of Aesthetic Judgement*, §12, p. 64.

23 According to Ficino vulgar love, the falling down from sight to touch, is a form of madness, contracted though the blood, by which 'man sinks back to the nature of the beast'; *Commentary on Plato's Symposium*, VII.12.

24 Plotinus, *The Enneads*, VI.7.22.

Chapter 7

1 Ficino, *Commentary on Plato's Symposium*, VI.10.

2 Santayana, *The Sense of Beauty*, p. 23.

3 Ficino, *Commentary on Plato's Symposium*, VII.15.

4 *Ibid.*, V.4.

5 *Ibid.*, VII.5; I.4; VII.6. See also Lucretius, *De Rerum Natura*, 4.1052–6; 1108–20.

6 Ruskin, *Modern Painters*, II, Pt III, Sect. I, Ch. II, §8.

147

7 Ibid.
8 Ibid.
9 Ibid., §10.
10 Ibid., Ch. III, §1.
11 Eagleton, 'The Ideology of the Aesthetic', pp. 328–30. According to Adorno beauty is
 'a realm of possible freedom' because it 'falls outside of that natural causality which the
 subject continually imposes on phenomena'; *Aesthetic Theory*, p. 388, Note A–32.
12 This is roughly the position that Schiller takes in *On the Aesthetic Education of Man*, though
 his particular theory of what beauty is allows him to assert its pivotal importance in
 moral education. According to Schiller 'if man is ever to solve the problem of politics
 in practice he will have to approach it through the problem of the aesthetic, because it
 is only through Beauty that man makes his way to Freedom' (2.5). Only in the aes-
 thetic stage of perception is the world put outside the self, and thus manifested for the
 self which has now ceased to be one with it (25.1). Hegel, too, believed that artistic
 beauty could resolve and reduce to a unity the 'contradiction between the abstract self-
 concentrated mind and actual nature, whether that of external phenomena, or the inner
 subjective feelings and emotions'; *Introductory Lectures on Aesthetics*, p. 62.
13 'We love beauty', writes Augustine; 'let us first choose confession, that beauty may fol-
 low'; *Expositions on the Book of Psalms*, XCVI.7, p. 472. Fry notes that 'so curiously inter-
 twisted are our emotions that we are always apt to put a wrong label on them, and the
 label 'beauty' comes curiously handy for almost any of the more spiritual and disinter-
 ested feelings'; 'The Ottoman and the Whatnot' (1919), in *Vision and Design*, pp. 39–45
 (p. 44). And vice versa. (Likewise, as Nietzsche writes, 'Whenever man feels in anyway
 depressed, he senses the proximity of something "ugly"'; *Twilight of the Idols*, §20, p. 79.)
 There is, for example, Pater's famous reason for why we should be moral: because it is
 so beautiful! (As a classicist he must have been aware of Isocrates's claim – deliberately
 sophistical though it probably was – that the virtuous life is the most highly regarded
 because it is the most beautiful; in precisely the same sense, that is, in which Helen of
 Troy was beautiful; *Helen*, 54–5, pp. 89–91) 'The cultivated aesthetic sense', writes Day,
 'rejects the immoral as instinctively as the ugly'; *The Science of Aesthetics*, p. 420. Turner
 makes a similar claim, with a similar nineteenth-century vigour, in his late twentieth-
 century *Beauty: The Value of Values* (*passim*). According to Coomaraswamy beauty is the
 attractive aspect of goodness; 'Why Exhibit Works of Art?' (1941), in *Christian and Orien-
 tal Philosophy of Art*, pp. 7–22 (p. 17). Hume advocates the cultivation of 'delicacy of taste',
 that is, a susceptibility to beauty, as a remedy for an undesirable degree of 'delicacy of
 passion', and a way of approaching more closely to the ideal of stoicism, since such a
 cultivation both 'improves our sensibility for all the tender and agreeable passions'
 while at the same time rendering the mind 'incapable of the rougher and more boister-
 ous emotions'; 'Of the Delicacy of Taste and Passion' (1741), in *Essays*, pp. 3–8 *passim*.
 (Compare Mill's 'Bentham' (1838), in *Utilitarianism*, pp. 78–125 (p. 122).) Indeed
 Hume goes further, distinguishing reason from taste on the grounds that while the for-
 mer conveys knowledge by discovering objects 'as they really stand in nature, without
 addition or diminution', the latter, taste, 'gives the sentiments of beauty and deformity,
 vice and virtue', staining all objects with colours borrowed from internal sentiment;
 Enquiries Concerning Human Understanding, p. 294. The contextual background of values was,
 naturally, much emphasised in the eighteenth century; Gerard, for example, writes that
 a 'prevailing turn or disposition of mind', by which he means a narrowness of mind,
 'often makes us unable to relish any thing but what falls in with it, and thus perverts and

prejudices our judgement'; *An Essay on Taste* (1780), p. 131. Moreover it is such a narrowness or perversion, he continues, that gives rise to 'the depravity of public taste, and the pernicious influence it has on public entertainments and dramatic works: and hence, in a great measure, the connexion of the taste of a people with their morals' (p. 131). He continues by asserting that 'every appetite and passion in our nature, except avarice alone, or the love of money for the sake of hoarding, derives its origin and its vigour, in a great measure, from those ideas which imagination borrows from taste, and associates with the object of that passion. This being the case, the passions will naturally receive one tincture or another, in every man, according to the particular constitution of his taste' (p. 187). 'In order to give the foregoing observations their full weight', he continues, 'it is necessary to remember, that many different causes concur in forming the characters of men. Taste is but one of these causes; and not one of the most powerful' (p. 194). Coleridge, like Gerard, emphasises 'the close and reciprocal connexion of just taste with pure morality', and goes so far as saying that no person can understand the writings of Shakespeare without a knowledge of 'the heart of man' that is informed with Christian humility; *Shakespeare, with Introductory Matter on Poetry, the Drama, and the Stage* (1811–12), in *Essays and Lectures*, pp. 9–212 (p. 43). Crowther propounds a more contemporary view of the relationship between the aesthetic and the moral in *The Kantian Sublime* (pp. 165–74) and 'The Significance of Kant's Pure Aesthetic Judgement' (*passim*).

14 Pater, *The Renaissance*, pp. 188–90.
15 The following account is based on *Either/Or*, II, pp. 170–333.
16 He goes on to describe the aesthetic form which even this despair can take (pp. 197–203), but this does not concern us here.
17 Kant, too, had written that there is no intrinsic worth in the existence of a man who merely lives for enjoyment, for 'only by what a man does heedless of enjoyment, in complete freedom and independently of what he can procure passively from the hand of nature, does he give to his existence, as the real existence of a person, an absolute worth. Happiness, with all its plethora of pleasures is far from being an unconditioned good'; *Critique of Aesthetic Judgement*, §4, pp. 47–8. Schiller's position is even closer to that advanced by Kierkegaard; see *On the Aesthetic Education of Man*, 12.5. Apropos this distinction between living aesthetically and living in earnest see also Hegel, *Introductory Lectures on Aesthetics*, pp. 71–2.
18 Kierkegaard himself elsewhere asserts that one who wishes to promulgate Christianity must first become an 'aesthetic writer'; *The Point of View for My Work as an Author*, pp. 7–43 *passim*.
19 Judge William's objection to mysticism appears to centre on this very question of time: mysticism, in conceiving of the significance of life in terms of a moment rather than a succession, will not last the distance aesthetically.
20 'Think of an author; to him it never occurs to question whether he will obtain a reader or whether he will accomplish anything by his book; he is only intent upon apprehending the truth. Do you believe that such a writer accomplishes less than one whose pen is under the supervision and direction of the thought that he will accomplish something?'; *Either/Or*, II, p. 301. The ethical individual, if he really exists by contrast with the aesthetical, should not even ask such a question.
21 'The good is for the fact that I will it, and apart from my willing it, it has no existence. This is the expression for freedom. It is so also with evil, it is only when I will it. By this the distinctive notes of good and evil are by no means belittled or disparaged as merely subjective distinctions. On the contrary, the absolute validity of these distinc-

tions is affirmed. The good is the *an-und-für-sich-Seiende* posited by the *an-und-für-sich-Seiende* [being in and of itself], and this is freedom'; *Either/Or*, II, p. 228.

22 According to Hampshire, actions can be distinguished from objects of beauty on the grounds that the former 'do not bear their justification on the face of them; one must first inquire into reasons and purposes'; 'Logic and Appreciation', p. 163. But reasons and purposes must ultimately have a 'face' – if we do not see it, it is because every moral problem occurs in *medias res*. Thus Santayana holds that every sequence of evaluation must end with what is good in itself, what makes us happy just by being: every satisfaction of the passions or appetites takes on an 'aesthetic tinge' if we imagine that satisfaction removed from the possibility of variation or loss; even truth, when beheld for its own sake, 'becomes a landscape'; *The Sense of Beauty*, p. 29.

23 Goodness that is not beauty, says Schelling, is not genuine goodness; 'For goodness … becomes *beauty* – in every disposition, for example, whose morality no longer depends on the struggle of freedom with necessity, but rather expresses the absolute harmony and reconciliation of both'; *The Philosophy of Art*, p. 31.

24 See Kierkegaard, *Fear and Trembling*.

25 Rorty seems to advocate a very similar approach to Pater's. He asserts that we should make our lives like 'works of art', developing 'richer' and 'fuller' desires and hopes. Like Pater he exalts a self composed of 'a plurality of persons … [constituted by] incompatible systems of belief and desire'; 'Freud and Moral Reflection', pp. 11–17. But what will 'richer' and 'fuller' mean here? The same problem arises in Shusterman's criticism of Rorty, which accuses this standpoint of being 'empty' and 'meaningless'; *Pragmatist Aesthetics*, p. 248. Shusterman calls rather for a 'narrative unity' in life (p. 249). 'Rich', 'full', 'empty', 'meaningless', 'unified' – to which domain do any of these terms exclusively belong? There would appear to be no metalanguage for distinguishing the aesthetic from the moral. Without, then, asserting their identity, it seems that at least they cannot be brought into opposition in this way.

26 Thus Balthasar blames Kierkegaard for depriving man of 'all joy in the aesthetic' through his emphasis on the distance between agape and eros, and his age in general for choosing 'aesthetic' to stand for an attitude that is frivolous and self-indulgent; *Seeing the Form*, pp. 50–1. In contrast he says that 'to be a Christian is precisely a form' (p. 28). For, according to Balthasar, the ostensive sign (of revelation) and the signified of that sign (God) remain irredeemably parallel unless we introduce the beautiful, that form the form and content of which is inseparable, which is illumined from within (p. 151).

27 Kant, *Critique of Aesthetic Judgement*, §2, p. 43.

28 We can, in retrospect, link the taste of a period to its 'language of particulars', its *Zeitgeist*. The procedure, if often crude, is unremarkable enough. It is interesting to note how many such linkages rely on making explicit what was either suppressed, or so obvious as to be transparent, during the period in question. Is it not just that the emotional function of the pet loves of each contemporary nation – the sentimentality of America, the amatory 'obsession' of France, the stiff upper lip of England or Japan – seems too obvious and, therefore, the behaviour itself too much a matter of self-deception to those outside the particular culture?

29 Xenephon, *The Banquet*, VIII, p. 193. Hence it is that, while in Plotinus the individual fuses with the goal, in Plato it is the beholding of the goal which is the goal.

30 For an analysis of this distinction in Augustine see Nygren, *Agape and Eros*, especially pp. 476–518.

31 Schopenhauer, *The World as Will and Representation*, I, p. 314. Almost any book on aesthetics could illustrate this belief but Mothershill's *Beauty Restored* is perhaps the most appropriate; Nietzsche, 'On the Virtuous', in *Thus Spake Zarathustra*, II, p. 205; Baudelaire, *Intimate Journals*, pp. 11–12. The purely (consciously?) religious expression of the distinction also survives in Balthasar, for whom the aesthetic experience of the glory of God is not a mere perception or a delightful vision, not mere blissful repose. Rather the 'innermost attitude to the vision' is one of zeal, wholesale submission, and passion; *Seeing the Form*, p. 163. All true beauty 'demands for itself something like adoration', that is, it is not a merely self-gratifying absorption but inspires an aspiration, though one which 'if it is not transposed onto the Christian level, must condemn itself to eternal melancholy and self-consumption' (pp. 320–1). For it is only the concept of God that 'quenches and more than fulfils the human longing for love and beauty, a longing which, previous to and outside the sphere of revelation, exhausted itself in impotent and distorted sketches of such a desperately needed and yet unimaginable fulfilment' (p. 123).

32 Ruskin, *The Crown of Wild Olive*, §55, pp. 435–6. Newton asserts that an 'inability' to appreciate the canon can always be explained by reference to the subject's superficial knowledge of life! So that 'I know what I like' (an heroic phrase, incidentally) should always be translated into 'I know enough about life to like the superficial levels of art, but not enough to like its deeper levels'; *The Meaning of Beauty*, p. 130. It is refreshing to see the customarily implicit arrogance of the critic so plainly exhibited.

Chapter 8

1 Even Scruton's article 'Aesthetics' in the *Encyclopedia Britannica* does likewise, though far more self-consciously.

2 Diffey, speculating on the future of aesthetics, records, in passing, his conviction that Anglo-American aesthetics is 'overcommitted' to the Kantian paradigm; 'On American and British Aesthetics', p. 175n.1. Guyer, too, in a recent article, mentions the pernicious influence of Kant in encouraging the tendency for most subsequent aesthetics to 'reduce art to some single essential aspect', and, as a consequence, leaving the way open those 'laissez-faire' approaches (such as the institutional theory) which have sprung up as a reaction; 'Kant's Conception of Fine Art', p. 275. His own discussion of Kant's few direct remarks on art itself is illuminating, and, though not intended as such, is a good demonstration of the extent to which Kant's concept of art is much more appropriate to the concerns of modern aesthetics than is his general concept of beauty; which general concept was historically, and perniciously, the more influential.

3 See Kristeller, 'The Modern System of the Arts', *passim*. Kristeller credits Victor Cousin with the invention of the triumvirate beauty-truth-goodness, but that beauty is an elemental matter, independent of human artifice, is evident in everything written on the subject prior to the eighteenth century (pp. 203–4).

4 Tolstoy, *What is Art?* (1898), in *What is Art? and Essays on Art*, pp. 65–313 (pp. 116–18).

5 Maritain, *Creative Intuition*, p. 122. Sontag scorns the notion that the province of art is 'the beautiful', with its implications of 'unspeakableness, indescribability, ineffability'; 'The Aesthetics of Silence' (1967), in *Styles of Radical Will*, pp. 3–34 (§19, p. 31). The response to Wegener's *The Discipline of Taste and Feeling*, which does, in fact, use 'beauty' (and even 'sublimity') as synonymous with aesthetic merit (see, for example, p. 18),

would tend to confirm the impression that the association is old-fashioned, as would the historical bias of Wegener's references, and, indeed, his very title. The interesting point about Wegener's book, however, is that when he uses the words 'beauty' and 'sublimity' he really does appear to mean beauty and sublimity, though their very ubiquity in his text makes it difficult to be sure whether this is really the case or not.

6 Plutarch, Pericles, XIII, p. 39.

7 Alberti, On Painting, II, passim. Though see Reynolds, Discourses, III, pp. 42–53, and Maritain, Art and Scholasticism, p. 46. 'The autonomous work of art, which is functional only in reference to 'itself'', writes Adorno, 'aims at attaining through its immanent teleology what was once called beauty'; Aesthetic Theory, p. 89.

8 Alberti, On Painting, II, p. 75.

9 Cardano, De subtilitate (1550), quoted in Tatarkiewicz, History of Aesthetics, p. 160.

10 Ruskin, Modern Painters, III, Pt IV, Ch. III, §§12–15. See also Ruskin's Lectures on Architecture and Painting, pp. 208–9; 228. According to Bascom, beauty is neither an end nor a means in art, but rather 'springs from the perfection of the means which concur in and complete an end'; Aesthetics; or the Science of Beauty, p. 115. Since beauty 'inheres in an expression, – in a thought' this expression, or thought, must have a significance of its own that will make it 'an object of the intellect'; in this 'happy obedience to a noble use alone lies its beauty' (pp. 111–13). Passmore finds something suspect about 'beauty': it is too invariably nice, too soothing – it is what the bourgeois pays the artist for; 'The Dreariness of Aesthetics', p. 50.

11 The Aesthetes were, of course, uninterested in beauty per se. Neither Wilde nor Pater writes of it, and Allen's theoretical work, aside from being appallingly bad, could not, in its tone (the essential quality here), be further removed from Aestheticism. Pater is explicit: 'Beauty, like all other qualities presented to human experience, is relative; and the definition of it becomes unmeaning and useless in proportion to its abstractness. To define beauty, not in the most abstract but in the most concrete terms possible, to find not its universal formula, but the formula which expresses most adequately this or that special manifestation of it, is the aim of the true student of aesthetics [that is, critic]'; Preface to The Renaissance, p. xix. See also the opening of Wilde's lecture on 'The English Renaissance of Art', p. 3. The term 'beauty' itself was, nevertheless, a key one in their pronouncements on the value of art. Baudelaire had written that art is useful 'because it is art', and that 'Beauty is the single ambition, the exclusive aim, of taste'; 'Of Virtuous Plays and Novels' (1851), in Selected Writings, pp. 256–84 (p. 266). Wilde too defines the artist as a 'creator of beautiful things' in his 'Preface' to Dorian Gray, and Pater himself describes the 'desire of beauty' as 'a fixed element in every artistic organization'; Appreciations, pp. 241–61. Bell is in this tradition when he writes that, in our response to art, 'Rapture suffices'; Art, p. 241. The real, if unacknowledged, theoretician of aestheticism is Schiller in his On the Aesthetic Education of Man (see particularly 26.14). What separates Ruskin from aestheticism is not so much his theory of beauty as his attitude towards beauty. What could be more antithetical to its central credo than his assertion that it is not good to live constantly among beauty, because, since we are incapable of satisfaction, to be allowed habitually to possess the utmost the earth can offer would lead to lassitude and discontent: true beauty, according to Ruskin, should be the object of adventure, 'the cynosures of the fancies of childhood, and the themes of the happy memory, and the winter's tale of age'; Modern Painters, IV, Pt V, Ch. XI, §7.

12 Schelling, The Philosophy of Art, p. 4.

13 Ibid., p. 13.

14 Knight, *The Philosophy of the Beautiful*, p. 49. Croce is at pains (even to the point of inconsistency) to exclude nature from beauty, only allowing it to exist there when we invest nature with something like aesthetic value; an aesthetic value which is rarely perfectly achieved because of the medium, the lack of design; *Aesthetic*, Ch. XIII, *passim*. Schelling and, most famously, Wilde, likewise believed that we judge natural beauty by a standard derived from art; 'The Decay of Lying' in *Intentions*, pp. 1–54, *passim*. (A contemporary version of this thesis can be found in Carrier's 'Art Without its Objects?'.) Gadamer also believes that how nature pleases us is determined by the context of artistic creativity at any particular time; 'Aesthetics and Hermeneutics' (1964), in *Philosophical Hermeneutics*, pp. 95–104 (p. 98). 'The hermeneutic perspective', he writes, 'must include the experience of beauty in nature and art ... [But] we must admit that natural beauty does not "say" anything in the sense that works of art, created by and for men, say something to us' (pp. 96, 97). In contrast Hartley, and his Romantic successors, had made just the opposite case. The influence of artificial beauty, according to Hartley, is ultimately a childish and trivial thing compared to the 'far superior' beauty of nature, which leads us to 'humility, devotion, and the study of the ways of providence'; *Observations on Man*, II, p. 249. A similar Christianising of a Platonic or Neoplatonic theme is to be found in Shaftesbury's *Characteristicks of Men, Manners, Opinions, Times*, II, pp. 283–307. Carritt, unusually, holds that 'artistic and natural beauty are thoroughly homogeneous', and comments that the 'neglect of natural beauty' has often led to 'the loss of a valuable check upon theories hastily applied to art'; *The Theory of Beauty*, pp. 38; 44.

15 Fry, 'Retrospect' (1920), in *Vision and Design*, pp. 222–37 (p. 229).

16 Ibid., p. 229.

17 Collingwood, *The Principles of Art*, p. 37. Collingwood's is a strange case, for in his earlier *Outlines of a Philosophy of Art* he takes quite a different viewpoint. There he defines the work of art as a product 'intended to be beautiful', and the task of the philosophy of art as the studying of 'the awareness of beauty' (pp. 7–8). Beauty, according to Collingwood, is 'not a quality of objects apprehended by perception, nor yet a concept grasped by thought; it is an emotional colouring which transfigures the entire experience of the imagined object. ... Beauty is present to the mind simply in the form of an emotion' (pp. 27; 29). In accordance with this definition he also holds that a work of art is only such so long as it is looked at as a work of art (p. 25).

18 Herbart, *Practical Philosophy* (1808), quoted in Carritt, *Philosophies of Beauty*, p. 152; Reid, *Essays on the Intellectual Powers*, pp. 490–1; Richards, *Principles of Literary Criticism*, p. 160. Richards's entire *oeuvre* demonstrates just this proposition, that is, his total want of anything which might be called an aesthetic sensibility.

19 Croce calls the discourse of beauty a 'trackless labyrinth of verbalism'; *Aesthetic*, pp. 78–9; Bell, *Art*, pp. 13–16. Curiously enough this complaint about the meaning of a term having become, through careless or idiosyncratic usage, hopelessly imprecise is also made by Fisher about the word 'aesthetic'; 'Aesthetic Experience: Where Did We Go Wrong?', *passim*. Kant, at a time when, according to himself, only the Germans were using 'aesthetic' to denote the critique of taste, proposed that, since the principles of taste can never be raised to the ranks of a science (as, theoretically, the philosophy of art could), this appellation should be dropped or at least, in conformity with the historical roots of the word, confined to the denotation of either the doctrine of sensibility, the transcendental critique of the senses (his own use in the first critique), or psychology; *Critique of Pure Reason*, p. 66n.

20 Hegel, *Introductory Lectures on Aesthetics*, p. 4. Thus he describes the beauty of nature as a mere incomplete and imperfect reflection of the beauty which truly belongs to the mind (p. 4). A painted landscape, which has received the 'baptism of the spiritual', that is, is a manifestation of mind addressing itself to mind, is thus of a 'higher rank' than a mere natural landscape (pp. 33–4). Shaftesbury stands at the junction between the Neoplatonic concept of beauty as a ray of the divine shining through matter and Hegel's position here: '[The] beautiful, the fair, the comely, were never in the matter, but in the art and design; never in body itself, but in the form or forming power. Does not the beautiful form confess this, and speak the beauty of the design, whenever it strikes you? What is it but the design which strikes? What is it you admire but Mind, or the effect of Mind?'; *Characteristicks of Men, Manners, Opinions, Times*, II, p. 405.

21 Croce, *Aesthetic*, pp. 98–9. Alexander, too, holds that nature is only beautiful when we see it through the artist's eyes; *Beauty and Other Forms of Value*, pp. 30–4. Not surprisingly his chapter on the 'characteristics of the beautiful' is devoted to music, painting, and poetry (pp. 35–52).

22 Croce, *Aesthetic*, pp. 99–100. Tasso, for whom beauty is not expression, takes just the opposite stance, writing that beauty 'is a work of nature, and since it consists in a certain proportion of limb with a fitting size and beautiful and pleasing colouring, these conditions that once were beautiful in themselves ever will be beautiful, nor can custom bring about that they will appear otherwise', but 'in respect to … words it may be conceded (since they have nothing to do with our contention) they are best that are most approved by practice, for in themselves they are neither beautiful nor ugly but they appear such as custom makes them'; *Discourses on the Heroic Poem*, p. 497.

23 Newton, *The Meaning of Beauty*, p. 32.

24 Ibid., pp. 76–7.

25 Ibid., p. 86. In marked contrast to the writers mentioned above Collingwood (at least in his *Outlines of a Philosophy of Art*) holds that all beauty is natural beauty; pp. 52–5. Morris, on the other hand, implies that the contrast itself may be false when he writes that the beauty of art is necessary to life 'if we are to live as nature meant us to'; *The Beauty of Life* in *Collected Works*, XXII, pp. 51–80 (pp. 53–8).

26 Examples of such psychological/metaphysical interpretation can be found in Burke's *A Philosophical Enquiry* (Part II, Sections III–VIII), throughout Ruskin's *Modern Painters*, in Schopenhauer's description of the meaning of the sudden appearance of a mountain range in *The World as Will and Representation*, and in Adorno's *Aesthetic Theory* (Chapter 4, passim). According to Schopenhauer 'the whole of the visible world is only the objectification, the mirror, of the will, accompanying it to knowledge of itself' and of salvation; *The World as Will and Representation*, I, p. 266. According to Rousseau it is 'in man's heart that the life of nature's spectacle exists'; so that before we have experience of those moods which can be represented, analogically, by nature, we are incapable of finding nature beautiful; *Emile*, III, pp. 168–9. Knight, likewise, writes that all Nature is analogical, teeming with resemblances and correspondences to our humanity – 'a museum of types, similitudes, metaphors, and even parables of man'; *The Philosophy of the Beautiful*, p. 48. It speaks the language of the human mind and heart, disclosing certain phases of our own being, phases that are usually hidden 'in the pressure, and the multitudinousness of our ordinary life' (pp. 54–5). However, he attributes the beauty of nature to its production, through effort, of certain 'ideals' of nature, thus invoking a more Platonic or intrinsic view, and evading the question of the grounds of beauty entirely (p. 49). '[All] things are artificial', writes Browne, 'for nature is the Art of

God'; *Religio Medici*, I, §XVI, p. 81. According to Kant self-subsisting natural beauty shows nature in the light of a system, the principles of which we do not understand. This principle is that of a finality relative to the employment of judgement, which causes nature to be regarded after the analogy of art – 'inviting profound enquiries as to the possibility of such a form'; *Critique of Aesthetic Judgement*, §23, p. 92. However, his final judgement on the potential meaningfulness of these profound enquiries is not in line with any revelatory theory of beauty.

27 Yet the love of loving nature (from Wordsworth to the poodle parlour) renders nature into art, into sentimentality. For what is most poignant, yet also most uncanny, about that which lives beyond the self is that, while being ineluctably other, it is nevertheless imbued with our essence, with life. Thus it is that we must drag this other down by investing it with our accidents, our feelings, morals, habits, character, create a role for what we have not created, ensure that in our homeland our own language is spoken. We love and fear otherness, and our fear is always destroying that otherness; never more so than when we celebrate the other.

28 Croce, *Aesthetic*, pp. 87–93. One of his objections is that each time we use one of these 'psychological' terms in connection with a particular work we find that we must define it anew (p. 90). Beauty has an obvious advantage in this respect. I presume it is some kink in the English translation that places 'beautiful' among this very list of 'psychological concepts' on page 89! Newton, too, writes that the spectator's attitude to the work of art is bound by the 'laws of contemplation, and contemplation deals in no other value but beauty'; *The Meaning of Beauty*, p. 118.

29 Lorand, 'The Purity of Aesthetic Value', pp. 14–20.

30 Ibid., pp. 17; 19. For an even more explicit appropriation of 'beauty' to stand for aesthetic value see Lorand's 'Beauty and its Opposites' (these opposites being the ugly, meaningless, kitsch, boring, insignificant, and irrelevant).

31 Fry, 'An Essay in Aesthetics' (1909), in *Vision and Design*, pp. 22–39 (pp. 32–4).

32 Ibid., p. 33.

33 Beardsley, *Aesthetics*, pp. 527–9.

34 This would not be true of Berleant's current use of 'aesthetic', but then it is difficult to see what would be true of that use, except that it has something vaguely to do with what has been already labelled, presumably by an obliging third party, 'art'; see his 'Beyond Disinterestedness'.

35 For such uncritical uses see, for example, Eagleton's *The Ideology of the Aesthetic*, or almost anything on postmodernism. For a sense of how far, by contrast, the term has become problematic for aesthetics one might see, for example, Matravers, 'Aesthetic Concepts and Aesthetic Experiences'.

36 Margolis, 'Exorcising the Dreariness of Aesthetics', p. 133. Consideration of Dickie's statement that 'the aesthetic cannot completely absorb the concept of art' only further muddies the waters; *Introduction to Aesthetics*, p. 4. Hegel long ago wrote that though 'Aesthetic' is, etymologically, an unsuitable name for the philosophy of art, that is nevertheless what it stands for; *Introductory Lectures on Aesthetics*, p. 3.

37 See Chapter 5 above for a discussion of the difficulties of adequately characterising the 'aesthetic attitude'. Stolnitz, perhaps the most famous modern champion of the theory, writes that we cannot, for example, claim to have read a book aesthetically if we have interposed 'moral or other responses of our own which are alien to it', but also that we should not infer from this that we can simply 'expose ourselves to the work of art' and expect to have an 'aesthetic perception' of it. Rather we become absorbed by the

rhythm of an exciting piece of music, we exclude everything but our sense of the novel's suspense. Aesthetic attention is accompanied by activity, not goal-seeking activity, but rather whatever is required for or evoked by the perception of the object. Moreover, to perceive the distinctive value of the object, to see it as itself, we must be attentive to its 'frequently complex and subtle details'; we must discriminate. The object of aesthetic perception 'stands out' from the world and 'rivets our interest'. He does concede that such an attitude can be 'adopted' towards any object sensed or perceived, whether the product of imagination or of conceptual thought, but confines his discussion to that obvious work site – art – which he describes, like Beardsley, in terms of entertainment; Stolnitz, *Aesthetics and Philosophy of Art Criticism*, pp. 33–42. For a discussion of Stolnitz' notion (of aesthetic perception as a suspension of practical perception) as it appears in Hegel, Schopenhauer, and Heidegger see my *Literature, Rhetoric, Metaphysics*, pp. 76–9. (Shklovsky's notion of 'defamiliarisation' and Mukarovsky's of 'deautomatization' could also be mentioned in this context; see Shklovsky's 'Art as Technique', and Mukarovsky's 'Standard Language and Poetic Language' and 'The Esthetics of Language'.) This is no longer a popular theme in aesthetics. Dickie pointed out long ago that attitude-aestheticians do not really contrast one kind of attention (disinterested, intrinsic) to another, but rather contrast attention to distraction, that is, inattention. What they define 'aesthetic attention' against is always an instance of only attending to certain features (as when the subject uses the object as a source of information about something else or as the occasion of daydreaming) rather than attending to the whole. 'Disinterested', then, cannot be used to refer to a special kind of attention. It refers rather to the motives of specific actions (findings, judgements). All attention has a motive but attending in itself cannot be called interested or disinterested on the basis of these motives. Attention itself can only be either close or casual, given or not given; 'The Myth of the Aesthetic Attitude', pp. 22–7. The theory is, however, by no means an historical curiosity. According to Shusterman (after Dewey), for example, aesthetic experience is differentiated not by the unique possession of a particular element, but rather by its more consummate integration of all the elements of ordinary experience, existing only by virtue of the entire pattern to which it contributes and in which it is absorbed. Art, therefore, is a quality of experience; 'Analytic and Pragmatist Aesthetics', pp. 192–3. This seems to be a form of aesthetic attitude theory, or rather the beginning of a theory that would lead to an aesthetic attitude theory; the 'beginning' because if we say there is a particular kind or quality of experience which is aesthetic, to characterise this by saying that it is a kind of experience made up of the intensification of other experiences in such a way that the whole becomes what we call aesthetic experience, yet without delimiting what kinds of other experience are involved, or what it means to say they are 'intensified' or 'integrated', seems a particularly empty manoeuvre.

38 Novitz describes the idea of aesthetic autonomy as 'sheer perversity'; 'The Integrity of Aesthetics', p. 15.

39 Gide, *Journals 1889–1949*, p. 54.

40 According to Worringer, writing in the first decade of the twentieth century, aesthetics had become solely occupied with establishing and defining the concept of beauty only because it had become no more than a psychological interpretation of style applied to Classical works of art – a type of art which manifests an 'artistic will' fundamentally in agreement with the taste of the times; 'A clear distinction between aesthetics and an objective theory of art [as the psychological investigation of style or

"artistic will"] is therefore the most vital necessity in a serious, scientific investigation of art'; Form in Gothic, pp. 7–20.

41 Danto, The Transfiguration of the Commonplace, p. 94. Interestingly Danto later argued, apropos criticism of his Transfiguration of the Commonplace, that he was led to put the aesthetic 'on ice' in working on the defining character of works of art by the reflection that aesthetic qualities are not exclusive to works; 'A Future for Aesthetics', p. 275.

42 Dickie, 'Defining Art II', p. 122. See also his 'The Institutional Concept of Art', passim, and Introduction to Aesthetics, pp. 82–93. For a further consideration of Dickie's position see Scholz, 'Rescuing the Institutional Theory of Art'.

43 Danto, 'The Last Work of Art', p. 561. See also his 'The Artistic Enfranchisement of Real Objects', pp. 22–35. For objections to this theory see Wollheim, Art and its Objects, pp. 157–66.

44 I hasten to add, a decade after first writing this, that I am not referring to the philosophy of art. The debate on the definition of art as it is currently being conducted in various journals of aesthetics strikes me as one of the most lively and interesting debates in the humanities for many years, though I concede that the general reader – such a reader as might have, in another age, enjoyed, for example, Clive Bell – might find this debate itself rather dull also. An excellent recent book on the whole question is Davies's Definitions of Art, though the debate has moved on even since the books publication in 1991.

45 Eco, The Open Work, pp. 169–78. Likewise Lyotard holds that since the turn of the century the arts have turned from a concern with beauty to a concern with the (Kantian) sublime; 'After the Sublime', pp. 297–9. See also his Lessons on the Analytic of the Sublime.

46 Eaton 'Where's the Spear?', pp. 2–9. According to Adorno aesthetic norms must be historicised, since they can become outdated when the needs to which they cater are really met, and new ones arise in answer to certain new needs. Past norms can, however, have a contemporary validity; Aesthetic Theory, pp. 456–92.

47 Eaton, 'Where's the Spear?', p. 3.

48 Ibid., p. 5.

49 Ibid., p. 8. Mukarovsky, writing in the 1930s, asserted that 'an active capacity for the aesthetic function' is not the real property of any object, but rather one that manifests itself only in a certain social context, a certain period, and then only on the basis of collective rather than individual judgement; Aesthetic Function, pp. 3; 18–20.

50 For a further discussion of aesthetic properties see Goldman's 'Realism about Aesthetic Properties', the discussion of his views in Gould's 'The Reality of Aesthetic Properties' and Levinson's 'Being Realistic About Aesthetic Properties', and Goldman's reply to this discussion in 'Reply to Gould and Levinson on Aesthetic Realism'.

51 Ludeking 'Does Analytical Aesthetics Rest on a Mistake?', pp. 124–9.

52 Ibid., p. 127. Thus he describes the idea that the concept of art must be descriptive or classificatory as a 'myth'; 'In order to learn about the distinction between art and non-art, we must explore not our concept, but our conceptions of art.'

53 Levinson, 'Extending Art Historically', p. 410. Ludeking ends his account of the aesthetic by calling for a more self-reflective, even personal, approach to aesthetics; an approach similar to that recommended by Pater in his preface to The Renaissance and Passmore in his 'The Dreariness of Aesthetics'; an approach that is, in fact, close to the reality of contemporary practice. That aesthetics can only be done piecemeal and usually in situ seems a reasonable conclusion, and one which aesthetics has been implicitly acting on for some time. See also Carroll's 'Art, Practice, and Narrative'.

54 Levinson, 'Extending Art Historically', p. 412. For further discussion of this definition see Oppy, 'On Defining Art Historically', Levinson's reply, 'Art Historically Defined', and Carney's 'Defining Art Externally' in Levinson's defence. Lind's rather similar extension of the institutional definition of art seems, in contrast, unsatisfactory. According to Lind what differentiates art from history, philosophy, and so on is that its function is to produce an aesthetic object, that is, an object which holds our attention in a certain way, whether by being intriguing, fascinating, beautiful, or gorgeous, that is, 'contemplatively interesting'. What differentiates art from other aesthetic objects is that art is created in order to be aesthetic; 'The Aesthetic Essence of Art', pp. 118–27. While his theory seems quite a good explanation of the draw of puzzles and other species of what Addison called 'Low Wit', it is really no more than a good description of one kind of aesthetic essence, one kind of interest in art. That it is a personal credo seems indicated by his conclusion that novelty or originality are necessary to art, his introduction of the non-category 'nonart', and his characterising the Mona Lisa as a 'stale icon everyone would mechanically recognize as 'great' art' (p. 122).

55 It is evidently the fear of this contingency – that a 'closed' definition of 'art' would be rendered inadequate by the general acceptance, as art, of what could not be encompassed by that definition – which lies behind Weitz's claim that a true theory of art is a logical impossibility; 'The Role of Theory in Aesthetics', *passim*. His emphasis on the necessary 'openness' of art, however, betrays the same incurably Romantic instincts that are to be found beneath the similarly 'tough-minded' approach of his contemporaries in literary studies – the New Critics. Weitz confuses openness *within* art for the openness *of* art itself, and does so, unwittingly, in the interests of exalting art itself to an evaluative category.

56 According to Fehér and Heller, who take a more pessimistic view, aesthetics is 'irreformable'; its sources of error cannot be eliminated. For, they argue, deductive art criticism must assume a coherent community of value, which is not possible, while inductive art criticism, which can accommodate new species, must overlook the validity its judgements may have beyond the present; *Reconstructing Aesthetics*, pp. 1–22 *passim*.

57 In a recent paper in defence of the sceptical spirit, though not the letter, of Weitz's 'The Role of Theory in Aesthetics' (see note 55 above), Kamber asserts that 'there is no deep-structure connection – nothing invariable, self-replicating, recurrent, or otherwise persistent through time – to sustain the continuing unity of the concept of art'; 'Weitz Reconsidered: A Clearer View of Why Theories of Art Fail', pp. 44–5. While I take it to be self-evident that there is no such continuity to be found in artworks *qua* objects, I feel that Kamber's thesis, though perhaps theoretically sound, relies too heavily on the idea that changes in the criteria for conferring 'art status' can be arbitrary. Certainly if the Royal Academy had mounted an exhibition of ready-mades at the end of the eighteenth century this would have been a purely arbitrary act, but, though placing Duchamp's *Fountain* next to Reynolds's *Mrs Siddons as the Tragic Muse* would, at first sight, make it appear that the changes in criteria for artness have been, as it were, cumulatively arbitrary, such a conclusion would have to ignore two centuries of remarkable consistency in artistic theory, practice, and 'consumption'. The old Wittgenstein 'family-resemblance dodge', for such indeed it deserves to be called by now, should be a last resort, and I do not believe that we are yet anywhere near the last resort. However, as I mentioned at the beginning of this chapter, aesthetics is not my main aim here.

58 See my *Literature, Rhetoric, Metaphysics*, particularly Chapters 5 and 6.

59 In the sense that it gains a power of expression by being placed in a set that also includes the Belvedere Apollo.

60 Kant, *Critique of Aesthetic Judgement*, §49, pp. 175–6.

61 Bell, *Art*, chapters I–II *passim*.

62 Ibid., pp. 13–16.

63 Pater, *The Renaissance*, pp. 105–9; Hanslick, *The Beautiful in Music*, p. 71. Indeed though statements of this aspiration are rare they are not unknown. Mondrian, for example, prophesies (like William Morris) that the 'new art' will 'offer to the future a pure image of beauty that will transform our surroundings as well as our life – now dominated by the natural – into an equilibrium between nature and nonnature'. This art will achieve, and be replaced by, 'the beauty of life'; 'Neo-Plasticism' (1923), in *The New Art – The New Life*, pp. 176–7 (pp. 176–7).

64 Adorno, *Aesthetic Theory*, pp. 114–15. Elsewhere he writes that 'Art is beautiful by virtue of its opposition to mere being' (p. 76).

65 Frye, *Anatomy of Criticism*, p. 18.

66 Read, *Collected Essays in Literary Criticism*, p. 14. See also Goodman's 'Merit as Means', pp. 56–7.

67 Even given the fundamental importance of drawing this distinction between the subject matters of art and beauty I might still have decided to restrict an enquiry into the beautiful solely to art, on the grounds that at least by doing so I would have both set some limit on my enquiry, and gained the advantage of having a more or less common reference point with my audience. There are two chronic difficulties with this. The lesser of these is that if beauty is divisible according to its object (which we cannot *a priori* discount), then, in discovering the basis of beauty in art, I would have done no more than discover the basis of artistic beauty. The second and far more serious difficulty is that in so restricting the enquiry I would have been perpetuating, and running the risk of falling into, that very confusion between aesthetic (artistic) value and beauty which has brought enquiries into beauty into such justifiable disrepute, and led to the almost total neglect of the subject by mainstream philosophy. For although the beauty of an artefact is ostensibly the most stable form of beauty (compared, for example, to a cloud formation), such an artefact is also, because of both its obvious cognitive element and its ability to arouse admiration in a subject irrespective of whether that subject considers it beautiful, one of the least suitable sites of potential beauty to have in mind when considering beauty *per se* – the risk of becoming side-tracked into issues that are essential to art but may be only accidental to beauty is too great. Indeed, it must strike anyone who turns to the question of beauty how many texts announce themselves as accounts of beauty yet end as accounts of poetics or design. (The fault is not exclusively a modern one – its roots lie perhaps in the unfortunate habit of an earlier age of calling, no doubt as a matter of polite compliment, every merit in a work of art, or even every property peculiar to art, a 'beauty'.) If a piece of art can be beautiful there is every reason to suppose that aesthetics or poetics would not be irrelevant to showing why it is so (on any particular occasion to any particular subject), but this does not mean that either field of enquiry – beauty or aesthetics – is a necessary part of the other. There are hundreds of books on both poetics and design which do not find it necessary to mention beauty, and the intentions, scope, and conclusions of which are obviously by no means damaged by this 'omission'. Likewise it would be quite conceivable to write a book on beauty, drawing on a wide variety of examples, without mentioning art at all. To restrict an enquiry into beauty solely to its manifestations in art, then,

would both risk confusing the fundamental issue, and serve to reinforce the erroneous idea that the subject itself is no more than a poor, and quite probably illegitimate, relation of aesthetics.

68 Richards, *Principles of Literary Criticism*, pp. 20–1. Dewey also describes 'beauty' as an ejaculation, a word 'at the furthest remove from an analytic term, and hence from a conception that can figure in theory as a means of explanation or classification'; for the purposes of aesthetics, he concludes, it has become 'obstructive'; *Art as Experience*, pp. 129–30. Likewise Ransom, believing that criticism should become 'more scientific', holds that it will only achieve this by abjuring all 'vocabulary which ascribes to the object properties really discoverable in the subject, as: moving, exciting, entertaining, pitiful … great … admirable … beautiful'; 'Criticism Inc.' (1937), in *The World's Body*, pp. 327–50 (pp. 329; 343).

69 Adorno, *Aesthetic Theory*, pp. 22 (see also p. 384, note A–29). Baumgarten first coined, or rescued, the term 'aesthetics' to distinguish between 'the science of knowing things philosophically, that is … the science for the direction of the higher cognitive faculty in apprehending the truth', or logic, and the science of simply perceiving things by 'the lower cognitive faculty', or aesthetics; *Reflections on Poetry*, §§115, 116.

70 Osborne, 'Introduction' to *Aesthetics*, pp. 1–24 (p. 16). He was, however, later guilty of an obfuscation worthy of the start of the twentieth century when he defined 'beauty' as 'whatever among natural objects is capable of arousing and sustaining aesthetic experience', by contrast, that is, with whatever among artefacts is capable of performing the same function, which last, he proposes, should be designated 'art'; 'What Is a Work of Art?', p. 10.

71 The distinction is not, however, new. That the admirable and the enjoyable may be distinct categories is a commonplace of eighteenth-century criticism. In the nineteenth century Bascom writes that, while the 'application' of taste has come to seem the sole function of criticism, in fact beauty is not the 'exclusive object' of the fine arts; 'Criticism, then, though finding a most important criterion of excellence in the decisions of taste, is, in the rules and principles of its judgements, possessed of a much wider range than that of any single department. It is the application to products of the tests of excellence in any or all directions'; *Aesthetics; or, the Science of Beauty*, p. 7. Likewise Day writes that though beauty (that is, in his system, aesthetic merit) gives pleasure, the 'proper aim of art' is not pleasure but rather the effecting of a 'communication between different spirits'; *The Science of Aesthetics*, pp. 20–1.

72 Schelling, *The Philosophy of Art*, p. 9.

73 Ibid., p. 10.

74 Danto, *The Philosophical Disenfranchisement of Art*, pp. 12–13. Gerard writes that 'vigorous internal senses', even when 'attended with the greatest delicacy of passion', are not alone sufficient for 'good taste', but must be 'aided with judgement, the faculty which distinguishes things different, separates truth from falsehood, and compares together objects and their qualities'; *An Essay on Taste* (1780), pp. 82–3. 'A Man of fine taste in Writing', declares Addison, 'will discern after the same manner, not only the general Beauties and Imperfections of an Author, but discover the several Ways of thinking and expressing himself, which diversify him from all other Authors', and should be able to 'enter into the very Spirit and Soul of fine Writing, and show us the several Sources of that Pleasure which arise in the Mind upon the Perusal of a noble Work'; *Spectator* No. 409. Voltaire writes that the perception of beauty, 'in order to constitute true *taste*, must not be a vague and confused sensation; but must be attended with a distinct view, a

quick and comprehensive discernment of the various qualities, in their several relations and connexions, which enter into the composition of the object we contemplate', and D'Alembert that 'the philosophical analysis' of a work consists 'in distinguishing well [the various sources of the pleasure we receive from the work] and keeping them separate from each other, that so we may refer to each what properly belongs to it, and may not attribute our pleasures to causes that have no sort of influence in their production'; Voltaire, 'An Essay on Taste', p. 214; D'Alembert, 'Reflexions', p. 236. Dryden, too, had written that 'It requires philosophy as well as poetry to sound the depth of all the passions; what they are in themselves, and how they are to be provoked'; 'The Author's Apology for Heroic Poetry and Poetic Licence' (1677), in *Of Dramatic Poesy and Other Critical Essays*, I, pp. 195–207 (p. 200). Discovering the source of the pleasure one derives from a work is not the same thing as tracing the sources of those pleasures *per se*. D'Alembert elsewhere defines 'taste' as 'the *Faculty of distinguishing, in the works of art, the various qualities which are adapted to excite pleasure or, disgust, in minds that are susceptible of delicate sentiments and perceptions*', and this is perhaps the more correct emphasis; 'Reflexions', p. 227. In criticism, that is, in aesthetics *in situ*, the question is more often than not how we *should* respond to a work, that is, what is relevant. When we look, are we doing it as the others are doing it? This is, of course, at any particular time, a serious question.

75 Levinson, 'Pleasure and the Value of Works of Art', pp. 295; 297. Davies believes that, at one time, the 'primary function of art is [*sic*] to provide enjoyment', though, since being a work of art is a matter of possessing a status conferred by an 'Artworld' which may evolve beyond the use of such a criterion in conferring such a status, there is no reason why any work of art should be explicable in terms of this function; *Definitions of Art*, pp. 219–20. Unfortunately he does not specify what forms this enjoyment could take. Given the diversity of experiences that might come under the heading of 'enjoying', I think it would be difficult to find any work of art that could be shown *not* to be potentially enjoyable in some way – even if the enjoyment were only to reside in the idea of enjoying something which no one could possibly 'enjoy' (not, I believe, as rare a case as it sounds).

76 Levinson, 'Pleasure and the Value of Works of Art', p. 299.

77 Ibid., p. 300.

78 Ibid., p. 296. Hegel too pays back-handed tribute to just this capacity of art while disparaging, as no doubt would Levinson, the idea that this in itself is the true vocation of art: 'This awakening of all feelings in us, the dragging of the heart through the whole significance of life, the realization of all such inner movements by means of a presented exterior consisting merely of deception – all this was what, from the point of view which we have been considering, constituted the peculiar and pre-eminent power of art'; *Introductory Lectures on Aesthetics*, p. 52. According to Hegel the beauty, meaning aesthetic merit, of works is rather a function of the profundity of the 'inner truth of their content and thought' (p. 81).

79 It has been suggested that the institutional definition would turn aesthetics into a branch of sociology. However, the distance between professed grounds of admiration and real grounds of admiration is so great in the realm of art that if it were to be subsumed under another discipline it would be far more likely to belong to psychology. As long as 'Aesthetics' remains the philosophy of art – and there seems no good reason why it should not – then 'aesthetic' itself will require an institutional definition. For the 'aesthetic' is never simply an effect it is a mixture of an effect and the concept of an effect. This emerges most clearly at certain 'extremes', that is, in what runs delib-

erately counter to the prevailing aesthetic, as was the case at one time with conceptual art, or, more directly, punk. For the punk aesthetic can be summed in a single, once often-heard, phrase: 'It's horrible, I like it.'

80 Mothershill, *Beauty Restored*, pp. 422–4 (my emphasis). Likewise Adorno, who, having written that the 'autonomous work of art … aims at attaining through its immanent teleology what was once called beauty' (so that reflection on natural beauty is an 'integral and inalienable' part of any theory of art), nevertheless later gives way to a more, or less, modern view when he describes the true, the beautiful, and the good as 'the ideals of a philistine culture'; *Aesthetic Theory*, pp. 89; 91; 138. Dufrenne, too, uses the word 'beauty' to mean 'aesthetic', though it is obvious that he does not identify the beautiful with the aesthetic; 'The Beautiful' (1961), in *In the Presence of the Sensuous*, pp. 75–84.

81 Mothershill, *Beauty Restored*, pp. 247; 45; 257–8. In contrast, Leddy's claim that beauty is a 'core [or paradigmatic] concept to the concept of aesthetics' is one which I find far more sympathetic, as my discussion of the continuity between beauty and aesthetic merit (as objects of taste) should show; see Leddy, 'Sparkle and Shine', pp. 270–2.

82 Savile, *The Test of Time*, pp. 173–4.

83 Mothershill, *Beauty Restored*, pp. 423; 222–4. Indeed the problem which mainly concerns Mothershill is the relevance or validity of critical commentary. She does add elsewhere that though introspective reflection can sharpen the focus of an effect, this cannot be a systematic process (pp. 325–6).

84 Savile, *The Test of Time*, pp. 166–81. Later he seems to retract this when he writes that the assertion of beauty is true if and only if, when viewed in a certain way, the object elicits the right response, and that the parameters of the way of viewing are, in the case of natural objects at least, chosen by the beholder. Shusterman, too, has the word 'beauty' in the full title of his *Pragmatist Aesthetics*, and yet uses it solely as a rhetorical flourish; identifying it with the aesthetic (p. 33), defining 'aesthetic' in opposition to it (p. 48), and, in general, not talking about it at all. Likewise Sheppard, in her 'introduction to the philosophy of art', tries to appropriate a Kantian definition of 'beauty' for characterising the aesthetic; *Aesthetics*, Chapter 5 *passim*. Not surprisingly she finds that the 'inadequacies' of the Kantian formulation 'became particularly acute in relation to works of art' (p. 76), and the word 'beauty' passes, silently, out of use for the rest of her analysis (where, indeed, it would be completely inappropriate), reappearing only in the final paragraph of the book (pp. 153–4). Beauty likewise disappears from Zemach's *Real Beauty* at a fairly early stage – despite the opinion of the index. The nineteenth century seemed particularly drawn towards using 'beauty' and 'beautiful' as synonymous with 'aesthetic' and 'possessing aesthetic merit'. Samson, for example, writes that 'the general impression produced on the human mind by works of art is entitled "Beauty;" and the power of the mind both to appreciate and to create objects is styled "Taste"'; *Elements of Art Criticism*, p. 76. Day defines 'beauty' in such a way as to make the word able to stand for a whole class of effects – including the sublime and the comic – appropriate to the enjoyment and admiration of art; *The Science of Aesthetics; or, the Nature, Kinds, Laws, and Uses of Beauty*, pp. 103–25. He can then, in the name of an analysis of beauty, spend three hundred and fifty pages describing the 'laws' for producing, in the various arts, art that will be to his taste. Such writers, being more pedagogical in their intentions, could carry off this absurdity with far more aplomb (or consistency) than is to be found in my modern examples, though it is obvious from their very texts that their 'beauty' did not mean beauty at all.

85 Dutton, 'Kant and the Conditions of Artistic Beauty', pp. 226–31.

86 Ibid., pp. 238–9.

87 Ibid., p. 239. He also writes that Kant had not completely thought through the obvious fact that beauty is dependent on concepts (p. 232). Kant's difficulties, however, are ones that Dutton does not even recognise as such, specifically (1) that beauty is felt as free of concepts, and, more importantly, (2) that there appears to be nothing in any kind of concept of an object (even an object of desire) that would account for the peculiar kind of static delight beauty is.

88 Mothershill, *Beauty Restored*, pp. 211, 379–80. Valentine says that, for the sake of simplicity, he will use 'aesthetic' to mean 'involving appreciation or enjoyment of beauty', but continues by saying that 'aesthetic' has a wider sense, in which it describes the attitude in which anything is 'apprehended or judged without reference to its utility or value or moral rightness'; *The Experimental Psychology of Beauty*, pp. 3–4.

89 Mothershill, *Beauty Restored*, pp. 260–1.

90 While other aesthetic, or potentially aesthetic, properties are reducible to properties within the work itself, beauty is, by definition ineffable. It is like the moving or, even more, the comic in this respect, yet, unlike them, it does not admit of degrees. Beardsley proposes placing (or replacing) beauty, along with the sublime, graceful, tragic, and so on, in a family of distinct qualities producing aesthetic (artistic) value; *Aesthetics*, p. 509. Yet he discovers that to say that a work is beautiful is to involve oneself in the statement in a way that saying the work is, for example, graceful, does not. 'When we have distinguished in a painting its lines and shapes and colour-tones, its structural relations, and its human regional qualities – the movement and swirl, the joyousness and vitality – is there something else left over that we have not yet mentioned, namely its beauty? I can easily doubt it; and yet there are some occasions when I cannot think of any more appropriate thing to say that 'That is beautiful'' (pp. 508–9). This only surprises him because, despite rejecting the identification of artistic merit with beauty, he is nevertheless still thinking of beauty solely in terms of art; there is no reason why a painting should not have all the qualities he describes and yet still not be beautiful. Beauty (as state and act) is, necessarily, more than can be deduced from the sum of the objective properties of the object.

91 It is not uncommon, of course, to hear it said that this woman is more beautiful than that one. What this could only mean, however, if it does not simply mean that this woman is prettier or has a more interesting face than that one, is that that woman is pretty/attractive/striking but this woman is beautiful. If you are accustomed to using 'beautiful' hyperbolically, that is, to mean very pretty, attractive, very neat, and so on, I cannot help you, beyond recommending that you ask yourself if 'beautiful' is what you really mean. On the other hand an expression which uses a comparison with a disparate object which is *conventionally* beautiful – 'She was more beautiful than the rising sun' – is a quite natural hyperbole emphasising the overwhelming perfection of every instance of present beauty.

92 Mothershill, *Beauty Restored*, p. 327.

93 Ibid., p. 150.

94 Ibid., pp. 167; 174.

95 Savile, *The Test of Time*, p. 183.

96 Ibid., pp. 166–81.

97 Mothershill, *Beauty Restored*, p. 348; though she does later, reluctantly, say that there is nothing about which we can say in advance that it might become beautiful, thereby

capitulating before at least a weakened form of that relativism which she finds so counter-intuitive (p. 365). Zangwill has written that the strict line between judgements of beauty which are directly based on some given feeling of pleasure and displeasure felt in response to the perception of a thing and judgements which are based on inductive grounds, though previously apparently definitive of the domain of taste, is actually part of a dogma that should be rejected; 'Two Dogmas of Kantian Aesthetics', p. 237. We do not, in his opinion, have to see an object to decide if it is beautiful. First, we are often aware that were we in a different mood the object before us might strike us differently, so that it is only 'sensible to be less precipitous and rash in advancing to judgements' purely on the basis of firsthand experience (p. 234). (As if we were judging an objective property for others!) Secondly, because testimony 'is as important in aesthetics as it is for empirical knowledge', he would not hesitate to assert not merely that he has heard that a certain object is beautiful, but that it is beautiful, if he hears as much on good authority (pp. 234–5). Lastly, if I have decided, on the basis of a review or previous experience, that I will find something beautiful or ugly and subsequently do, there can be said to be no difference in the 'contents' of the judgement made before direct acquaintance and the 'contents' of the judgement made on acquaintance (pp. 235–6). I confess that I cannot bring myself to rule out the possibility that he is being ironic.

Chapter 9

1 'But to speak in a Christian fashion of the *je ne sais quoi*, is there not a mysterious something in us which makes us feel, despite all the weaknesses and disorders of corrupt nature, that our souls are immortal, that the grandeurs of the earth cannot satisfy us, that there is something beyond ourselves which is the goal of our desires and the centre of that felicity which we everywhere seek and never find? Do not really faithful souls recognize, as one of the Fathers of the Church says, that we were made Christians not for the goods of this life but for something of an entirely different order, which God promises to us in this life but which man cannot yet imagine?' (p. 237).

2 The popularity of pure pessimism, as Chesterton wrote apropos Byron, is almost a contradiction in terms: 'Men would no more receive the news of the failure of existence or of the harmonious hostility of the stars with ardour or popular rejoicing than they would light bonfires for the arrival of cholera or dance a breakdown when they were condemned to be hanged'; *Twelve Types*, pp. 37–8.

3 Compiled, in keeping with the philosopher's systrophic method, from the Greek, Armenian, and Arabic versions of 'The Life of Secundus the Philosopher'; Perry, *Secundus the Silent Philosopher*, pp. 83 (§9); 114 (§10); 149 (§39). 'Beauty is but a vain and doubtful good; / A shining gloss that vadeth suddenly; / A flower that dies when first it 'gins to bud; / A brittle glass that's broken presently'; Shakespeare, *The Passionate Pilgrim*, XIII, ll. 1–4.

4 Thus the later Croce writes that the experience of beauty is like 'a looking back, with no regret, but at the same time not without tears ... A veil of sadness seems to envelop beauty, but it is not a veil: it is the very face of beauty'; *Poetry and Literature*, p. 21. For Breton, on the other hand, beauty is always and only the marvellous; 'Manifesto of Surrealism' (1924), in *Manifestoes of Surrealism*, pp. 1–47 (p. 14). Elsewhere, however, when Breton describes beauty as 'convulsive', Croce's tone of sadness is also present; *Nadja*, p. 160.

5 Unamuno, *The Tragic Sense of Life*, pp. 202–3. 'If man were never to fade away like the dews of Adashino, never to vanish like the smoke over Toribeyama, but lingered on forever in this world, how things would lose their power to move us!'; Kenko, *Essays in Idleness*, §7, p. 7. Chaplin defined beauty as 'the omnipresence of death and loveliness, a smiling sadness'; his examples are a dustbin with a shaft of sunlight across it, a rose in the gutter, an El Greco crucifixion, a newsreel he once saw of a farmer ploughing a field in Flanders shortly after Armistice, and Cellini's *Perseus*; *My Autobiography*, pp. 494; 385. A moment later, however, he describes a woman at a dance as ravishingly beautiful, and Helen Wills playing tennis is also included in his list. It is not clear whether the rose in the gutter represents an aesthetic preference or a definition, or if he chooses it because he feels it is the only type of beauty he can explain. But all roses are in the gutter, for beauty is universal optimism against a background of universal pessimism – and vice versa.

6 France, *On Life and Letters*, pp. 299–301.

7 Segur, *Conversations with Anatole France*, pp. 91–2; France, *On Life and Letters*, p. 304.

8 France, *On Life and Letters*, p. 301.

9 As, for example, Baudelaire, for whom beauty is 'something intense and sad, something a little vague': for some a beautiful woman's head is seductive, inspiring confused dreams of pleasure and sadness, mystery and regret, melancholy, lassitude, even satiety – 'a desire for life together with a bitterness which flows back upon them as if from a sense of deprivation and hopelessness'; *Intimate Journals*, p. 11.

10 Kierkegaard, *Either/Or*, II, p. 207.

References

The following list is restricted to works cited in the text. I was, indeed, surprised to find no references to the works of Erwin Panofsky, which I read, and found very thought-provoking, at an early stage in writing.

Addison, Joseph, *The Spectator* (1711–12) in [Joseph] Addison and [Richard] Steele, *The Spectator*, edited by Gregory Smith (1907), revised edition, four volumes (London, 1945)

Adorno, Theodor, *Aesthetic Theory* (1970), translated by C. Lenhardt (London, 1984)

Alberti, Leon Battista, *Ten Books on Architecture* (1485), translated by James Leoni (1726), edited by Joseph Rykwert (London, 1965)

Alberti, Leon Battista, *On Painting* (1435–6), translated by John R. Spencer, second edition (London, 1966)

Alexander, S., *Beauty and Other Forms of Value* (London, 1933)

Alison, Archibald, *Essays on the Nature and Principles of Taste* (1790), third edition, two volumes (Edinburgh, 1812)

Allen, Grant, *Physiological Aesthetics* (London, 1877)

Aquinas, St Thomas, *Summa Theologiae*, general editor Thomas Gilby, translated by various hands, sixty volumes (London, 1963–75)

Aristotle, *The Complete Works of Aristotle*, edited by Jonathan Barnes, two volumes (Princeton, New Jersey, 1984)

Aschenbrenner, Karl and Isenberg, Arnold (eds), *Aesthetic Theories: Studies in the Philosophy of Art* (Englewood Cliffs, New Jersey, 1965)

Athanasius, *Select Writings and Letters of Athanasius, Bishop of Alexandria*, translated and edited by Archibald Robertson (London, 1891)

Augustine, St, *The Immortality of the Soul, The Magnitude of the Soul, On Music, The Advantage of Believing, and On Faith in Things Unseen*, translated by Ludwig Schopp, John J. McMahon, Robert Catesby Taliaferro, Luanne Meagher, Roy Joseph Deferrari, and Mary Francis McDonald (Washington, D. C., 1947)

Augustine, St, *Letters*, translated by Wilfrid Parsons and Robert E. Enos, six volumes (Washington, D. C., 1951–89)

Augustine, St, *Of True Religion in Earlier Writings*, translated by John H. S. Burleigh (London, 1953), pp. 225–83

Augustine, St, *Confessions*, translated by R. S. Pine-Coffin (Harmondsworth, 1961)

Augustine, St, *City of God*, translated by Henry Bettenson (Harmondsworth, 1972)

Augustine, St, *Expositions on the Book of Psalms*, translated by J. E. Tweed, Charles Marriott, T. Scratton, H. M. Wilkins, and H. Walford (1847–57), edited and condensed by A. Cleveland Coxe (New York, 1888; reprint, Edinburgh, 1989)

Augustine, St, *On Free Choice of the Will*, translated by Thomas Williams (Indianapolis, 1993)

Bacon, Francis, *Essays*, many editions

Balfour, Arthur James, *Theism and Humanism* (London, 1915)

Balthasar, Hans Urs von, *Seeing the Form* (1961), translated by E. Leiva-Merikakis, edited by J. Fessio and J. Riches (Edinburgh, 1982) [Volume 1 of, *The Glory of the Lord*, a translation of, *Herrlichkeit. Eine theologische Aesthetic* (1961–9)]

Barthes, Roland, *A Lover's Discourse: Fragments* (1977), translated by Richard Howard (1978), (Harmondsworth, 1990)

Bascom, John, *Aesthetics; or, the Science of Beauty* (New York, 1871)

Basil of Caesarea, *Exegetic Homilies*, translated by Agnes Clare Way (Washington, D. C., 1963) [Also known as, *Hexaemeron*]

Baudelaire, Charles-Pierre, *Selected Writings on Art and Artists*, translated by P. E. Charvet (Harmondsworth, 1972)

Baudelaire, Charles-Pierre, *Intimate Journals*, translated by Christopher Isherwood (London, 1990)

Baumgarten, Alexander Gottleib, *Reflections on Poetry* (1735), translated, with the original text, by Karl Aschenbrenner and William B. Holther (Berkeley, California, 1954)

Beardsley, Monroe C., *Aesthetics: Problems in the Philosophy of Criticism* (New York, 1958)

Bell, Clive, *Art* (1914), second edition (London, 1914)

Benson, Arthur Christopher, *From a College Window* (London, n. d.)

Berkeley, George, *The Works of George Berkeley, Bishop of Cloyne*, edited by A. A. Luce and T. E. Jessop, nine volumes (London, 1948–57)

Berleant, Arnold, 'Beyond Disinterestedness', *British Journal of Aesthetics* 34 (1994) 242–54

Bevan, Edwyn, *Symbolism and Belief* (1938) (London, 1968)

Blair, Hugh, *Lectures on Rhetoric and Belles Lettres* (1783), 'a new edition complete in one volume' (London, 1825)

Boethius, *The Consolation of Philosophy*, translated by V. E. Watts (Harmondsworth, 1969)

Bonaventure, *The Brevíloquium*, translated by José de Vinck (New York, 1963)

Bonaventure, *The Soul's Journey into God*, in *The Soul's Journey into God, The Tree of Life, The Life of St Francis*, translated by Ewert Cousins (New York, 1978), pp. 51–116

Bouhours, Dominique 'The je ne sais quoi', from *The Conversations of Aristo and Eugene* (1671), in Elledge and Schier (1960), pp. 228–38

Bradley, F. H., *Appearance and Reality: A Metaphysical Essay* (1893), second edition (Oxford, 1897)

Breton, André, *Nadja* (1928), translated by Richard Howard (New York, 1960)

Breton, André, *Manifestoes of Surrealism*, translated by Richard Seaver and Helen R. Lane (Michigan, 1969)

Browne, Thomas, *Pseudodoxia Epidemica; or Enquiries into Very Many Received Tenents and Commonly Presumed Truths* (1646–72), vol. II of, *The Works of Sir Thomas Browne*, second edition, edited by Geoffrey Keynes (Chicago, 1964)

Browne, Thomas, *Religio Medici* (1643), in *Sir Thomas Browne: The Major Works*, edited by C. A. Partrides (Harmondsworth, 1977), pp. 57–161

Burke, Edmund, *A Philosophical Enquiry into the Origin of our Ideas of the Sublime and Beautiful* (1757), second edition (1759), edited by J. T. Boulton (London, 1958)

Carney, James D., 'Defining Art Externally', *British Journal of Aesthetics* 34 (1994) 114–23

Carrier, David, 'Art Without its Objects?', *British Journal of Aesthetics* 19 (1979) 53–62

Carritt, E. F. (ed.), *Philosophies of Beauty: From Socrates to Robert Bridges, Being the Sources of Aesthetic Theory* (Oxford, 1931)

Carritt, E. F., *The Theory of Beauty* (1914), fifth edition (London, 1949)

Carroll, Noël 'Art, Practice, and Narrative', *Monist* 71 (1988) 140–56

Castiglione, Baldassare, *The Book of the Courtier* (1528), translated by Thomas Hoby (1561), edited by J. H. Whitfield (London, 1975)

Chambers, E[phraim], *Cyclopaedia: or, an Universal Dictionary of Arts and Sciences*, two volumes (London, 1728)

Chaplin, Charles, *My Autobiography* (London, 1964)

Chesterton, G. K., *Twelve Types* (London, 1910)

Cicero, *De Officiis*, translated by Walter Miller (London, 1913)

Cicero, *De Natura Deorum and Academia*, translated by H. Rackham (London, 1933)

Cicero, *Tusculan Disputations*, translated by J. E. King, revised edition (London, 1945)

Clement of Alexandria, *Christ the Educator*, translated by Simon P. Wood (Washington, D. C., 1954)

Coleridge, Samuel Taylor, *Essays and Lectures On Shakespeare and Some Other Old Poets and Dramatists* (London, 1907)

Coleridge, Samuel Taylor, *Selected Poetry and Prose*, edited by Elisabeth Schneider, second edition (San Francisco, 1971)

Collingwood, R. G., *Outlines of a Philosophy of Art* (London, 1925)

Collingwood, R. G., *The Principles of Art* (Oxford, 1938)

Coomaraswamy, Ananda K., *Christian and Oriental Philosophy of Art* (New York, 1956)

Croce, Benedetto, *Aesthetic as Science of Expression and General Linguistic* (1901), fourth edition (1911), translated by D. Ainslee, revised edition (London, 1922)

Croce, Benedetto, *Poetry and Literature: An Introduction to its Criticism and History* (1936), sixth edition (1963), translated by Giovanni Gullace (Carbondale, Illinois, 1981)

Crowther, Paul, *The Kantian Sublime: From Morality to Art* (Oxford, 1989)

Crowther, Paul, 'The Significance of Kant's Pure Aesthetic Judgement', *British Journal of Aesthetics* 36 (1996) 109–21

D'Alembert, Jean le Rond, 'Reflexions on the Use and Abuse of Philosophy in Matters that are Properly Relative to Taste' (1757), in Gerard (1759), pp. 209–50

Danto, Arthur C., 'The Artistic Enfranchisement of Real Objects: The Artworld' (1964), reprinted in Dickie and Scalafini (1977), pp. 22–35

Danto, Arthur C., 'The Last Work of Art: Artworks and Real Things' (1973), reprinted in Dickie and Scalafini (1977), pp. 551–62

Danto, Arthur C., *The Transfiguration of the Commonplace* (Harvard, 1981)

Danto, Arthur C., *The Philosophical Disenfranchisement of Art* (New York, 1986)

Danto, Arthur C., 'A Future for Aesthetics', *Journal of Aesthetics and Art Criticism* 51 (1993) 271–7

Darwin, Charles, *The Descent of Man and Selection in Relation to Sex* (1871), in *The Origin of Species by Means of Natural Selection and The Descent of Man and Selection in Relation to Sex* (Chicago, 1952), pp. 253–597

Davies, Stephen, *Definitions of Art* (London, 1991)

Day, Henry N., *The Science of Aesthetics; or, the Nature, Kinds, Laws, and Uses of Beauty* (New Haven, 1872)

Delattre, Roland André, *Beauty and Sensibility in the Thought of Jonathan Edwards: An Essay in Aesthetics and Theological Ethics* (New Haven, 1968)

Derrida, Jacques, *The Truth in Painting* (1978), translated by Geoff Bennington and Ian McLeod (Chicago, 1987)

Dewey, John, *Art as Experience* (1934) (New York, 1958)

Dickie, George 'The Myth of the Aesthetic Attitude' (1964), reprinted in John Hospers (ed.), *Introductory Readings in Aesthetics* (New York, 1969), pp. 28–44

Dickie, George, 'The Institutional Concept of Art' (1970), in Benjamin R. Tilgham (ed.), *Language and Aesthetics: Contributions to the Philosophy of Art* (Lawrence, Kansas, 1973), pp. 21–30

Dickie, George, 'Defining Art II', in Matthew Lipman (ed.), *Contemporary Aesthetics* (Boston, 1973), pp. 118–31

Dickie, George, *Introduction to Aesthetics: An Analytical Approach* [revised edition of, *Aesthetics: An Introduction* (1971)] (Oxford, 1997)

Dickie, George and Scalafini, R. J. (eds), *Aesthetics: A Critical Anthology* (New York, 1977)

Diderot, Denis, 'The Beautiful' (1752) [*Encyclopédie* article], translated by Karl Aschenbrenner in Aschenbrenner and Isenberg (1965), pp. 129–47

Diderot, Denis, *Selected Writings on Art and Literature*, translated and edited by Geoffrey Bremner (Harmondsworth, 1994)

Diffey, T. J., 'On American and British Aesthetics', *Journal of Aesthetics and Art Criticism* 51 (1993) 169–75

Dryden, John, *Of Dramatic Poesy and Other Critical Essays*, edited by George Watson, two volumes (London, 1962)

Du Bos, Abbé [Jean Baptiste Dubos], *Critical Reflections on Poetry, Painting and Music with An Inquiry into the Rise and Progress of the Theatrical Entertainments of the Ancients* (1719), translated by Thomas Nugent 'from the fifth edition revised, corrected and inlarged by the author', three volumes (London, 1748; reprint, New York, 1978)

Dufrenne, Mikel, *In the Presence of the Sensuous: Essays in Aesthetics*, edited by Mark S. Roberts and Dennis Gallagher (Atlantic Highlands, New Jersey, 1987)

Durer, Albrecht, 'Aesthetic Excursus' (1528), translated by William Martin Conway and Erwin Panofsky in Holt (1957–66), I, pp. 318–29

Dutton, Dennis, 'Kant and the Conditions of Artistic Beauty', *British Journal of Aesthetics* 34 (1994) 226–41

Eagleton, Terry, 'The Ideology of the Aesthetic', *Poetics Today*, 9 (1988) 327–38

Eagleton, Terry, *The Ideology of the Aesthetic* (Oxford, 1990)

Eaton, Marcia Muelder, 'Where's the Spear? The Question of Aesthetic Relevance', *British Journal of Aesthetics* 32 (1992) 1–12

Eco, Umberto, *The Open Work*, translated by A. Cancogni and B. Merry (London, 1989)

Edwards, Jonathan, *Basic Writings*, edited by Ola Elizabeth Winslow (New York, 1966)

Elledge, Scott and Schier, Donald (eds), *The Continental Model: Selected French Critical Essays of the Seventeenth Century, in English Translation* (Minneapolis, 1960),

Elton, William (ed.), *Aesthetics and Language* (Oxford, 1954)

Emerson, Ralph Waldo, *Essays and Lectures*, edited by Joel Porte (New York, 1983)

Eriugena, John Scotus, *Periphyseon (Division of Nature)*, translated by I. P. Sheldon-Williams and John J. O'Meara (Montréal, 1987)

Fehér, Ferenc and Heller, Agnes (eds), *Reconstructing Aesthetics: Writings of the Budapest School* (Oxford, 1986)

Feijoo, Fr. Benito Jerónimo, *The 'I Know Not What'* (1676, 1764), translated by Willard F. King in Milton C. Nahm (ed.), *Readings in Philosophy of Art and Aesthetics* (Englewood Cliffs, New Jersey, 1975), pp. 336–44

Fichte, Johann Gottlieb, *The Vocation of Man* (1800), translated by William Smith, revised edition by R. M. Chisolm (Indianapolis, 1956)

Ficino, Marsilio, *Commentary on Plato's Symposium on Love* (1484), translated by Sears Jayne (Dallas, 1985)

Findlay, J. N. 'The Perspicuous and the Poignant: Two Aesthetic Fundamentals' (1967), in Osborne (1972), pp. 89–105

Firenzuola, Agnolo, *On the Beauty of Women* (1584), translated by Konrad Eisenbichler and Jaqueline Murray (Philadelphia, 1992)

Fisher, John 'Aesthetic Experience: Where Did We Go Wrong?', in Woodfield (1990), pp. 66–9

France, Anatole, *On Life and Letters: First Series* (1888–93), translated by A. W. Evans (London, 1914)

Freud, Sigmund, *The Interpretation of Dreams* (1900), translated by James Strachey, edited by Angela Richards, in *The Pelican Freud Library*, vol. 4 (Harmondsworth, 1976)

Fry, Roger, *Vision and Design* (1925) (Harmondsworth, 1937)

Frye, Northrop, *Anatomy of Criticism: Four Essays* (Princeton, New Jersey, 1957)

Frye, Northrop, *The Stubborn Structure: Essays on Criticism and Society* (London, 1970)

Gadamer, Hans-Georg, *Philosophical Hermeneutics*, translated by David E. Linge (Berkeley, California, 1976)

Garvin, P. L. (ed.), *A Prague School Reader on Esthetics, Literary Structure, and Style* (Washington, D. C., 1964)

Gautier, Theophile, *Mademoiselle de Maupin* (1835), translated by Joanna Richardson (Harmondsworth, 1981)

Gerard, Alexander, *An Essay on Taste, With Three Dissertations on the Same Subject by Mr. De Voltaire, Mr. D'Alembert, Mr. De Montesquieu* (London, 1759)

Gerard, Alexander, *An Essay on Taste: To which is Now Added Part Fourth, Of the Standard of Taste, with Observations Concerning the Imitative Nature of Poetry* (Edinburgh, 1780)

Gide, André, *Journals 1889–1949*, translated and edited by Justin O'Brien (Harmondsworth, 1967)

Goldman, Alan H., 'Realism about Aesthetic Properties', *Journal of Aesthetics and Art Criticism* 51 (1993) 31–7

Goldman, Alan H., 'Reply to Gould and Levinson on Aesthetic Realism', *Journal of Aesthetics and Art Criticism* 52 (1994) 354–6

Goodman, Nelson, 'Merit as Means', in Sidney Hook (ed.), *Art and Philosophy: A Symposium* (New York, 1966), pp. 56–7

Gould, Carol S., 'The Reality of Aesthetic Properties: A Response to Goldman', *Journal of Aesthetics and Art Criticism* 52 (1994) 349–51

Gregory of Nyssa, *On Virginity*, in *Select Writings and Letters*, translated by William Moore and Henry Austin Wilson (New York, 1892; reprint, Michigan, 1976), pp. 343–71

Grosseteste, Robert, *On the Six Days of Creation*, translated by C. F. J. Martin (Oxford, 1996)

Guibert of Nogent, *The Memoirs of Abbot Guibert of Nogent* (1651), translated and edited by John F. Benton (New York, 1970)

Guyer, Paul, 'Kant's Conception of Fine Art', *Journal of Aesthetics and Art Criticism* 52 (1994) 275–85

Hampshire, Stuart, 'Logic and Appreciation' (1952), in Elton (1954), pp. 161–9

Hanslick, Eduard, *The Beautiful in Music: A Contribution to the Revisal of Musical Aesthetics*, seventh edition (1885), translated by Gustav Cohen (London, 1891)

Hartley, David, *Observations on Man, His Frame, His Duty, and His Expectations*, two volumes (London, 1749)

Hazlitt, William, *The Round Table: A Collection of Essays on Literature, Men, and Manners*, two volumes (Edinburgh, 1817)

Hegel, G. W. F., Phenomenology of Spirit (1807), translation of the fifth edition by A. V. Miller (Oxford, 1977)

Hegel, G. W. F., Introductory Lectures on Aesthetics (1835), translated by Bernard Bosanquet, edited by Michael Inwood (Harmondsworth, 1993)

Heidegger, Martin, Being and Time (1927), translated by John Macquarrie and Edward Robinson (Oxford, 1962)

Heidegger, Martin, Poetry, Language, Thought, translated by Albert Hofstadter (London, 1971)

Hogarth, William, The Analysis of Beauty (London, 1753)

Holt, Elizabeth Gilmore (ed.), A Documentary History of Art, three volumes (New York, 1957–66)

Huet, Pierre-Daniel, 'The Original of Romances' (1670), translated by Samuel Croxall (1720), in Elledge and Schier (1960), pp. 186–205

Hume, David, A Treatise of Human Nature (1739), edited by L. A. Selby-Bigge (1888) (Oxford, 1967)

Hume, David, Enquiries Concerning Human Understanding and Concerning the Principles of Morals (1777), edited by L. A. Selby-Bigge, third edition revised by P. H. Nidditch (Oxford, 1975)

Hume, David, Essays Moral, Political, and Literary (1777), edited by Eugene F. Miller, revised edition (Indianapolis, 1987)

Hutcheson, Francis, An Inquiry into the Original of Our Ideas of Beauty and Virtue (London, 1725; reprint, Hildesheim, 1990)

Isocrates, Helen, translated by Larue van Hook, in Isocrates, translated by George Norlin and Larue van Hook, three volumes (London, 1928–45), III, pp. 61–97

Jacopone da Todi, The Lauds, translated by Serge and Elizabeth Hughes (New York, 1982)

James, William, The Principles of Psychology (1890), edited by Frederick Burkhardt and Fredson Bowers, three volumes (Cambridge, Massachusetts, 1981)

Jeffrey, Francis, 'Essay on Beauty' (1816), in Aschenbrenner and Isenberg (1965), pp. 277–94

John Chrysostom, The Homilies on the Statues in On the Priesthood; Ascetic Treatises; Select Homilies and Letters; Homilies on the Statues, translated by W. R. W. Stephens, T. P. Brandam, and R. Blackburn (New York, 1889; reprint, Edinburgh, 1989), pp. 313–489

John of the Cross, St, The Collected Works of St John of the Cross, translated by Kieran Kavanaugh and Otilio Rodriguez (Washington, D. C., 1964)

Johnson, Samuel, Rambler No. 93, 5 February, 1751

Johnston, V. S. and Franklin, M., 'Is Beauty in the Eye of the Beholder?', Ethology and Sociobiology 14 (1993) 183–99

Kamber, Richard, 'Weitz Reconsidered: A Clearer View of Why Theories of Art Fail', British Journal of Aesthetics 38 (1988) 33–46

Kames, Lord [Henry Home], Elements of Criticism, three volumes (Edinburgh, 1762; reprint, Hildesheim, 1970)

Kant, Immanuel, Critique of Pure Reason (1781, 1787), translated by Norman Kemp Smith, second edition (London, 1933)

Kant, Immanuel, Critique of Aesthetic Judgement (1790), in The Critique of Judgement (1790), translated by James Creed Meredith (Oxford, 1952)

Kant, Immanuel, Dreams of a Spirit-Seer Elucidated by Dreams of Metaphysics (1766), in Theoretical Philosophy, 1755–1770, edited by David Walford and Ralf Meerbote (Cambridge, 1992), pp. 301–59

Kenko, Essays in Idleness: The Tsurezuregusa of Kenko, translated by Donald Keene (Columbia, 1967)

Kierkegaard, Soren, The Point of View for My Work as an Author: A Report to History (1859), in The Point of View Etc., translated by Walter Lowrie (New York, 1939), pp. 1–103

Kierkegaard, Soren, Either/Or (1843), translated by D. F. Swenson, L. M. Swenson and H. A. Johnson, two volumes (Princeton, New Jersey, 1959)

Kierkegaard, Soren, *Fear and Trembling* (1843), translated by Alastair Hannay (Harmondsworth, 1985)

Kirwan, James, *Literature, Rhetoric, Metaphysics: Literary Theory and Literary Aesthetics* (London, 1990)

Knight, Richard Payne, *An Analytical Inquiry into the Principles of Taste* (1805), fourth edition (London, 1808)

Knight, William, *The Philosophy of the Beautiful: A Contribution to its Theory, and to A Discussion of the Arts,* Volume II (London, 1893)

Kristeller, Paul Oskar, 'The Modern System of the Arts' (1951–2), in *Renaissance Thought II: Papers on Humanism and the Arts* (New York, 1965), pp. 163–227

Lactantius, *The Workmanship of God*, in *The Minor Works*, translated by Mary Francis McDonald (Washington, D. C., 1965), pp. 1–56

Leddy, Thomas, 'Sparkle and Shine', *British Journal of Aesthetics* 37 (1997) 259–73

Lee, Vernon and Anstruther-Thomson, C., *Beauty and Ugliness: And Other Studies in Psychological Aesthetics* (London, 1912)

Leibniz, Gottfried Wilhelm, *Philosophical Papers and Letters*, translated and edited by LeRoy E. Loemaker, two volumes (Chicago, 1956)

Levinas, Emmanuel, *Totality and Infinity: An Essay on Exteriority* (1961), translated by Alphonso Lingis (The Hague, 1979)

Levinson, Jerrold 'Pleasure and the Value of Works of Art', *British Journal of Aesthetics* 32 (1992) 295–306

Levinson, Jerrold, 'Extending Art Historically', *Journal of Aesthetics and Art Criticism* 51 (1993) 411–23

Levinson, Jerrold, 'Art Historically Defined: Reply to Oppy', *British Journal of Aesthetics* 33 (1993) 380–5

Levinson, Jerrold 'Being Realistic About Aesthetic Properties', *Journal of Aesthetics and Art Criticism* 52 (1994) 351–4

Lind, Richard, 'The Aesthetic Essence of Art', *Journal of Aesthetics and Art Criticism* 50 (1992) 117–29

Longinus, *On the Sublime*, translated by T. S. Dorsch, in T. S. Dorsch (ed.), *Classical Literary Criticism* (Harmondsworth, 1965), pp. 99–158

Lorand, Ruth, 'The Purity of Aesthetic Value', *Journal of Aesthetics and Art Criticism* 50 (1992) 13–21

Lorand, Ruth, 'Beauty and its Opposites', *Journal of Aesthetics and Art Criticism* 52 (1994) 399–406

Lucretius, *De Rerum Natura*, translated by W. H. D. Rouse (1924), revised by Martin Ferguson Smith (London, 1975)

Ludeking, K., 'Does Analytical Aesthetics Rest on a Mistake?', in Woodfield (1990), pp. 123–7

Lyotard, Jean-François, 'After the Sublime: The State of Aesthetics', in David Carroll (ed.), *The States of 'Theory': History, Art, and Critical Discourse* (New York, 1990), pp. 297–304

Lyotard, Jean-François, *Lessons on the Analytic of the Sublime* (1991), translated by Elizabeth Rottenberg (Stanford, 1994)

Mandeville, Bernard, *The Fable of the Bees* (1714, 1724), edited by Phillip Harth (Harmondsworth, 1970)

March, Ausias, *Selected Poems*, translated and edited by Arthur Terry (Edinburgh, 1976)

Margolis, Joseph, 'Exorcising the Dreariness of Aesthetics', *Journal of Aesthetics and Art Criticism* 51 (1993) 133–40

Maritain, Jacques, *Art and Scholasticism* (1920), translated by J. F. Scanlan, second edition (London, 1930)

Maritain, Jacques, *Creative Intuition in Art and Poetry* (New York, 1955)

Mather, Frank Jewett, *Concerning Beauty* (Princeton, New Jersey, 1935)

Matravers, Derek, 'Aesthetic Concepts and Aesthetic Experiences', *British Journal of Aesthetics* 36 (1996) 265–77

Maximus of Tyre, *The Philosophical Orations*, translated by M. B. Trapp (Oxford, 1997)

Methodius, *Three Fragments from the Homily on the Cross and Passion of Christ*, translated by William R. Clark, in Roberts, Alexander and Donaldson, James (eds), *Fathers of the Third Century*, translated by S. D. F. Salmond, James B. H. Hawkins, William R. Clark, Hamilton Bryce, and Hugh Cambell (New York, n. d.; reprint, Edinburgh, 1997), pp. 399–400

Mill, John Stuart, *Utilitarianism, On Liberty, Essay on Bentham*, edited by Mary Warnock (London, 1962)

Mitchell, William, *Structure and Growth of the Mind* (London, 1907)

Mondrian, Piet, *The New Art – The New Life: The Collected Writings of Piet Mondrian*, edited and translated by Harry Holtzman and Martin S. James (London, 1987)

Montesquieu, Charles Louis de Secondat, Baron de, *The Spirit of Laws* (1748), translated by T. Nugent (1750), revised by J. V. Prichard (Chicago, 1952)

Montesquieu [Charles Louis de Secondat, Baron de], 'An Essay on Taste: Considered with Respect to the Productions Both of Nature and Art' (n. d.), in Gerard (1759), pp. 251–314

Morris, William, *The Collected Works of William Morris*, edited by May Morris, twenty four volumes (London, 1910–15)

Mothershill, Mary, *Beauty Restored* (Oxford, 1984)

Mukarovsky, Jan, 'Standard Language and Poetic Language' (1932), in Garvin (1964), pp. 17–30

Mukarovsky, Jan 'The Esthetics of Language' (1948), in Garvin (1964), pp. 31–69

Mukarovsky, Jan, *Aesthetic Function, Norm and Value as Social Facts* (1936), translated by Mark F. Suino (Ann Arbor, 1970)

Newton, Eric, *The Meaning of Beauty* (1959) (Harmondsworth, 1962)

Nicholas of Cusa, *The Vision of God*, translated by Emma Gurney Salter (London, 1928)

Nietzsche, Friedrich, *Thus Spake Zarathustra* (1883–92), translated by Walter Kaufman, in *The Portable Nietzsche* (New York, 1954), pp. 112–439

Nietzsche, Friedrich, *On the Genealogy of Morals* (1887), in *On the Genealogy of Morals and Ecce Homo*, translated by Walter Kaufmann and R. J. Hollingdale, edited by Walter Kaufmann (New York, 1968), pp. 13–163

Nietzsche, Friedrich, *Twilight of the Idols* (1889), translated by R. J. Hollingdale (Harmondsworth, 1968)

Novitz, David, 'The Integrity of Aesthetics', *Journal of Aesthetics and Art Criticism* 48 (1990) 9–20

Nygren, Anders, *Agape and Eros* (1930, 1936), translated by Philip S. Watson (London, 1953)

Ogden, C. K., Richards, I. A., and Woods, James, *The Foundation of Aesthetics*, (1922), second edition (London, 1925)

Oppy, Graham, 'On Defining Art Historically', *British Journal of Aesthetics* 32 (1992) 153–61

Osborne, Harold (ed.), *Aesthetics* (Oxford, 1972)

Osborne, Harold, 'What Is a Work of Art?', *British Journal of Aesthetics* 21 (1981) 3–11

Otto, Rudolf, *The Idea of the Holy: An Inquiry into the Non-rational Factor in the Idea of the Divine and its Relation to the Rational* (1917), translated by John W. Harvey (1923), second edition (London, 1950)

Pacteau, Francette, *The Symptom of Beauty* (London, 1994)

Paglia, Camille, *Sexual Personae: Art and Decadence from Nefertiti to Emily Dickinson* (1990) (Harmondsworth, 1992)

Pascal, Blaise, *Pensées: Notes on Religion and Other Subjects* (1670), edited by Louis Lafuma (1953), translated by John Warrington (London, 1960)

Passmore, J. A., 'The Dreariness of Aesthetics', in Elton (1954), pp. 36–55

Pater, Walter, *Appreciations: With an Essay on Style* (London, 1889)

Pater, Walter, *The Renaissance: Studies In Art and Poetry* (1873), 1893 edition edited by Donald G. Hill (London, 1980)

Perry, Ben Edwin, *Secundus the Silent Philosopher: The Greek Life of Secundus Critically Edited and Restored So Far as is Possible Together with Translations of the Greek and Oriental Versions, the Latin and Oriental Texts, and a Study of the Tradition* (1964)

Philo of Alexandria, *The Embassy to Gaius*, vol. X of, *Philo*, translated by F. H. Colson, G. H. Whitaker, and Ralph Marcus, twelve volumes (London, 1929–53)

Plato, *The Collected Dialogues of Plato*, edited by Edith Hamilton and Huntington Cairns (Princeton, New Jersey, 1963)

Plotinus, *The Enneads*, translated by Stephen MacKenna, third edition revised by B. S. Page (London, 1962)

Plutarch, *Pericles and Fabius Maximus, Nicias and Crassus*, vol. 3 of *Plutarch's Lives*, translated by Bernadotte Perrin, eleven volumes (London, 1914–29)

Poe, Edgar Allan, *Poems and Essays* (London, 1927)

Pope, Alexander, *An Essay on Criticism* (1711), in *The Poems of Alexander Pope: A One-Volume Edition of the Twickenham Text with Selected Annotations* (1963), edited by John Butt, second edition (London, 1968), pp. 144–68

Poussin, Nicolas, *Observations on Painting* (1672), translated by Elizabeth Gilmore Holt in Holt (1957–66), II, pp. 142–6

Prall, David W., *Aesthetic Judgement* (New York, 1927)

Proust, Marcel, *Remembrance of Things Past* (1913–27), translated by C. K. Scott Moncrieff and Terence Kilmartin (1981), three volumes (Harmondsworth, 1983)

Pseudo-Dionysius, *The Complete Works*, translated by Colm Luibheid and Paul Rorem, edited by Paul Rorem (New York, 1987)

Ransom, John Crowe, *The World's Body* (London, 1938)

Read, Herbert, *The Meaning of Art* (1931), second edition (London, 1935)

Read, Herbert, *Collected Essays in Literary Criticism* (1938), second edition (London, 1951)

Reid, Thomas, *Essays on the Intellectual Powers of Man* (1785), in *The Works of Thomas Reid: Now Fully Collected with Selections from his Unpublished Letters*, edited by William Hamilton, fifth edition, two volumes (London, 1858), I, pp. 215–505

Reynolds, Joshua, *Discourses on Art* (1769–97), edited by Robert R. Wark (London, 1975)

Richards, I. A., *Principles of Literary Criticism* (1924), second edition (London, 1926)

Rorty, Richard, 'Freud and Moral Reflection', in J. H. Smith and W. Kerrigan (eds), *Pragmatism's Freud: The Moral Disposition of Psychoanalysis* (Baltimore, 1986), pp. 1–27

Rousseau, Jean-Jacques, *The Confessions* (1781), translated by J. M. Cohen (Harmondsworth, 1953)

Rousseau, Jean-Jacques, *Essay On the Origin of Languages which Treats of Melody and Musical Imitation* (1781), translated by John H. Moran, in John H. Moran and Alexander Gode (eds), *On the Origin of Language* (New York, 1966), pp. 1–74

Rousseau, Jean-Jacques, *Emile or On Education* (1762), translated by Allan Bloom (1979) (Harmondsworth, 1991)

Ruskin, John, *Lectures on Architecture and Painting, Delivered at Edinburgh in November 1853* (London, 1854)

Ruskin, John, *Modern Painters* (1843–60), five volumes, third edition (London, 1900)

Ruskin, John, *The Crown of Wild Olive: Three Lectures on Work, Traffic, and War* (1866), in *The Complete Works of John Ruskin*, edited by E. T. Cook and Alexander Wedderburn, thirty-nine volumes (London, 1903–12), XVIII, pp. 369–533

Samson, G. W., *Elements of Art Criticism* (1868), abridged edition (Philadelphia, 1874)

Santayana, George, *The Sense of Beauty: Being the Outline of Aesthetic Theory* (New York, 1896)

Savile, Anthony, *The Test of Time: An Essay in Philosophical Aesthetics* (Oxford, 1982)

Schelling, F. W. J., *The Philosophy of Art: An Oration on the Relation Between the Plastic Arts and Nature* (1807), translated by A. Johnson (London, 1845)

Schelling, F. W. J., *System of Transcendental Idealism* (1800), translated by Peter Heath (Charlottesville, 1978)

Schelling, F. W. J., *Bruno, Or On the Natural and the Divine Principle of Things* (1802), translated by Michael G. Vater (New York, 1984)

Schelling, F. W. J., *The Philosophy of Art* (1859), translated by D. W. Stott (Minneapolis, 1989)

Schiller, Friedrich, *On the Aesthetic Education of Man: In a Series of Letters* (1795), translated by E. M. Wilkinson and L. A. Willoughby (Oxford, 1967)

Schlegel, Frederick von, *The Philosophy of Life and Philosophy of Language in a Course of Lectures* (n. d.), translated by A. J. W. Morrison (London, 1847)

Scholz, Barbara C., 'Rescuing the Institutional Theory of Art: Implicit Definitions and Folk Aesthetics', *Journal of Aesthetics and Art Criticism* 52 (1994) 309–25

Schopenhauer, Arthur, *The World as Will and Representation* (1844), translated by E. F. J. Payne, two volumes (New York, 1966)

Schopenhauer, Arthur, *Essays and Aphorisms*, selected and translated by R. J. Hollingdale [from *Parerga and Paralipomena* (1851)] (Harmondsworth, 1970)

Scruton, Roger 'Aesthetics' in the *Encyclopaedia Britannica* (15th edition)

Secundus: See Perry (1964)

Segur, Nicolas, *Conversations with Anatole France* (n. d.), translated by J. Lewis May (London, 1926)

Sextus Empiricus, *Against the Professors*, vol. 4 of, *Sextus Empiricus*, four volumes, translated by R. G. Bury (London, 1933–49)

Shaftesbury, Third Earl of [Anthony Ashley Cooper], *Characteristicks of Men, Manners, Opinions, Times*, three volumes (London, 1711; reprint, Hildesheim, 1978)

Shelley, Percy Bysshe, *Essays and Letters*, edited by Ernest Rhys (London, 1886)

Sheppard, Anne, *Aesthetics: An Introduction to the Philosophy of Art* (Oxford, 1987)

Shklovsky, Victor, 'Art as Technique' (1917), in Lee T. Lemon and Marion J. Reis (eds), *Russian Formalist Criticism: Four Essays* (Lincoln, 1965), pp. 5–24

Shusterman, Richard, 'Analytic and Pragmatist Aesthetics', in Woodfield (1990), pp. 190–4

Shusterman, Richard, *Pragmatist Aesthetics: Living Beauty, Rethinking Art* (Oxford, 1992)

Sircello, Guy, *A New Theory of Beauty* (Princeton, New Jersey, 1975)

Smith, Adam, *The Theory of Moral Sentiments* (1759, 1792), edited by D. D. Raphael and A. L. Macfie (Oxford, 1979)

Sontag, Susan, *Styles of Radical Will* (New York, 1969)

Spencer, Herbert, *The Principles of Psychology* (1855), second edition, two volumes (London, 1870–2)

Spinoza, Benedict, *Ethics and De Intellectus Emendatione* (1677), translated by A. Boyle (London, 1910)

Spinoza, Benedict, *The Correspondence of Spinoza*, translated and edited by A. Wolf (London, 1928)

Stace, W. T., *The Meaning of Beauty: A Theory of Aesthetics* (London, 1929)

Steenberg, Elisa, 'Verbalizing the Aesthetic Experience', *British Journal of Aesthetics* 32 (1992) 342–6

Stolnitz, Jerome, *Aesthetics and Philosophy of Art Criticism: A Critical Introduction* (Boston, 1960)

Summers, David, *The Judgement of Sense: Renaissance Naturalism and the Rise of Aesthetics* (Cambridge, 1987)

Swinburne, Algernon Charles, *The Complete Works of Algernon Charles Swinburne*, edited by Edmund Gosse and Thomas James Wise, twenty volumes (London, 1925–7)

Tasso, Torquato, *Discourses on the Heroic Poem* (1594), in Allen H. Gilbert (ed.), *Literary Criticism: Plato to Dryden* (New York, 1940), pp. 467–503

Tatarkiewicz, Wladyslaw, *History of Aesthetics* (1962–7), translated by Adam Czerniawski, Ann Czerniawski, R. M. Montgomery, C. A. Kisiel, and J. F. Besemeres, edited by J. Harrel, C. Barrett, and D. Petsch, three volumes (The Hague, 1970–4)

Taylor, A. E., *Plato: The Man and his Work*, fourth revised edition (London, 1937)

Tolstoy, Leo, *What Is Art? and Essays on Art*, translated and edited by Aylmer Maude (Oxford, 1930)

Traherne, Thomas, *The Centuries*, in *Poems, Centuries and Three Thanksgivings*, edited by Anne Ridler (London, 1966), pp. 165–372 [Also known as, *Centuries of Meditations*]

Turner, Frederick, *Beauty: The Value of Values* (Charlottesville, 1991)

Unamuno, Miguel de, *The Tragic Sense of Life in Men and in Peoples* (1913), translated by J. E. Crawford Flitch (London, 1924)

The Upanishads: Translations from the Sanskrit, translated by Juan Mascaró (Harmondsworth, 1965)

Valentine, C. V., *The Experimental Psychology of Beauty* (London, 1962)

Voltaire, François-Marie, 'An Essay on Taste' (n. d.), in Gerard (1759), pp. 213–22

Voltaire, François-Marie, *Philosophical Dictionary* (1765), edited and translated by Theodore Besterman (Harmondsworth, 1971)

Wegener, Charles, *The Discipline of Taste and Feeling* (Chicago, 1992)

Weil, Simone, *Waiting for God* (1950), translated by Emma Craufurd (New York, 1951)

Weitz, Morris, 'The Role of Theory in Aesthetics', *Journal of Aesthetics and Art Criticism* 15 (1956) 27–35

Whitehead, Alfred North, *Adventures of Ideas* (New York, 1933)

Whitehead, Alfred North, *Modes of Thought* (1938) (New York, 1968)

Wilde, Oscar, *Intentions* (London, 1891)

Wilde, Oscar, *The Picture of Dorian Gray* (London, 1891)

Wilde, Oscar, 'The English Renaissance of Art' (1882), in Derek Stanford (ed.), *Writing of the Nineties: From Wilde to Beerbohm* (London, 1971), pp. 3–24 [This lecture was reproduced in the volume, *Essays and Lectures* in Robert Ross's edition of Wilde's, *Collected Works* but not in any subsequent collected editions.]

Wollheim, Richard, *Art and its Objects* (1968), second edition (Cambridge, 1980)

Woodfield, Richard (ed.), *Proceedings of the XIth International Congress in Aesthetics: 1988* (Nottingham, 1990)

Worringer, Wilhelm, *Form in Gothic* (1912), edited by Herbert Read (London, 1957)

Xenephon, *The Banquet*, translated by James Welwood (1710), in A. D. Lindsay (ed.), *Socratic Discourses by Plato and Xenephon* (London, 1910), pp. 162–200

Zangwill, Nick, 'Two Dogmas of Kantian Aesthetics', in Woodfield (1990), pp. 233–8

Zemach, Eddy M., *Real Beauty* (Pennsylvania, 1997)

Index

Note: ' n.' after a page reference indicates the number of a note on that page.

177